W9-BSQ-844

42298

ND
210
.A7285
1986 American pa

42298

ND
210
.A7285
1986 American paintings

AMERICAN PAINTINGS

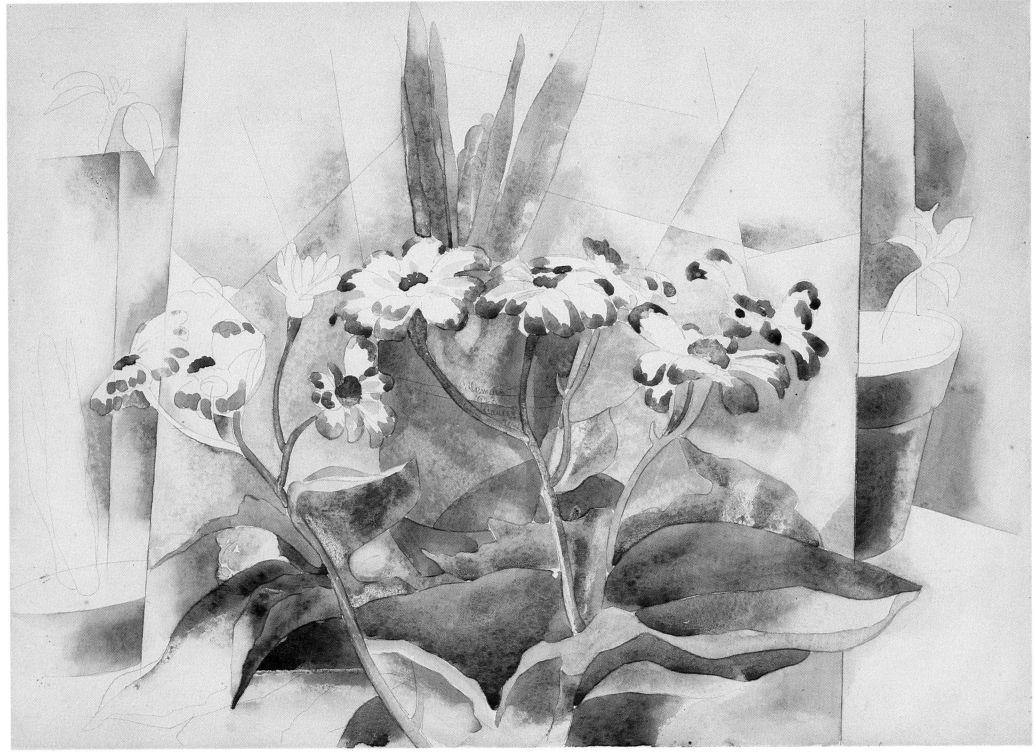

Charles Demuth (1883-1935) *Cineraria*, 1923
Watercolor and graphite on paper, 10 x 14 in. (25.4 x 35.5 cm)
Inscribed l.c.: "C. Demuth-/1923/Lancas/ter."
Purchased with funds provided by the Nenetta Burton Carter Fund

42298

AMERICAN PAINTINGS

Selections from the Amon Carter Museum

Linda Ayres

Jane Myers

Mark Thistlethwaite

Ron Tyler

with an introduction by *Jan Keene Muhlert*

Oxmoor House®

Copyright 1986 by Amon Carter Museum of Western Art
Fort Worth, Texas

All rights reserved. No part of this book may be reproduced
in any form, or by any means without the prior written
permission of the Publisher, excepting brief quotations in
connection with reviews written specifically for inclusion in
a magazine or newspaper.

Library of Congress Catalog Number: 86-061361
ISBN: 0-8487-0694-3
Manufactured in the United States of America

First Edition

Published by Oxmoor House, Inc.
Book Division of Southern Progress Corporation
P.O. Box 2463, Birmingham, Alabama 35201

Executive Editor: Candace N. Conard
Production Manager: Jerry Higdon
Associate Production Manager: Rick Litton
Art Director: Bob Nance

American Paintings
Selections from the Amon Carter Museum

Editor: Rebecca Brennan
Editorial Assistant: Margaret Allen Northen

Introduction

The Amon Carter Museum was founded on a dream—Amon G. Carter, Sr. (1879-1955) wanted a museum built for the people of his city, Fort Worth, Texas. It was to be an "artistic enterprise" for the benefit of all, and he hoped its collections and programs would "particularly stimulate artistic imagination among young people." Carter established the Amon G. Carter Foundation in 1945 and later provided that it would oversee the construction and future funding of the museum which would house his extensive collection of works by Frederic Remington and Charles M. Russell.

Within twenty-five years, the original collection of over four hundred paintings, watercolors, and sculpture has grown to more than 6,380 works of art, including major additions of prints. The photography collection, not included in this total, began in 1961 with a gift from Dorothea Lange of her portrait of Charles Russell. Today it consists of more than 250,000 prints and negatives and is one of the country's major repositories of American photography. In addition to the works of Remington and Russell, the painting collection includes early landscapes from the Hudson River School, luminist paintings, trompe l'oeil still lifes, and examples of American Impressionism and early modernism. Complementing Remington's and Russell's paintings is an important group of their sculptures. Additional pieces of sculpture have been added, including Augustus Saint-Gaudens's *Diana* (1928), originally owned by architect Stanford White, and sculpture by Elie Nadelman, Alexander Archipenko, and John Flannagan. There are also more than five hundred watercolors and drawings that span American art history and range from early exploration works, wildlife studies, still lifes, landscapes, and twentieth-century works up to the 1940s. Carter's dream, more than amply fulfilled, continues to guide the staff and Board of Trustees.

This publication focuses on some of the highlights of the Amon Carter Museum's collection of paintings. Although the Museum's holdings are extensive in many areas, we chose to celebrate twenty-five years of collecting by giving an overview of the breadth of the Museum's interests and a glimpse at some of the landmarks in the history of American art.

When Amon Carter died in 1955, he left his son, Amon Carter, Jr. (1919-1982), and daughter, Ruth Carter Johnson, president and vice president of the Board of Directors of the Foundation, to implement his dream. "As heirs to the spirit and the keeping of the trust of his ideals," they, along with Katrine Deakins (1900-1985), Carter's long-time assistant and secretary-treasurer of the Foundation, enthusiastically accepted the responsibility. In the Museum's inaugural publication, Mrs.

1 *Inaugural Exhibition, Amon Carter Museum of Western Art, Selected Works, Frederic Remington and Charles Marion Russell* (Fort Worth, 21 January 1961).

Johnson wrote, "The inheritance of a legacy imposes many responsibilities and duties. Specifically, faithfulness and loyalty to a legacy of the dreams and hopes of a man of vision demand, above all, humility and dedication to ideals of staggering proportions." With those words, Ruth Johnson (now Ruth Carter Stevenson) took up her responsibilities as president of the Museum's Board of Trustees.

After meeting architect Philip Johnson and seeing his newly constructed University of St. Thomas Galleries in Houston, Mrs. Stevenson chose him as the architect for the Amon Carter Museum. Johnson had more than adequate experience with the problems peculiar to museum design. He had been a leader in the establishment of the architecture department of the Museum of Modern Art and had served as a trustee and architect for the Museum's 1950 annex. In addition to the Houston project, Asia House in New York City and the Munson-Williams-Proctor Institute at Utica, New York, were evidence of Johnson's growing concern with institutional, especially museum, architecture, in contrast to his earlier focus on domestic structures.

The museum Johnson designed is built of Texas shell-stone with interior detailing of bronze and teak. He also planned the gardens, terraces, and walkways leading to the entrance of the building. Johnson wrote, "The site, a noble slope overlooking the city's center, led naturally to a portico design. . . . The five segmental arches on tapered columns form an open porch overlooking terraced areas, much as a Greek stoa or Renaissance loggia overlooked Mediterranean plazas, a shaded place looking on a sunny openness. Behind the colonnade, a glass wall separates the art from the city, the cool from the warm, the peaceful from the active, the still from the windy."[1]

Johnson concerned himself with every detail, including the choice of a sculpture for the front plaza. Ruth Stevenson, guided by the architect and other members of the Board, considered several sculptors, including Alexander Calder, who was invited to submit maquettes. None of the five studies he presented and which were purchased by the Museum, however, met the group's vision of what was needed for the space. In 1962 on a visit to New York, Mrs. Stevenson saw the work of Henry Moore. His three bronzes, *Upright Motives Nos. 1, 2,* and *7,* were unanimously agreed upon and were installed in 1963. The totemic pieces stand at the far end of the plaza, mounted on a black granite base designed by Philip Johnson in collaboration with Moore.

Philip Johnson agreed with the Carter family that "the Museum should not be a mausoleum" but "an active institution," with a growing collection and a varied and changing exhibition program. The three officers of the Foundation and Johnson formed the Museum's first advisory board. They invited a few friends and experts in the art world to help them outline the institution's program and collecting goals and convened the first meeting January 22, 1961, the day after the Museum's festive opening. René d'Harnoncourt and Alfred Barr from the Museum of Modern Art, New York; Richard F. Brown from the Los Angeles County Art Museum; and John de Menil, a Houston businessman and art collector, joined in the collaboration and shared their experience and ideas for the new museum.

In the spring of 1961, Mitchell A. Wilder was selected as director of the Museum, and by July of that year, he was fast at work. Previously he had been the director of the Chouinard Art Institute in Los Angeles and earlier had been associated with Colonial Williamsburg in Virginia and the Colorado Springs Fine Arts Center. His varied background and the breadth of his knowledge and

expertise in American history and art made him the ideal person to orchestrate the development and growth of a new museum's collection and program.

The Museum's Articles of Incorporation and Bylaws were adopted in the fall of 1961, and a Board of Trustees was appointed. Two members were added—Mrs. Amon G. Carter, Jr., and C. R. Smith, President of American Airlines, a collector and long-time friend of the Carter family. Barr stepped down officially but retained a close association with the institution. Brown and d'Harnoncourt became the first of many museum professionals to serve as trustees, an unusual tradition that continues today.

In their early meetings, Wilder and the Board discussed the scope of the Museum's program. They saw the West as a peculiarly American phenomenon in which society, both on the frontier and in the settled areas, was endlessly moving. Viewing the West more as a concept than a geographical region, the group agreed that the Museum's program should be interdisciplinary, a program "expressed in publications, exhibitions, and the permanent collection . . . reflecting many aspects of American culture, both historic and contemporary."

It was also at this time that the Board decided that the library should be an integral part of the Museum's program. The initial collection of some four thousand books assembled by Carter during his lifetime has grown to include more than twenty-five thousand books, newspapers on microfilm, bound periodicals, maps, and illustrated books. All acquisitions are made in support of research on the Museum's collection and on exhibition and publication projects. Library materials, particularly maps and illustrated books, are often incorporated in exhibitions.

Although the Museum was not the first institution to have a program devoted to a particular theme or region, it was a pioneer in the field of western studies and scholarship. That area which Wilder called "westering North America"—its land, the people, and the people's interaction with their environment—became the primary field of research for the Museum. With endless imagination, Wilder presented one exhibition after another, each providing ideas for how the Museum's program could be enhanced through the addition of certain works representing significant moments in the history of America and records of its artistic heritage. While exhibitions served as inspiration for the initial additions to the Carter collection, the resulting publications, over ninety in all, permanently document what has become, in the course of twenty-five years, a substantial contribution to scholarship in American cultural and aesthetic history.

The Museum's earliest acquisitions, numerous bird's-eye views of American towns and cities and prints by John J. and John W. Audubon, were logical beginnings for an institution seeking to document the frontier as it moved across the continent, for printed works contained much of the historic record and graphic beauty of the country. Topography, Indians and their culture, animal and plant life—virtually every aspect of the new frontier was recorded. Prints were especially important in the dissemination of information about the New World and enticed immigrants to the exciting new land. The Audubon prints were acquired for an exhibition held in 1966, and many of the city views were purchased in anticipation of future exhibitions, most notably the 1976 exhibition, "Cities on Stone: Nineteenth Century Lithograph Images of the Urban West."

Under the broad guidelines drawn up by the Board of Trustees, the Museum's exhibitions and collection reflected numerous interests, including works by European artists dealing with American

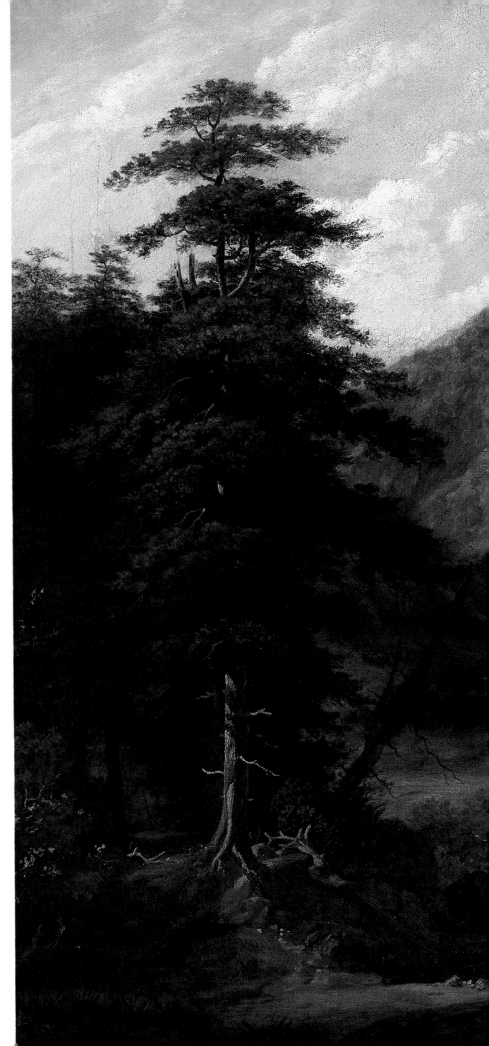

George Caleb Bingham (1811-1879)
View of Pikes Peak, 1872
Oil on canvas, 28 x 42 1/8 in.
(71.1 x 107.0 cm)

viii

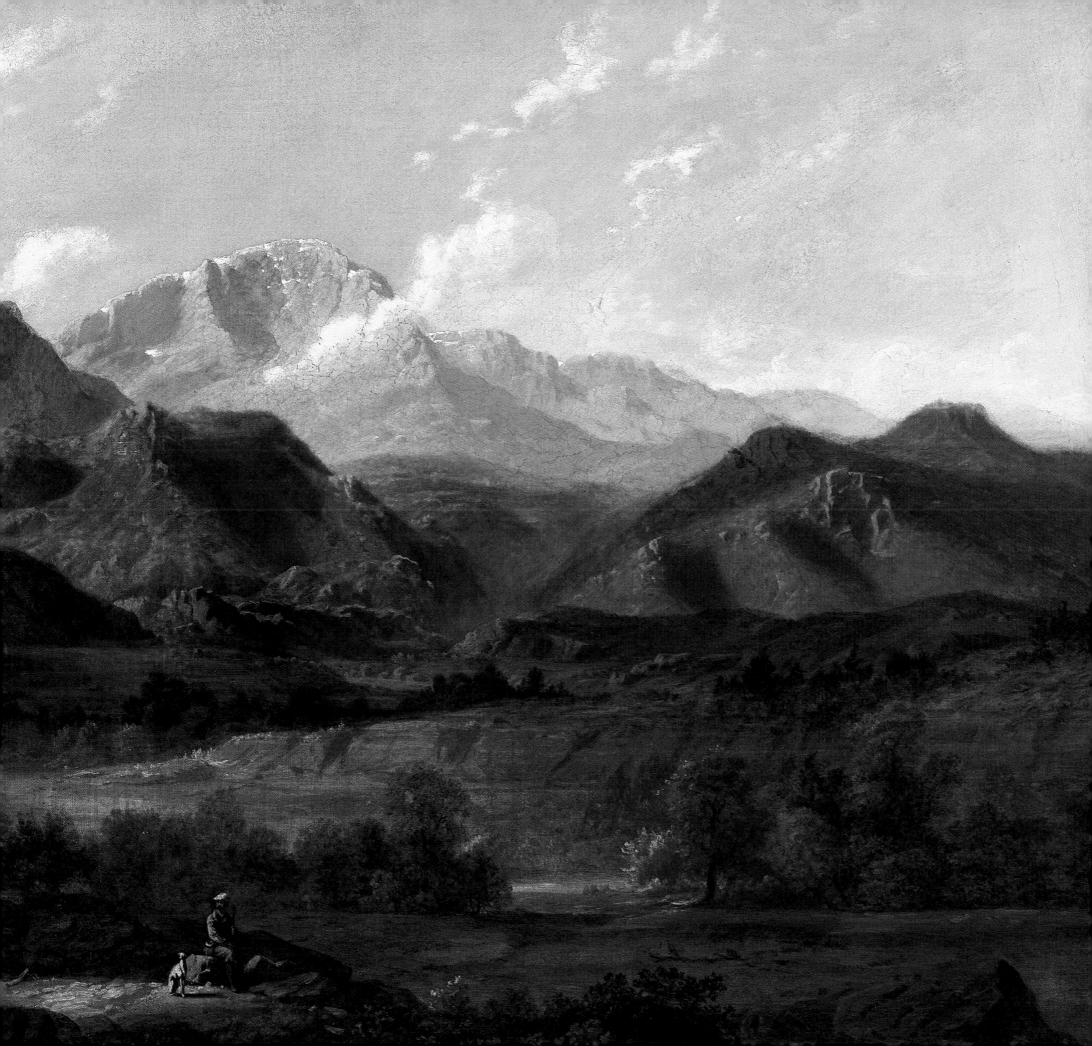

subjects, early American artists working in the East, those who traveled and lived in the West, and artists who may or may not have traveled west but created works peculiarly American which illustrated important trends in the history of American art.

America was home to many European artists throughout the eighteenth, nineteenth, and twentieth centuries. Peter Rindisbacher, a Swiss immigrant, created numerous watercolors which recorded life on the northern frontier in the 1820s and 1830s. Three of his small, delicate watercolors and two pen and ink drawings are an important part of the Museum's early nineteenth-century collection. Thomas Moran, who emigrated from England with his family in 1844, contributed greatly to the recording of western America. His painting *Cliffs of Green River,* acquired in 1975, complements the Museum's earlier purchase in 1965 of nineteen watercolors and drawings by Peter Moran. That group included *Cliffs Along the Green River,* which the younger Moran completed during an 1879 trip with his brother Thomas. German-born Albert Bierstadt also gained considerable recognition for paintings of some of the same regions visited by Moran. His Yosemite paintings are considered to be some of his finest. The Museum acquired *Sunrise, Yosemite Valley* in 1966, well before the market for his work soared to the record-breaking heights seen in the late 1970s and in the 1980s.

There were other artists who served as documentarians for European explorers: most notably, Karl Bodmer, a Swiss painter, who accompanied Prince Maximilian on his North American tour from 1832 to 1834 and Alfred Jacob Miller, a Baltimore artist, who was commissioned by the Scottish nobleman Sir William Drummond Stewart to record his 1837 expedition to the Rocky

Peter Moran (1841-1914)
Cliffs Along the Green River, 1879
Watercolor, gouache, and graphite on tan paper, 6 5/8 x 19 in.
(16.8 x 48.3 cm)

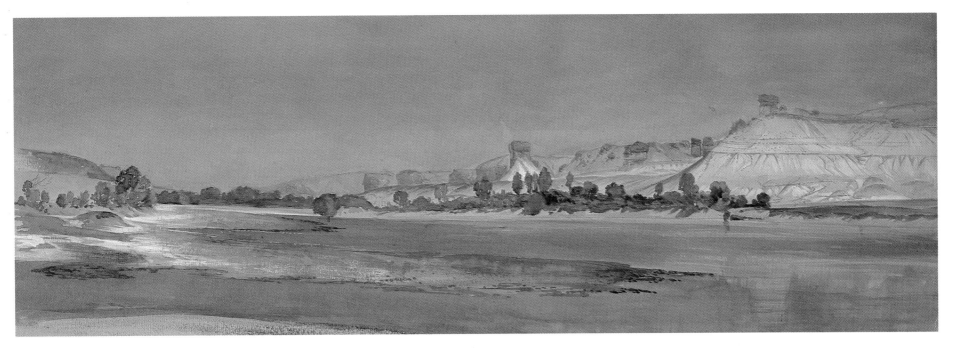

Mountains. Again in advance of the growing market for "Western" works, the Museum acquired in 1965 *Travels in the Interior of North America,* a lavishly illustrated volume recording Maximilian and Bodmer's journey. The following year, two oil paintings and eight watercolors and pen and ink drawings by Alfred Jacob Miller were purchased.

Preceding Miller in the West was George Catlin, a native of Wilkes-Barre, Pennsylvania. He set out on his own to record the life of Native Americans on the Great Plains. His *North American Indian Portfolio,* a collection of hand-colored lithographs based on his paintings, acquired by the Museum in 1972, finally made it possible to represent the work of the three major artist/explorers of the American West in the early nineteenth-century.

From the beginning, the Museum's exhibitions and collection emphasized the importance of the land and the uniqueness of the American landscape. This interest became more fully realized as important examples of nineteenth-century landscape paintings began to be added to the collection. Key among these acquisitions are paintings from the Hudson River School, including some by its founder, Thomas Cole, several of his followers and admirers, and Frederic Edwin Church, Cole's devoted protégé.

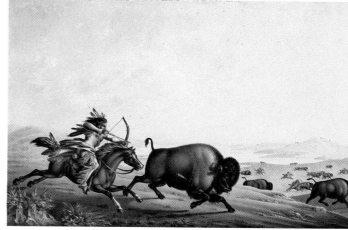

Peter Rindisbacher (1806-1834)
Assiniboin Hunting on Horseback, 1833
Watercolor, ink wash, and graphite on paper,
9 3/4 x 16 1/8 in.
(24.8 x 41.0 cm)
Inscribed l.l.: "P. Rindisbacher 1833."

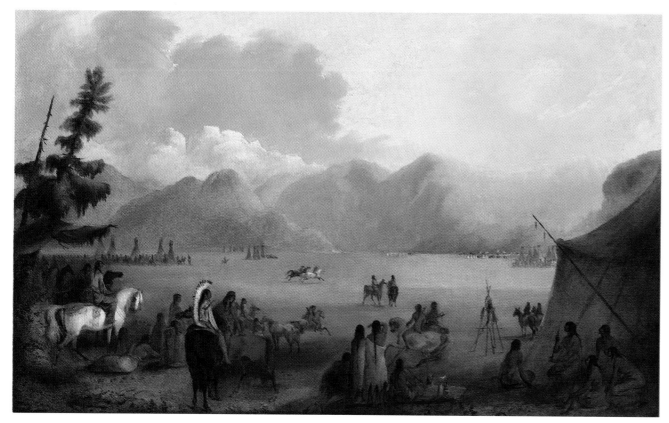

Alfred Jacob Miller (1810-1874)
Indian Village, c. 1850
Oil on canvas, 30 1/4 x 48 3/4 in.
(76.8 x 122.9 cm)

2 Shortly after the sale of *The Icebergs* at Sotheby Parke Bernet, 25 October 1979, the purchasers, who asked to remain anonymous, donated the painting to the Dallas Museum of Art.

Jasper F. Cropsey's *The Narrows from Staten Island*, a compendium of all the elements deemed important by artists of the "School," was acquired in 1972. This was a significant moment for the Museum as the painting embodied the philosophy the Board had been discussing for ten years—that the western movement first began on the east coast. Although *Study on Long Island Sound at Darien, Connecticut* by John Frederick Kensett had been purchased in 1969 and Worthington Whittredge's painting *A Breezy Day—Sakonnet Point, Rhode Island* was acquired earlier in 1972, it was the Cropsey that generated the most discussion. With its purchase, the Board reconfirmed that the Museum's collection and program should encompass the full history of American art, that the western material should not be separated but should be seen in a broad context.

Then in October 1979, when the art world was intensely interested in the works of Frederic Church—the sale of his monumental painting *The Icebergs* had just been announced[2]—the Museum secured Church's *New England Landscape (Evening After a Storm)*. The collection, however, was still lacking a masterpiece by Cole himself.

Finally a painting which had been "lost" for more than one hundred years, *The Hunter's Return* by Cole, was offered in 1983 and was purchased by the Museum. The marketplace was abuzz with the news of the acquisition, American scholars applauded it, and the staff and Board delighted in the fact that the champion of American landscape painting was now represented in the collection by one of his acknowledged masterpieces. The collection was further strengthened by the twenty-fifth anniversary (1986) purchase of another painting by Kensett, his beautiful *Newport Coast,* painted between 1865 and 1870.

In many areas, the staff has attempted to represent key figures in the history of American art with more than one example of their work. This is clearly illustrated by the three paintings by Martin Johnson Heade. *Marshfield Meadows, Massachusetts* was acquired in 1971; then in 1977, Ruth Stevenson and Mitch Wilder leaped at the opportunity to purchase the quintessential Heade painting *Thunderstorm Over Narragansett Bay*. But one important facet of the artist's later career was still not represented in the collection. Heade delighted in painting hummingbirds and orchids and completed numerous canvases of these tropical subjects. When the beautiful *Two Hummingbirds Above a White Orchid* came on the market in 1981, there was no hesitation on the part of the staff or the Foundation to make the acquisition.

As landscape painting flourished in the nineteenth century, there was a rising interest in genre and still-life painting, as well. Genre painting, which first became popular near the artistic center of New York City, soon found its way across the country. As artists began to travel westward, they captured scenes which were quickly changing and soon to disappear. The desire to record an era animated William T. Ranney. His *Virginia Wedding* and *Marion Crossing the Pedee* are monumental examples of what can be called historic genre.

When *Virginia Wedding* was acquired in 1975, it was the only major genre painting in the collection, but the staff, supported by the Directors of the Foundation, soon moved to strengthen the Museum's holdings in this area. Seth Eastman's *Ballplay of the Sioux on the St. Peters River in Winter* was acquired in 1979 and was dedicated to the memory of Mitch Wilder, who had died that April after almost eighteen years as director. This was the painting Wilder had been "working on" at his death. Also purchased that year was John Mix Stanley's *Oregon City on the Willamette River. A*

Group of Sioux by Charles Deas was added in 1980 as part of the Museum's twentieth-anniversary celebration, and then in 1983 the collection's second Ranney, *Marion Crossing the Pedee,* was purchased.

The Museum was finally able to present a historic overview of one of the major themes in American painting of the nineteenth century. However, there was a significant void: a representative painting by George Caleb Bingham. Although a landscape by Bingham, *View of Pikes Peak,* had been in the collection since the mid-sixties, an example of the artist's most popular subject—men on their flatboats along the Mississippi and Missouri rivers—was desired. The staff, repeatedly told by dealers that no such Bingham could possibly come on the market, acknowledged that most were already in public collections. Mitch Wilder recalled in 1967 that "it has been almost a joke when I have casually added Bingham to the list of artists in whom we were interested. They [the dealers] were most pessimistic about our ever finding one as there had been none offered in the New York market for a good many years." In 1984, however, the Museum was offered and purchased *Wood-Boatmen on a River,* one of the few nocturnal riverboat scenes Bingham painted.

Still-life painting, aesthetically and socially important in the nineteenth century, is represented in the Museum's collection with works by some of its finest practitioners. William Michael Harnett's unusual figural piece, *Attention, Company!,* was acquired at auction in 1970. Then in 1972 there was much excitement when the artist's more typical, magnificently painted still life, *Ease,* was offered to the Museum. Alfred Frankenstein, Harnett's biographer, had discovered the painting, long believed to have been lost in the San Francisco earthquake and fire of 1906. There was no question that it was a necessary complement to the atypical painting acquired by the Museum two years earlier. Amon Carter, Jr., fascinated by the picture's previous history and delighted by some of its details, gave his endorsement wholeheartedly. The still life incorporated elements which held direct references to his father (and to himself)—a newspaper and a cigar. Both men were very involved in the newspaper publishing business, Amon Sr. as the founding publisher of the *Fort Worth Star-Telegram* and Amon Jr. as his successor. Each, too, was rarely seen without his stogie.

John Peto's work was, until recent years, often mistaken for Harnett's paintings, although his pictures are more painterly and filled with nostalgia. *Lamps of Other Days,* acquired in 1969, was the first trompe l'oeil work to enter the collection. It paved the way for later acquisitions of the two Harnetts, and in 1974 for the Severin Roesen still life with fruit entitled *Abundance.* Finally, in 1983 during the exhibition "Important Information Inside, The Art of John F. Peto," the Museum consummated the purchase of one of the artist's famous rack pictures entitled *A Closet Door.* Late in his career, Peto did a series of these paintings showing personal memorabilia tacked to panels or doors. Three more trompe l'oeil paintings were added to the collection within a few years. With the 1985 acquisitions of a De Scott Evans work, John Haberle's *Can You Break a Five?* (anticipating the exhibition "John Haberle: Master of Illusion" the same year), and the beautiful still life by William J. McCloskey of wrapped oranges, the collection had again been enhanced by building on its current holdings and the Museum's exhibition program.

Paintings of children were also popular in the nineteenth century, and two artists in particular, Winslow Homer and Eastman Johnson, pursued this subject in some of their most successful paintings. Homer did a number of canvases devoted to childhood themes, perhaps the best known

3 Lisbet Nilson, "The Art Market," *Art News,* May 1982, p. 9.

being *Snap the Whip* (1872) in the collection of The Butler Institute of American Art in Youngstown, Ohio. After returning from a publisher's meeting in Youngstown, Amon Carter, Jr., asked his sister why the Carter Museum did not have a Homer like the one he had seen. Ruth Stevenson promptly found one and obtained her brother's approval for the 1976 purchase of *Crossing the Pasture,* a painting close in date to *Snap the Whip* and another example of Homer's reflection on youth. When Eastman Johnson's painting of a mother and child playing peekaboo, *Bo-Peep,* was purchased in 1980, it was seen as a delightful pendant to the Homer.

In the late nineteenth century and first decades of the twentieth century, many artists in America turned their attention to Europe. They traveled there for study and inspiration and to see the latest styles in painting, especially in France. Mary Cassatt lived most of her adult life in Paris and developed close associations with the French Impressionists. Women and children were her preferred subjects, and the Museum's painting, *Mother and Daughter, Both Wearing Large Hats,* is a late example of her extraordinary painting skills and her primary theme, maternity. The painting was given to the Museum in 1981 by Ruth Carter Stevenson in honor of Adelyn Dohme Breeskin, a Cassatt scholar and a member of the Museum's Board of Trustees from 1972 to 1982.

This addition pointed up the need for more impressionist paintings in the collection. The problem was that the availability of paintings by William Merritt Chase and Childe Hassam, two of the most important American Impressionists, was limited, and the market for their works was highly competitive. Fortunately in late 1981, the Museum was the first institution to be told of a Chase painting which had been in a family collection for over fifty years and was about to "hit" the market. *Idle Hours,* an exquisite example of Chase's plein-air painting, was purchased, adding the dimension to the collection which the staff and Mrs. Stevenson had longed for. The art world and the press pronounced it a "once-in-a-lifetime picture."[3] Then, of course, the question was whether the Museum could ever match that success with a Hassam. In 1986, in honor of its twenty-fifth anniversary, the Museum announced the purchase of a superb example of Hassam's impressionist work, *Flags on the Waldorf.*

The American public became aware of European modernism through the Armory Show in 1913, just a few years after Cassatt painted *Mother and Daughter.* But several artists had been studying the works of Cézanne, Matisse, and the Fauves in France during the first decade of the twentieth century. Among these artists was Arthur Dove, whose painting of *The Lobster* is the Museum's earliest "modern" picture. Dove had used this painting to introduce himself to Alfred Stieglitz in 1910 and was immediately invited into his circle of artists, which included John Marin, Marsden Hartley, and later, Georgia O'Keeffe. Stieglitz championed modernism in America and supported his pioneering artists.

The theme of the pioneering spirit, the exploration of new frontiers, shown in the Museum's nineteenth-century collection is also seen in its twentieth-century works. As early as 1963 the Board of Trustees recognized the need for the Museum to move into the early decades of this century in its program and collection. The purchase of Marsden Hartley's *Sombrero and Gloves* in 1963 was followed in 1965 by the addition of two Marin watercolors and O'Keeffe's *Dark Mesa and Pink Sky.* In 1966 a retrospective exhibition for Georgia O'Keeffe was presented. Another Hartley, four more O'Keeffes, and two Doves had been acquired by 1967, the year the Museum staged its second major

Marsden Hartley (1877-1943)
Sombrero and Gloves, 1936
Oil on canvas, 20 3/8 x 28 1/4 in.
(51.8 x 71.8 cm)

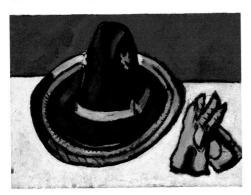

exhibition of early modernist works, "Image to Abstraction," from the collection of Edith Halpert. The Museum had made a quantum leap into the twentieth century.

More works by the artists in the original Stieglitz group and their contemporaries were added to the collection in subsequent years. Watercolors, drawings, and prints, as well as paintings, have been included to represent the masters of American modernism, including Stuart Davis, Morton Schamberg, and Charles Demuth. A conscious effort continues to be made to illustrate an artist's career through different styles, subjects, and choices of media. For example, the Museum's earlier purchases of three paintings by Davis, particularly *Blips and Ifs* acquired in 1967, were enhanced by the 1984 addition of a complete set of the artist's twenty-six lithographs and serigraphs and sixteen drawings. Schamberg's painting *Figure B* is also complemented in the collection by two of his delicate drawings in pastel, another of his favored media. Many of Demuth's paintings deal with architectural, figural, and still-life subjects and since 1980 examples of each of these have been added to the Museum's growing collection of works on paper. Arthur Dove is represented by works from each decade of his career, showing the development of his own personal style and his use of various media including watercolor and pastel. Similarly, O'Keeffe's work is illustrated in the collection by three of her early watercolors, four paintings devoted to her beloved Southwest, and finally a painting of another of her favorite subjects, flowers. *Red Cannas,* purchased in 1986 as part of the Museum's twenty-fifth anniversary, is a celebration and a tribute to the life and work of one of this century's finest American artists. The acquisition further illustrates the Museum's desire to show significant examples of work created by key figures in the history of American art prior to 1945.

Many American artists excelled in printmaking in the late nineteenth century and the first half of the twentieth century. Since 1980, the Museum has sought to augment its extensive holdings of historical prints by collecting graphic works by artists such as Mary Cassatt, Winslow Homer, John Marin, Charles Sheeler, and Grant Wood, whose paintings were already represented in the collection. Other artists who made significant contributions to the American printmaking tradition are also represented, including John Taylor Arms, James Abbott McNeill Whistler, Howard Cook, Edward Hopper, Martin Lewis, Louis Lozowick, Reginald Marsh, and John Sloan. A master set of 220 prints by George Bellows, the largest collection of his graphic work, was also added in 1985. The scope of the print collection, beginning with the late nineteenth-century etching revival and extending to color abstractions of the early 1950s, marks an ongoing commitment to the acquisition of works which will add yet another dimension to the Museum's resources and offerings.

Museums often accumulate, during their formative years, an agglomeration of disparate objects. It might have seemed, at times, that this was true for the Amon Carter Museum. However, as one looks over its twenty-five-year history it becomes obvious that the pieces of the puzzle have fit together rather neatly. As Alfred Barr noted in the first meeting of the Advisory Board in 1961, "If one out of ten purchases is able to stand the test of time then one has done very well indeed." If the collection of paintings as represented by the fifty-eight works presented in this volume stands as a test, the ratio is far better than one to ten!

As the collection grew and the Museum's programs became more extensive, it became obvious that the physical plant had to expand as well. An annex was added as early as 1964, and in 1977 a major addition was completed. Both expansions, designed by Philip Johnson, retained the

original concept of the first building—to make the Museum " 'art,' in order better to view the Art inside, as well as to give pleasure of a public and communal nature."

Over twenty-five years the staff has also grown, and there have been a few changes on the Board of Trustees, but each new player contributed or continues to contribute to the original goal as set forth by the Advisory Board during the Museum's first few months of operation—always strive for excellence, and above all aesthetic quality, and we cannot fail. Works of art are the heartbeat of this Museum.

Museums can be compared to libraries: they are both repositories, they are avidly acquisitive, and they are never complete. The Amon Carter Museum is no exception. As it moves toward the twenty-first century, the Museum will continue to augment its collections with the finest examples of American painting, sculpture, photography, drawings, and prints. From the visual records of the country's first European inhabitants to works which approach the threshold of contemporary art, the Museum's holdings, which span more than 150 years of artistic production, are testimony to the artist's contribution and the pleasures to be derived from studying the history of American art.

Amon Carter, Sr., loved his paintings. Perhaps C. R. Smith expressed it best in the Museum's 1961 inaugural brochure: "Paintings should be acquired, owned and preserved by those who have a deep affection for them. . . . Good paintings are produced by artists able to understand the mood of a time and the mood of the people there, able to record and preserve these historical impressions for the knowledge and enjoyment of those to follow. . . . Paintings are among the most valuable of our heritages, able to record and interpret history even better than the printed page."

JAN KEENE MUHLERT
Director
May 1986

AMERICAN PAINTINGS

Thomas Cole (1801-1848)

The Hunter's Return, 1845

Oil on canvas, 40 1/8 x 60 1/2 in.
(101.9 x 153.7 cm)
Inscribed l.c.: "T.Cole/1845"

1 Henry Tuckerman, *Book of the Artists: American Artist Life*, 2nd ed. (1867; rpt. New York: James F. Carr, 1966), p. 231.
2 Donald D. Keyes, "Perceptions of the White Mountains, A General Survey," in *The White Mountains: Place and Perceptions* (Durham, New Hampshire: University Art Galleries, University of New Hampshire, 1980), p. 42.
3 Keyes, p. 43.
4 See Ellwood C. Parry III, "Thomas Cole's 'The Hunter's Return,'" *The American Art Journal*, 17, No. 3 (Summer 1985), 2-17.
5 Cole's "Subjects for Pictures," begun in 1827, can be found as Appendix II in Howard S. Merritt, *The Baltimore Museum of Art Annual II: Studies on Thomas Cole, An American Romanticist* (Baltimore: Baltimore Museum of Art, 1967), p. 90. Cole's idea for the Carter Museum painting was number 78: "The hunter's return. A log hut in the forest—several figures. Two men carrying a deer on a pole—a child running to meet them & a woman standing in the door of the cabin with a child in her arms—a dog—my wild scene." Both Louis L. Noble, *The Course of the Empire, Voyage of Life, and Other Pictures of Thomas Cole, N.A.* (New York: Cornish Lamport & Company, 1853), pp. 362-63, and Tuckerman, p. 231, describe the painting with lavish praise. The compositional oil sketch is in the collection of the Gulf States Paper Company, Tuscaloosa, Alabama. The drawings, *A Log Cabin, Huntsman Carrying A Deer, and Man Holding His Hat* (verso), and *Studies of Huntsmen* (recto) are in the Detroit Institute of Arts.

A major example of the Hudson River School of American landscape painting is Thomas Cole's *The Hunter's Return*. Heroic in scale and content, this painting ranks as one of his late masterpieces. Cole sought to educate the public by infusing his paintings of the American wilderness with noble, lofty themes. *The Hunter's Return* may be considered a genre-landscape painting, with figures telling a story, or, as Henry Tuckerman called it, a "most authentic illustration of American life and nature."[1]

Born in England, Thomas Cole immigrated with his family to the United States in 1818. He began his career as a portraitist but soon turned his attention to native scenery and became the leader of the Hudson River School. From his home in New York, Cole took frequent sketching trips to upstate New York and New England. In the late 1820s, he visited the White Mountains of New Hampshire at the urging of Daniel Wadsworth, an early patron.[2] It was there that he saw Mount Chocorua, the most spectacular peak in the Sandwich Range, which forms the dramatic setting for several of his most important works, notably *The Last of the Mohicans* (1827, Wadsworth Atheneum, Hartford, Connecticut), *Home in the Woods* (1845-1846, Reynolda House, Winston-Salem, North Carolina), *The Pic-nic* (1846, The Brooklyn Museum), and *The Hunter's Return* (1845).

With autumnal foliage ablaze in the late afternoon sun, *The Hunter's Return* reveals a clearing in the woods where man lives in harmony with nature. Paintings such as this one reflect Cole's concern for carving order out of the wilderness while at the same time preserving that wilderness.[3] Cole presents the pioneer family in a favorable light, snugly housed in a log cabin in an idyllic setting and making their living from the abundant land. Yet there are unmistakable signs of the price extracted from nature by civilization's intrusion. While the distant mountains, forests, waterfall, and lake represent the pristine American Garden of Eden, the prominent tree stumps and fallen logs in the painting's foreground symbolize man's destruction of nature and serve as Cole's warning to the country.

The theme of return was an important and recurring one for Cole and may have had autobiographical overtones (for example, *The Departure* and *The Return* [1837, The Corcoran Gallery of Art, Washington]). Cole, who had moved to a home in Catskill, New York, was often separated from his family due to sketching trips and journeys into New York City on business. He cherished the reunions with his family upon his return, and it may be Cole (whose name appears under the hunter) and his wife and children who are the symbolic protagonists in *The Hunter's Return*.[4]

Commissioned by prominent New York art collector and auctioneer George Austen, *The Hunter's Return* was seen publicly only once between 1848 and its rediscovery in 1983. During that period, it was known only by an entry in the Cole memorial exhibition catalogue, a notation in the artist's list of subjects for paintings, and a small oil sketch and preliminary drawings.[5]

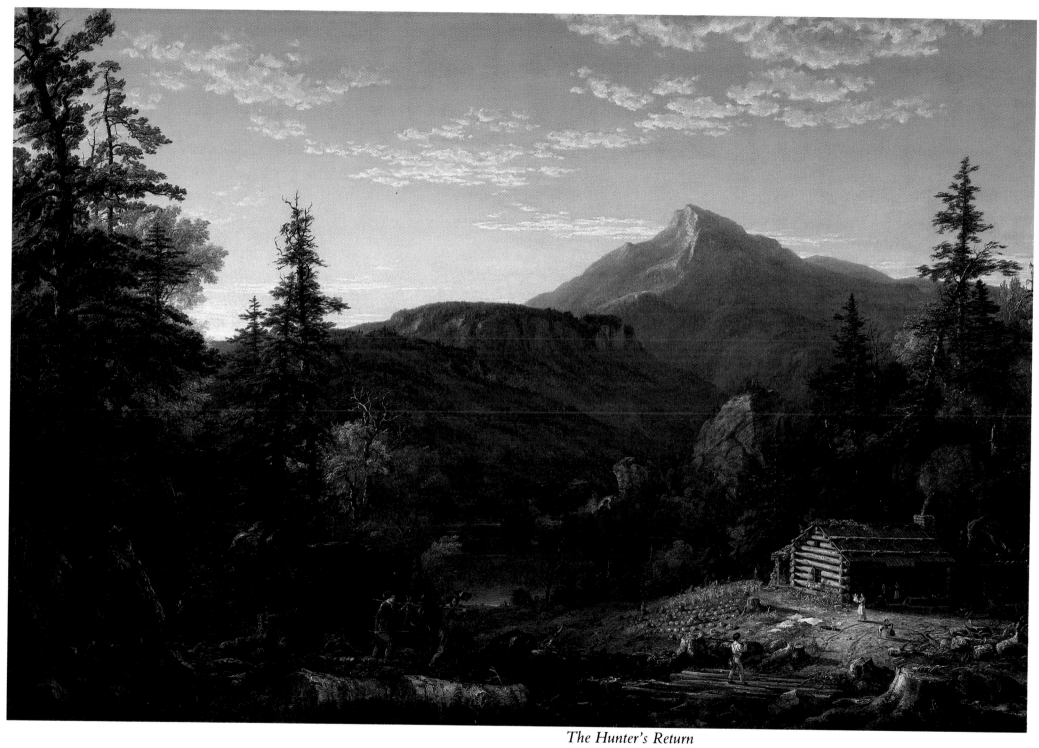

The Hunter's Return

Frederic Edwin Church (1826-1900)

New England Landscape (Evening After a Storm), c. 1849

Oil on canvas, 25 1/8 x 36 1/4 in.
(63.8 x 92.1 cm)
Inscribed l.l.: "F. CHURCH"

1 Franklin Kelly, "The Legacy of Thomas Cole," in T*he Early American Landscapes of Frederic Edwin Church, 1845-1854* (Fort Worth: Amon Carter Museum, in press).
2 Franklin Kelly and Gerald Carr have observed that several elements of *New England Landscape* relate to drawings Church made near Pittsford and Proctor, Vermont, in 1848. See their catalogue entry to this painting in *The Early American Landscapes of Frederic Edwin Church, 1845-1854.*
3 Although the dimensions for *Evening After a Storm* are almost identical to *New England Landscape,* descriptions of the Art-Union painting do not mention a body of water (a prominent feature in the Amon Carter Museum painting), and the building is called a cottage in the review when, in fact, it is a mill.

In 1844, at the age of eighteen, Frederic Edwin Church left his affluent family in Hartford, Connecticut, to study with Thomas Cole and remained with Cole for two years. By 1847, Church had established a studio in New York City and was a regular contributor to the exhibitions there. By the late 1850s, he had become the most famous artist of his time, known for large, dramatic canvases of the exotic scenery of the far North and South America, such as *The Icebergs* (1861, Dallas Museum of Art) and *The Heart of the Andes* (1859, The Metropolitan Museum of Art, New York). However, the paintings of the first decade of his career (which include *New England Landscape*) depict Church's native New England and are particularly indebted to Cole's work in their coloring, brushwork, spatial organization, and subject matter.

The poetic beauty of *New England Landscape,* with its combination of the specific and the universal, relates strongly to Cole's visions of the American wilderness dating from the 1840s (for example, *The Old Mill at Sunset* [1844, Collection of Jo Ann and Julian Ganz, Jr.]). In *New England Landscape,* Church has combined the mill, luminous sky and water, and distant mountains to create an idyllic scene. Yet Church's paintings differ from Cole's in that they are filled with minute detail (note the meticulously rendered still life with picnic basket and red cloth at the lower left) and exhibit a more even and direct light which outlines objects crisply.[1]

Church's early landscapes, including *West Rock, New Haven* (1849, New Britain Museum of American Art, New Britain, Connecticut) and *New England Landscape,* fed the public's hunger for realistic pictures of American scenery. *West Rock, New Haven* is a direct topographical transcription of a specific site. *New England Landscape,* however, is comprised of a number of studies Church made during summer sketching trips to New England.[2]

The mood of *New England Landscape* is tranquil and contemplative. It depicts the moment after a cleansing storm when clouds lift to reveal the green vegetation, glassy pond, and rolling hills of the New World (seen as the new Garden of Eden), where man lives in harmony with nature. The entire painting is infused with the pink glow of twilight. In its composition and variety of detailed vignettes, *New England Landscape* serves as an important precursor for the painting considered to be Church's early masterpiece, *New England Scenery* (1851, George Walter Vincent Smith Art Museum, Springfield, Massachusetts).

Although it has been suggested that the Amon Carter Museum painting was the one Church exhibited in 1849 at New York's American Art-Union as *Evening After a Storm,* certain discrepancies between contemporary descriptions of the Art-Union painting and the Museum's argue for keeping the more generalized *New England Landscape* as the primary title.[3]

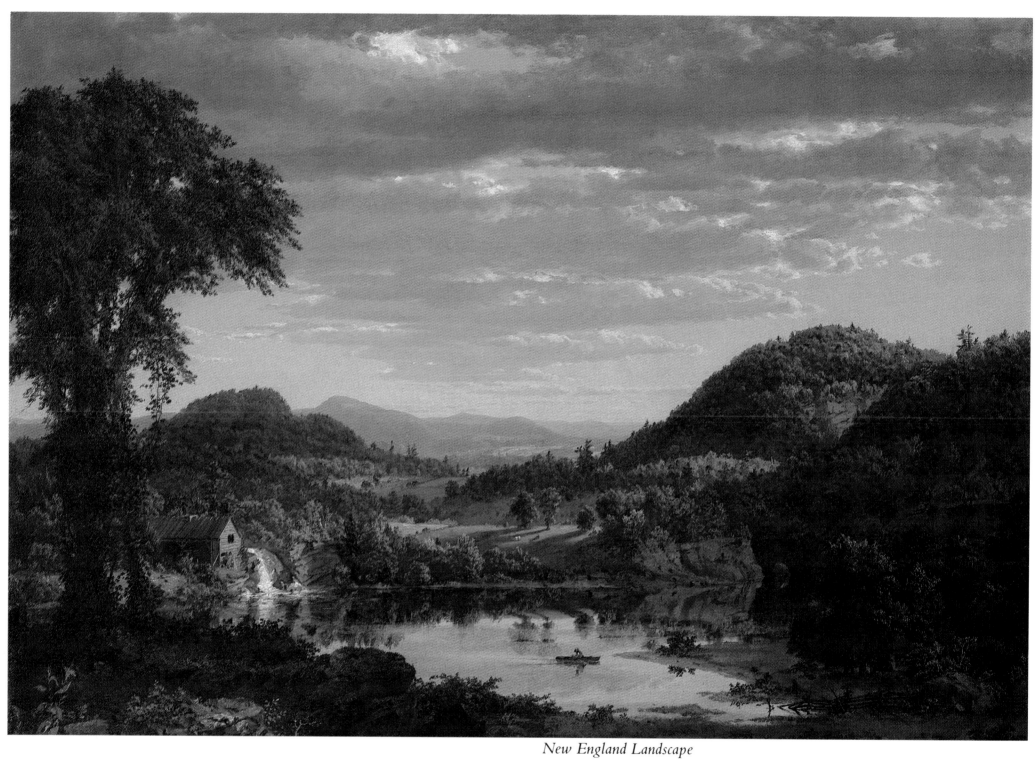

New England Landscape

5

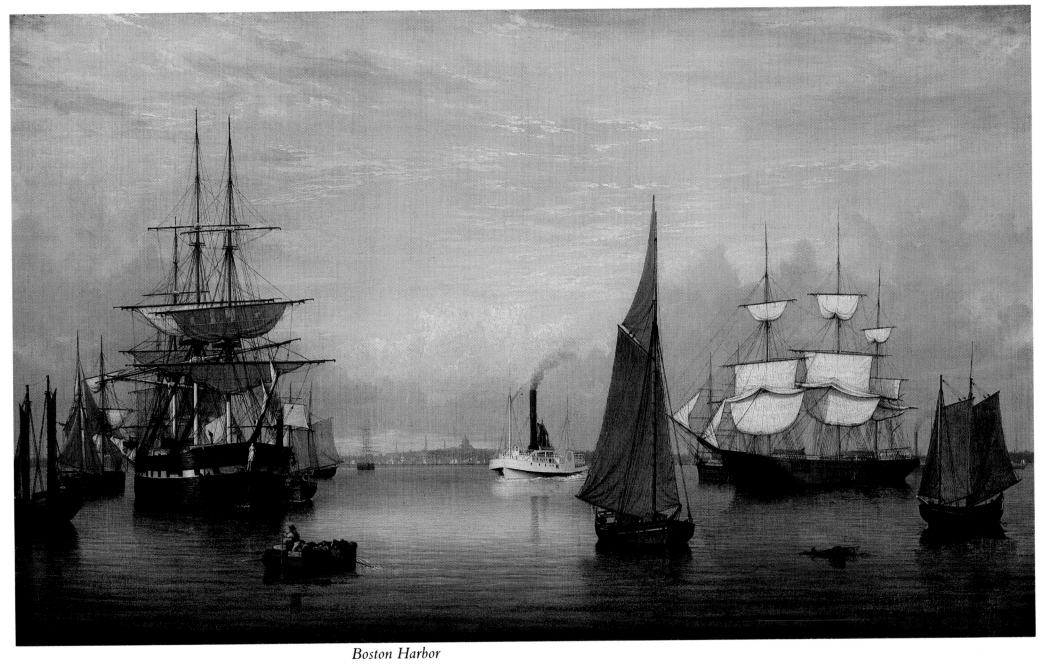

Boston Harbor

6

Fitz Hugh Lane (1804–1865)

Boston Harbor, 1856

Born in the fishing town of Gloucester, Massachusetts, to a family long associated with the sea, Fitz Hugh Lane is best known for his lyrical seascapes painted in the mid-nineteenth century. Before he began to paint in oil in 1840, Lane served an apprenticeship at Pendleton's lithography shop in Boston, where he would have seen examples of seventeenth-century Dutch marine painting and, perhaps more importantly, the views of Boston Harbor being created in the 1830s by the English-born artist Robert Salmon. Salmon's light-filled, spacious seascapes with low horizon lines had a great impact on the young Lane. While his early work was small in scale and filled with narrative detail, Lane's style changed following a trip to Maine in 1848; a change seen in a series of paintings of Boston Harbor that Lane painted in the 1850s (although he had returned to Gloucester in the late 1840s).[1]

The Amon Carter Museum's *Boston Harbor* is a more panoramic, poetic view than Lane's paintings of the previous decade, with a central pool of light that plays a significant role.[2] This use of light is representative of the luminist style practiced by a group which evolved from the second generation of Hudson River School painters and who worked primarily along the East Coast from 1850–1875. Lane, who was one of the earliest luminists, shared with John F. Kensett, Martin J. Heade, Sanford Gifford, and Frederic Church, among others, an interest in the poetic effects of light and atmosphere. Their tranquil, horizontal paintings of land, sea, and sky were smoothly and thinly painted, delicately colored, and precisely ordered. The works were characterized by both a nationalistic and a spiritual mood: nationalistic in showing the glories of the unspoiled American continent and spiritual in their equation of light with divine presence.[3]

Boston Harbor manifests this intense interest in light and silence. The sense of stillness after a storm is reinforced by the placid water, which reflects the boats and their slack, drying sails. There is little human activity, save for the tiny figures in several of the vessels. Although it is a contemplative painting of mood, Lane's scene is also topographically correct, from its rendering of the Boston shoreline (with Charles Bulfinch's State House identifiable in the far distance) to the complex composition's busy harbor. Lane has included a variety of vessels from several eras, including small fishing boats (the schooners to either side of the canvas), the larger ships and brigantines used to carry cargo, a rowboat, and a modern steamboat, which probably ferried passengers to nearby ports.

Oil on canvas, 25 1/2 x 42 1/4 in. (64.8 x 107.3 cm)
Inscribed l.r.: "1856"

1 Others in this series include *Boston Harbor at Sunset* (1850–1855, Museum of Fine Arts, Boston) and *Boston Harbor, Sunset* (1850–1855, Collection of Jo Ann and Julian Ganz, Jr.).
2 See John Wilmerding, *Fitz Hugh Lane* (New York: Praeger Publishers, 1971), pp. 27, 39, 48, 55, 56, for a discussion of this change in style.
3 The most thorough study on American luminism is John Wilmerding, et al., *American Light: The Luminist Movement, 1850-1875* (Washington, D.C.: National Gallery of Art, 1980).

John Frederick Kensett (1816-1872)

Newport Coast, c. 1865-1870

Oil on canvas, 18 1/4 x 30 1/4 in. (46.4 x 76.8 cm)

1 John Paul Driscoll, John K. Howat, et al., *John Frederick Kensett: An American Master* (Worcester, Massachusetts: W. W. Norton & Co. in association with the Worcester Art Museum, 1985), p. 99.
2 Driscoll, et al., p. 99.
3 Ellen Johnson, "Kensett Revisited," *Art Quarterly,* 20, No. 1 (Spring 1957), 80.
4 Heade, Worthington Whittredge, William S. Haseltine, and Alfred T. Bricher were also in Newport in the 1860s. See John Wilmerding, et al., *American Light: The Luminist Movement, 1850-1875* (Washington, D.C.: National Gallery of Art, 1980), p. 115.
5 For example, *Beacon Rock, Newport Harbor* (1857, National Gallery of Art), *Forty Steps, Newport, Rhode Island* (1860, Jo Ann and Julian Ganz, Jr.), and *View of the Beach at Beverly, Massachusetts* (1860, Santa Barbara Museum of Art).
6 According to Robert G. Workman, *The Eden of America: Rhode Island Landscapes, 1820-1920* (Providence: Museum of Art, Rhode Island School of Design, 1986), p. 29, the landscape depicted is typical of the southern coastline of Aquidneck, the island on which Newport is located.
7 Driscoll, et al., p. 108.

Newport Coast is a distinguished example of the type of painting for which John Kensett is best remembered: a tranquil scene of the New England coast, with crisply rendered details, bright light, delicate coloration, smooth surfaces, and simplification of forms. Kensett, one of the leading landscape artists of the mid-nineteenth century, was trained as an engraver and was a self-taught painter. In 1840 he went to Europe, in the company of Asher B. Durand, John Casilear, and Thomas Rossiter, to study the Old Masters. He particularly admired Claude Lorrain, Canaletto, and the Dutch genre artists whose warm light, precise realism, fine color and smooth surfaces, respectively, can be seen in works such as *Newport Coast.*[1] After more than seven years abroad, Kensett returned to America where he exhibited actively and became a prominent force in the artistic community of New York.

Kensett's early works were heavily influenced by Durand and Thomas Cole, but by the mid-1850s, his style and subject matter changed. Kensett moved away from the picturesque landscape tradition of the Hudson River School to coastal scenes painted in the luminist style.[2] Annual sketching trips to the Massachusetts, Rhode Island, and Connecticut shores (made easier by increased railroad services to the areas) provided the sketches which Kensett employed to create finished paintings in his New York studio during the winter months.[3] Some of his best works depict the area around Newport, Rhode Island, which drew a number of artists and writers in the mid-nineteenth century.[4] Kensett first visited there in 1854 and returned in the 1860s.

Works such as *Newport Coast* exemplify Kensett's aesthetics and his close study of the natural elements along the New England coast. The composition in this painting is a deftly balanced arrangement of masses and voids. The solid rocks to the left are crisply delineated in a sharp, clear light, and the vast, open expanse of sky and water to the right is painted with a hazy atmospheric effect which envelops the sailboats on the horizon. The curving shoreline, used also by Fitz Hugh Lane and Martin Johnson Heade in the 1860s, was a favorite device for Kensett.[5] The cove depicted in *Newport Coast* is seen again in a closely related work, *Beach at Newport* (c. 1869-1872, National Gallery of Art).[6] However, while the later painting has two figures and a rowboat placed prominently in the foreground, *Newport Coast* is reduced to earth, sea, and sky. (The overall tonality, light, viewpoint, and season—indicated by the bright red autumnal leaves—also differ in the two paintings.) Silence prevails, and it is Kensett's fascination with the "eloquence of silence" which is the most distinctive and innovative characteristic of his coastal scenes.[7] Indeed, Kensett's odes to tranquility and harmony comprise some of the most serenely poetic paintings in American art.

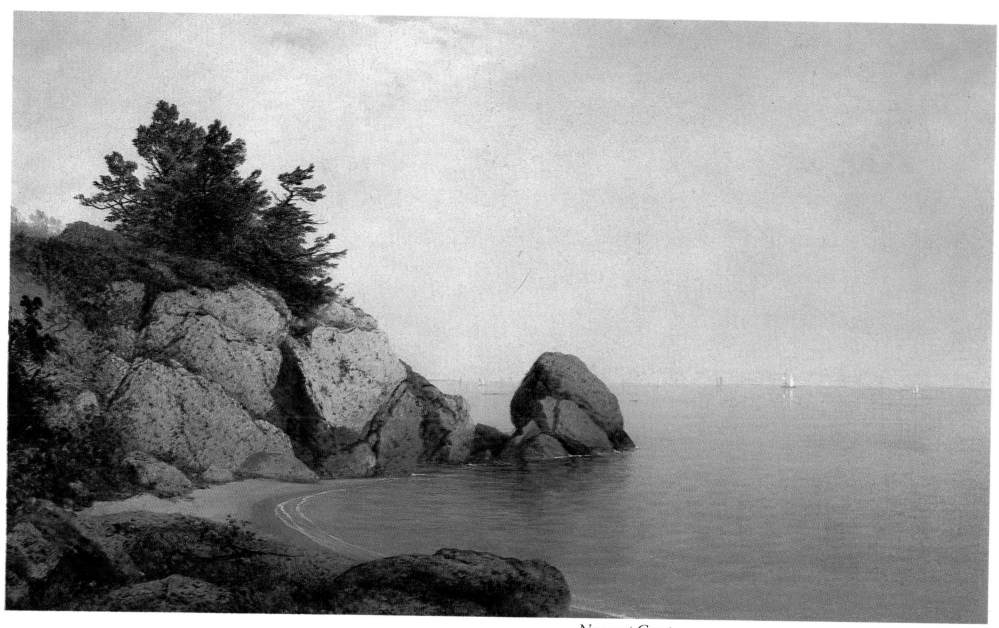

Newport Coast

Martin Johnson Heade (1819-1904)

Thunderstorm Over Narragansett Bay, 1868

Oil on canvas, 32 1/8 x 54 1/2 in.
(81.6 x 138.4 cm)
Inscribed l.l.: "M J Heade/1868."

1 Robert Workman, Museum of Art, Rhode Island School of Design, feels that the site depicted in the painting may be the union of the upper Bay and the Providence River, looking west from Sabin Point or Bullock Point in East Providence to a town across the water (possibly Warwick Neck, Pawtucket Neck, or Gaspee Point). (Letter from Robert Workman to Linda Ayres, 4 November 1985). Heade began to paint around Narragansett Bay in 1857, when he lived in Providence.
2 Theodore E. Stebbins, Jr., *The Life and Works of Martin Johnson Heade* (New Haven and London: Yale University Press, 1975), p. 67. Stebbins also links Heade with the 1860s revival of visionary art in America and with such artists as Elihu Vedder and James and William Beard (p. 81).
3 John Wilmerding, "Fire and Ice in American Art: Polarities from Luminism to Abstract Expressionism," in *The Natural Paradise: Painting in America, 1800-1950*, ed. Kynaston McShine (New York: Museum of Modern Art, 1976), p. 44.
4 One reviewer noted, "It is to be regretted that so hard and chilling a painting should have been allowed to leave his [Heade's] studio." See the brochure, "G.T.C.," *National Academy of Design, Exhibition of 1868* (New York, 1868), p. 87. A critic for the *Brooklyn Daily Eagle* (21 March 1868) reported that the only point on which everyone agreed is that the painting is "very peculiar."

Martin Johnson Heade's undisputed masterpiece—indeed, one of the icons of American art—is *Thunderstorm Over Narragansett Bay*. Like Frederic Church's *Twilight in the Wilderness* (painted in 1860 in New York's Tenth Street Studio Building where both artists maintained studios), it is an apocalyptic scene of intense dramatic power. Depicting Narragansett Bay, one of Heade's favorite regions,[1] this lonely seascape has mystical and visionary qualities, linking Washington Allston's early nineteenth-century seascapes and those of Albert Pinkham Ryder later in the century.[2] Extreme contrasts characterize the stark painting: white sails silhouetted against a black sky and reflected in the glassy surface of the black water are paired with a sense of tranquility amid imminent violence. The tiny figures are powerless in the face of the impending afternoon thunderstorm, yet they calmly lower their boats' sails and head for the safety of the cove whose rocks, shore grass, and wreckage (a reminder of past storms) Heade has executed in detail.

Equally adept at painting landscapes and still lifes, Heade received his first artistic training from Edward and Thomas Hicks of Bucks County, Pennsylvania, where he grew up. This was followed by several years of study in Europe (including two years in Rome). Heade returned to the United States in the early 1840s, traveling extensively throughout the East and Midwest, and eventually established a studio in New York City in 1859 (although he continued to move from place to place). First creating portraits, Heade's attention turned to landscapes in the 1850s.

In its smooth surface, sense of space, and palpable atmosphere, *Thunderstorm Over Narragansett Bay* belongs to the luminist movement. However, except for occasional works such as Church's *Twilight in the Wilderness* (1860, The Cleveland Museum of Art) and Fitz Hugh Lane's *Ships and an Approaching Storm Off Owl's Head, Maine* (1860, Collection of Senator and Mrs. John D. Rockefeller IV), it stands apart from the sunlit luminist views in its dark, brooding mystery. It is the culmination of a series of stormy seascapes by Heade created around the time of the Civil War. The series includes *The Coming Storm* (1859, The Metropolitan Museum of Art, New York) and *Approaching Storm: Beach Near Newport* (1866-1867, Museum of Fine Arts, Boston). The proximity of their creation (and that of the Lane and Church paintings) with these tumultuous years in America has been noted.[3]

Filled with tension and devoid of motion and air, the painting is an eerie distillation of nature's awesome power. A ragged, pink lightning bolt appears to split the very fabric of the sky as ghostlike sailboats glide through the background haze. Heade's surreal vision was an intensely personal one, not always understood by the public. This is evident from the unfavorable reviews given the painting when it was exhibited in 1868 at the National Academy of Design and the Brooklyn Art Association.[4] The painting disappeared from that point until 1943, when it was included in the Museum of Modern Art's landmark exhibition, "Romantic Painting in America." The excitement caused by *Thunderstorm Over Narragansett Bay* led to a renewed interest in and rediscovery of Heade's oeuvre.

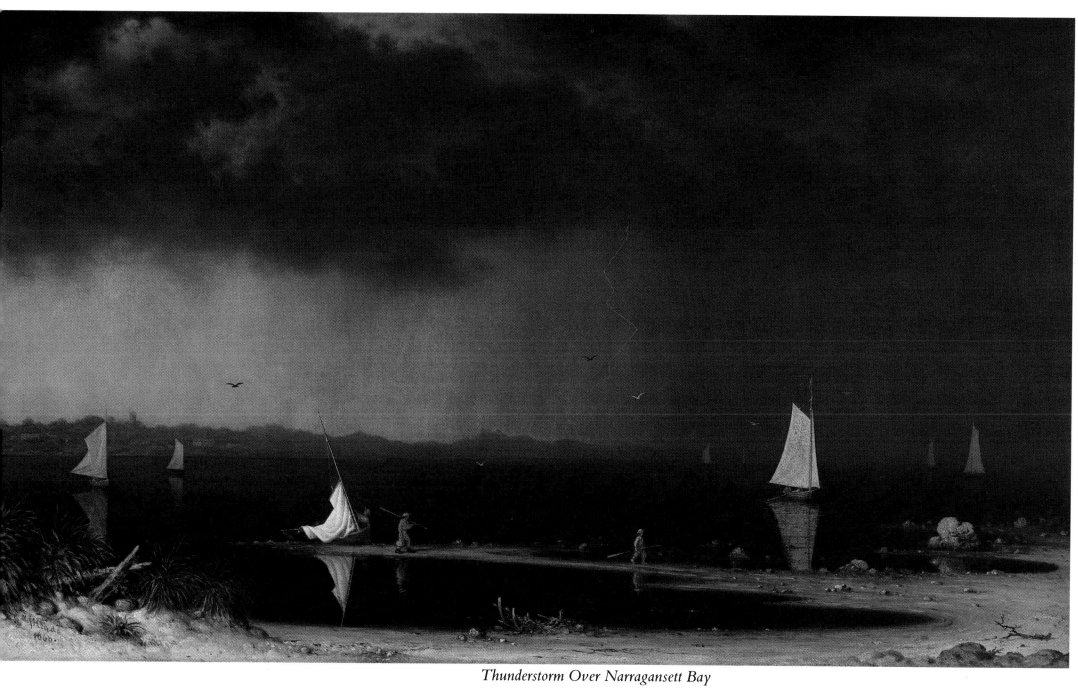

Thunderstorm Over Narragansett Bay

Martin Johnson Heade (1819-1904)

Marshfield Meadows, Massachusetts, 1870s

*Oil on canvas, 17 1/8 x 36 1/4 in.
(43.5 x 92.1 cm)
Inscribed l.l.: "M J Heade"; verso, on
fragment of original stretcher: "Marshfield
Mead[illeg.]"*

1 Theodore E. Stebbins, Jr., *The Life and
Works of Martin Johnson Heade* (New Haven
and London: Yale University Press, 1975), p.
44. Stebbins points out that the location of
many of the marsh scenes cannot be identified
due to the similarity of the salt marshes from
Maine to Florida. Most of the paintings' titles
were assigned in the last few decades.
2 Stebbins, p. 45. Stebbins provides a
good discussion on the harvesting of salt hay
(pp. 52-53).
3 Quoted in Stebbins, p. 101.

Martin Johnson Heade's favorite subject was the salt marshes along the East Coast, and he created more than one hundred paintings of them: in Rhode Island in the 1860s, Massachusetts and New Jersey in the 1870s, and Florida in the 1890s.[1] Like Claude Monet in France, Heade studied the haystacks at various times of day and under different kinds of light. Unlike the Impressionist painter, he never lost sight of three-dimensional form and precise draftsmanship.

Marshfield Meadows, Massachusetts is typical of Heade's work in this genre in its extreme horizontality, gray-green palette, contemplative mood, and interest in changing atmospheric conditions. The eye is drawn back into the picture by the zigzag flow of the North River and the haystacks, while the workers and ocean waves lead the eye across the wide picture plane. The small figures serve as a compositional element, and they give a sense of scale to the huge hayricks (which could stand as high as twenty feet). And on a different level, they represent the virtues of the outdoors and hard work.[2]

The painting is monochromatic (save for a few dots of orangish red on the background figures) and is thinly painted, revealing the water and marsh beneath the large haystack at the right. The painting is marked by a strong contrast of light and dark. While the background surf and men are in bright sunlight, an ominous storm cloud casts a deep shadow over the foreground. It is a romantic and dramatic scene of nature's forces, evoking a sense of the transitoriness of nature.

Henry Tuckerman, in *Book of the Artists,* praised Heade for the way in which he succeeded in "representing marshlands, with hay-ricks and the peculiar atmospheric effects thereof."[3] It is the marsh scenes which were the most popular works by this artist who received little notice in his lifetime. In addition to the many oil paintings on the subject, Heade created a remarkable series of charcoal drawings of the Newburyport marshes around 1867 or 1868.

Two Hummingbirds Above a White Orchid, 1870s

*Oil on canvas, 18 1/8 x 10 1/8 in.
(46.0 x 25.7 cm)
Inscribed l.r.: "M. J. Heade"*

1 Quoted in Theodore E. Stebbins, Jr.,
The Life and Works of Martin Johnson Heade
(New Haven and London: Yale University
Press, 1975), p. 129. Heade found the hummingbird to be a "seemingly insignificant but most brilliant & attractive little creature. For

Heade reported that he had been "almost a monomaniac" about hummingbirds since childhood.[1] Fascinated by the tiny birds and perhaps inspired by his friend Frederic Church's success with *The Heart of the Andes* (1859), Heade traveled to South America for the first time in 1863 to work on a book about the Brazilian hummingbird. Although the book did not come to fruition, a group of hummingbird paintings and a number of South American landscapes (among them the National Gallery of Art's *Rio de Janeiro Bay,* 1864) resulted from that trip. Heade returned to South America in 1866 and again, at Church's urging, in 1868.

At first Heade depicted hummingbirds in pairs against a landscape background. Then, in 1871, he began to combine the birds and flowers—first apple blossoms and then orchids. There were a number of artists and naturalists who juxtaposed flowers and hummingbirds, and their works may have served as precursors of this painting: John James Audubon, the Englishman John Gould (in his

five-volume *A Monograph of the Trochilidae*), and Currier and Ives.[2] Yet it was Heade's oil paintings of orchids and hummingbirds that were some of the most sensual and powerful still lifes of the nineteenth century.

The appeal of the flora and fauna lay not only in their exoticism, but in their emotional and sexual overtones. Orchids, believed in antiquity to possess aphrodisiac qualities, contain references in their appearance to both male and female sex organs. And the birds depicted are often either a male and female nesting or two males fighting over territory. The steamy, lush landscape against which the orchids and hummingbirds are placed further contributes to the atmosphere of sensuality.

The Amon Carter Museum's *Two Hummingbirds Above a White Orchid* depicts a close-up view of the Lealia Purpurata, the national flower of Brazil. Like Audubon before him, Heade shows us the colorful birds (male and female amethyst woodstars) and flower in their natural setting, giving us a microcosmic view of an Edenic world.[3] Related works—*Hummingbird with a White Orchid* (Shelburne Museum) and *An "Amethyst" Hummingbird with a White Orchid* (Collection of Jo Ann and Julian Ganz, Jr., Los Angeles)—also feature the white and red orchid (based on Heade's studies made in New York City greenhouses and private gardens) silhouetted against a vertical landscape.[4] Indeed, the painting can be considered as both a still life and a landscape, although the focal point is clearly the orchid, whose large, rhythmically curving forms almost project three-dimensionally toward the viewer.

Although Heade excelled in floral tabletop still lifes, which he painted throughout his life, it is the series of orchid and hummingbird paintings from the 1870s that constitutes some of his most provocative work in this genre.

one who is in the least degree attuned to poetic feeling they have a singularly fascinating power, which the subtlest mind is unable to explain . . . " Martin Johnson Heade Papers, 1865-1898, Archives of American Art, Smithsonian Institution, Roll D5, frame 736.

2 Stebbins, pp. 127-130. Heade was well read in ornithology and referred to Gould's work in his notebooks on hummingbirds. See Martin Johnson Heade Papers, 1865-1898, Roll D5, frames 731-735. He also observed the hummingbirds in their natural habitat and studied specimens when he had access to them.

3 Walt Davis, Dallas Museum of Natural History identified the birds as calliphlox amethystina (amethyst woodstar) but feels that Heade may have generalized some of the features of the birds depicted. See Rodolphe Meyer de Schauensee and William H. Phelps, Jr., *A Guide to the Birds of Venezuela* (Princeton: Princeton University Press, 1978), plate 12, for a good color reproduction of this bird. Heade admitted that his hummingbirds could not be considered strictly Brazilian, since they lived in other South American countries as well. See Martin Johnson Heade Papers, 1865-1898, Roll D5, frames 732-733. Gould's print and description of the calliphlox amethystina is on plate 159 and following pages in Volume 3 of his *A Monograph of the Trochilidae, or Family of Hummingbirds* (London: John Gould, 1861).

4 Stebbins, pp. 145, 147. The landscapes were probably painted from memory from his trips to Brazil.

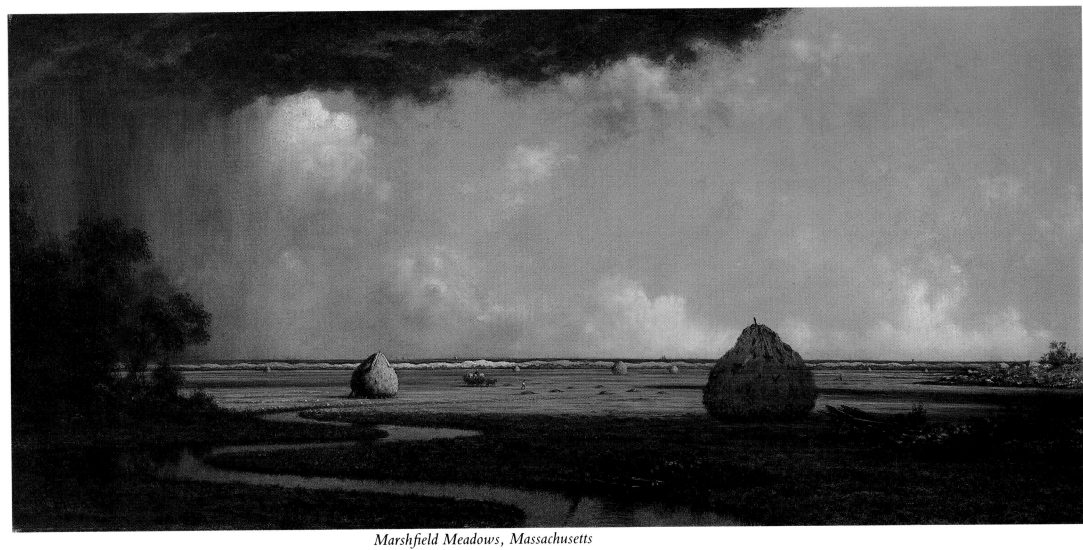

Marshfield Meadows, Massachusetts

14

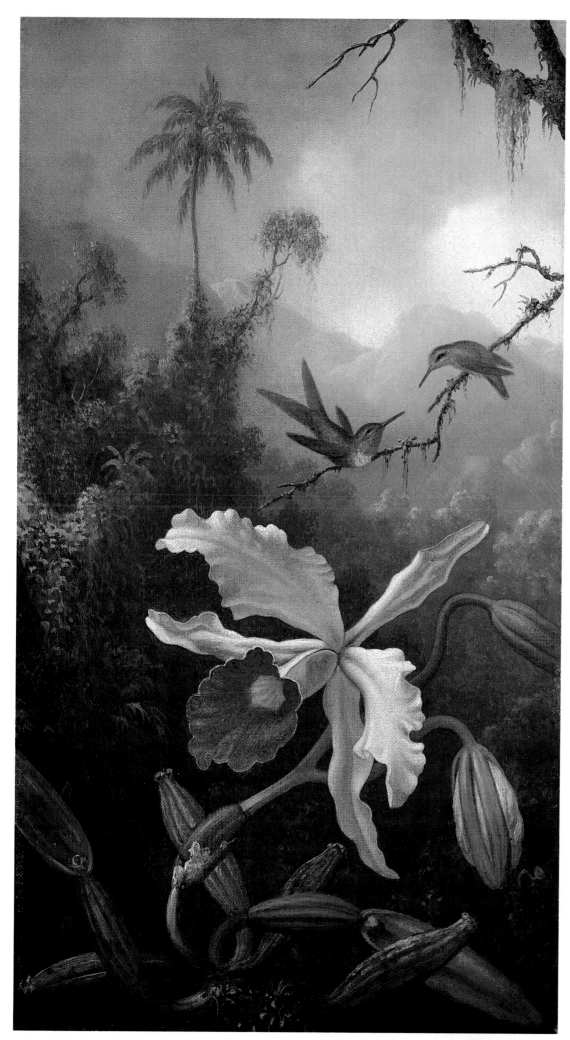

Two Hummingbirds Above a White Orchid

15

Jasper Francis Cropsey (1823-1900)

The Narrows from Staten Island, 1866-1868

Oil on canvas, 42 x 72 1/8 in.
(106.7 x 183.2 cm)
Inscribed l.r.: "J. F. Cropsey/1868"
Acquisition in memory of Richard Fargo
Brown, Trustee, Amon Carter Museum,
1961-1972

1 Others are *Looking Eastward from Todt Hill, The Vanderbilt Farm in the Distance* (1895, Staten Island Museum), *Grymes Hill* (1866, The Brooklyn Museum), and *Cortelyou Farm, Greenridge* (1843, Staten Island Historical Society).
2 William Talbot, *Jasper F. Cropsey, 1823-1900* (Washington, D.C.: National Collection of Fine Arts, 1970), p. 34. Talbot considers Cropsey's predilection for large-scale panoramic views the most significant development in the artist's style during the 1860s. William S. Talbot, "Jasper F. Cropsey, child of the Hudson River School," *Antiques,* November 1967, p. 715.
3 Carol Clark and William S. Talbot, "Jasper Francis Cropsey's *The Narrows from Staten Island* at the Amon Carter Museum," *American Art Review,* May 1978, p. 81. Cropsey is known to have been working on a large Staten Island picture for William H. Vanderbilt in 1866.
4 Barnett Shepherd, "Jasper Francis Cropsey's Staten Island: Paintings, Drawings, and Architecture," *Staten Island Historian,* 1, n.s., No. 1 (Summer 1983), 3-4. See "Forts in the Harbor," *Antiques,* January 1972, pp. 218-19.
5 William S. Talbot, "*Indian Summer* by Jasper F. Cropsey," *Bulletin of the Detroit Institute of Arts,* 58, No. 3 (1980), 151.
6 *New York Times,* 24 April 1870, p. 3, col. 4.

Of the seventeen paintings Jasper Cropsey produced of his native Staten Island, only four are known today, including *The Narrows from Staten Island* in the Museum collection.[1]

Cropsey, trained as an architect, had lived for three years in Italy and seven years in London when he returned to the war-torn United States in 1863. By that time, he was a successful landscapist, known abroad as the "Painter of the American Autumn." He created huge panoramic canvases of the eastern United States (perhaps inspired by the critical acclaim accorded the large landscapes of South America by Frederic Church and the American West by Albert Bierstadt).[2] Cropsey's art continued in this vein upon his return to New York as is evidenced by his impressive painting *The Narrows from Staten Island.* It is a postwar scene of peace and tranquility, a springtime depiction of regeneration for the land and for the nation. Although Staten Island, at the entrance to New York Harbor, was rapidly becoming more industrialized, it is the agrarian and marine aspects of island life that Cropsey presents—grazing cattle and a harbor dotted with sailing ships.

Perhaps commissioned by the Vanderbilt family, who had a vacation home on the island, the panoramic landscape is topographical in nature.[3] Cropsey clearly and precisely gives the viewer the salient geographical and architectural features of the east coast of Staten Island as seen from Grymes Hill, ranging from the Shot Tower near Stapleton Village on the left to Fort Wadsworth on the far right. He included not only Staten Island landmarks (such as the Seamen's Retreat and the Mariner's Family Asylum close to the shore) but sites on the Brooklyn side of the Narrows (Fort Lafayette, and, in the far distance, Gravesend Bay and Coney Island).[4]

Not far from Manhattan, Staten Island offered open space, solitude, and inspiration for the landscape painter (Cropsey himself) seen at work on the hill. The sense of vastness is reinforced by the small scale of the figures, the breadth of the view, and the low horizon line which allows a large area of canvas to be devoted to blue sky and clouds. Post-Civil War American landscape painting became a vehicle for the expression of gratitude for the preservation of the Union, pride, and hope; and *The Narrows from Staten Island* can be seen as a visual metaphor for the nation's renewed confidence in itself.[5] Crisp light and bright colors lend an air of sunny optimism to the scene.

Cropsey renders every section of nature faithfully and meticulously in Ruskinian detail. However, by the time the grand painting was exhibited at the National Academy of Design in 1870, the literal transcriptions of nature and panoramic views such as those created by Church, Bierstadt, and Cropsey were no longer in fashion. The public, instead, preferred the more subjective, looser, and atmospheric style of the Barbizon School, as a review of *The Narrows* in the *New York Times* indicates: "It is a painful picture by Mr. Cropsey. We will say no more of it than that we are heartily sorry to see that Mr. Cropsey appears to have lost that knowledge of art which he undoubtedly once possessed."[6]

A preparatory drawing for *The Narrows from Staten Island* (Newington-Cropsey Foundation, Hastings-on-Hudson, New York) contains all the essential elements of the landscape as well as color notes made by the artist. Following Cropsey's custom, the drawing was made en plein air, while the large finished painting was created in his studio.

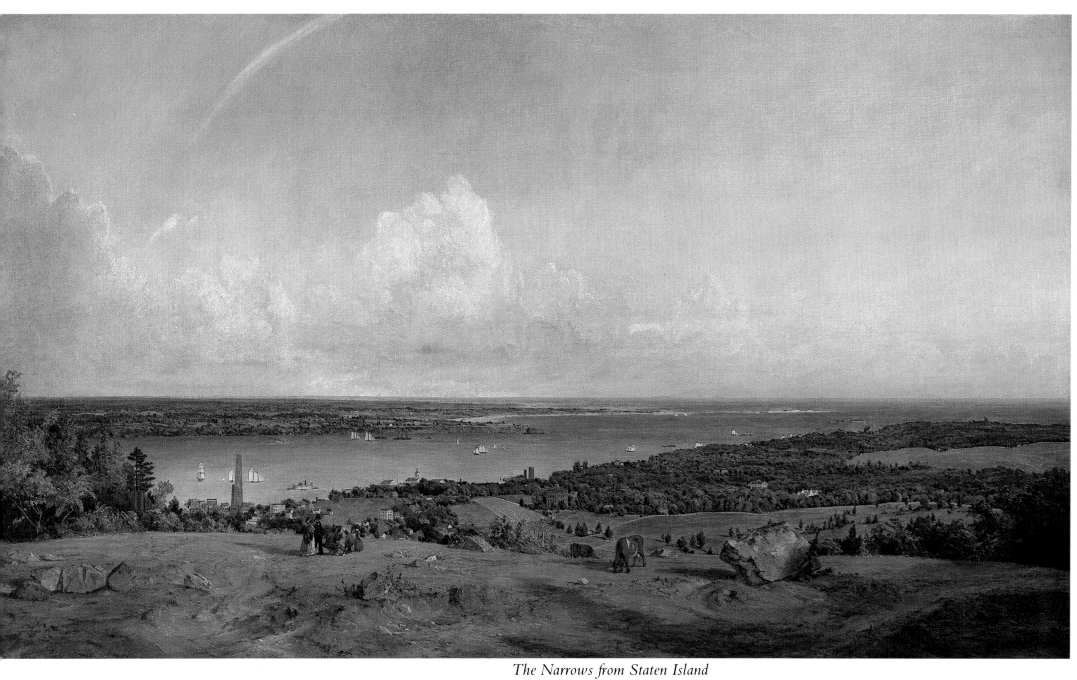

The Narrows from Staten Island

David Johnson (1827-1908)

Eagle Cliff, Franconia Notch, New Hampshire, 1864

Oil on canvas, 27 1/4 x 44 1/4 in.
(69.2 x 112.4 cm)
Inscribed l.l.: DJ [monogram]
verso l.r.: "Eagle Cliff, Franconia Notch.
N-H/David Johnson. 1864."

1 Linda S. Ferber and William H. Gerdts, *The New Path: Ruskin and the American Pre-Raphaelites* (Brooklyn: The Brooklyn Museum, 1985), p. 270.
2 Donald D. Keyes, "Perceptions of the White Mountains: A General Survey," in *The White Mountains: Place and Perceptions* (Durham, New Hampshire: University Art Galleries, University of New Hampshire, 1980), pp. 41, 44. Letter from Catherine Campbell to Linda Ayres, 21 October 1985, reports that Bierstadt, Kensett, Samuel L. Gerry, and Edward Hill painted Eagle Cliff, as did Jasper Cropsey, "at least nine times with considerable artistic license."
3 A related drawing (Robert Hull Fleming Museum, University of Vermont, Burlington) identifies the body of water as Profile Lake. Eagle Cliff derived its name from an eagle's nest on its crags. See Works Progress Administration, Federal Writers' Project, *New Hampshire: A Guide to the Granite State* (Boston: Houghton Mifflin Company, 1938), p. 327.
4 Others include *Buck Mountain, Lake George* (c. 1867, New York Art Market) and *Eagle Cliff, Franconia Notch* (1869, Mr. and Mrs. John McGinty). For a discussion of Johnson's career, see John I. H. Baur, " '. . . the exact brushwork of Mr. David Johnson,' An American Landscape Painter, 1827-1908," *The American Art Journal*, 12, No. 4 (Autumn 1980), 32-65.
5 Asher B. Durand, an early adherent to Ruskinian theories, urged artists to observe nature closely.

David Johnson, a member of the second generation of Hudson River School painters, was born in New York and spent most of his life there. He never traveled to Europe and received little artistic training, save for a few lessons with Jasper Cropsey in 1850. Johnson's early landscapes featured realistically rendered subjects (for example, *Forest Rocks* [1851, The Cleveland Museum of Art]). Although Johnson occasionally painted in a looser, dark style akin to the Barbizon School (especially in his later years), he frequently returned to a precisionist style.[1]

The crisp, light-filled landscapes—among Johnson's finest works—were products of frequent sketching trips to upstate New York and the White Mountains of New Hampshire, which he first visited in 1851 with John William Casilear, Benjamin Champney, and other artists. The White Mountains region was popular with writers, scientists, and tourists in the mid-nineteenth century, and artists such as Thomas Cole (see *The Hunter's Return*), John F. Kensett, Frederic Church, Albert Bierstadt, Jasper Cropsey, and Asher Durand made its magnificent scenery known to the American public. For many, these rugged mountains—the highest in the Northeast—represented the archetypal picturesque American wilderness.[2]

David Johnson faithfully recorded the beauty of the mountains in his 1864 canvas, *Eagle Cliff, Franconia Notch, New Hampshire*.[3] In this masterfully drawn and executed work, the viewer is confronted not with a fear-provoking scene of the Sublime but with a tranquil, poetic vision of America's unspoiled natural resources. Typical of Johnson's landscapes of that decade, the Amon Carter Museum painting depicts a foreground bank of rocks, a placid body of water over which two people in a rowboat glide, and a mountain in the background.[4] Overwhelmed by the precipitous foothill of Mount Lafayette (alt. 3,466 ft.), the tiny figures provide a sense of scale. Sharp summer light bathes the scene and unifies the compositional elements, and it is this clear light, along with the composition's carefully ordered space and the precise brushstrokes of the water, which call to mind the luminist landscapes of this period. Yet the intense coloration and Johnson's detailed interest in the geologic formations of the hillside's crags demonstrate, as well, the aesthetics of the American Pre-Raphaelites Henry and Thomas Farrer and John William Hill, followers of the British artist John Ruskin.[5]

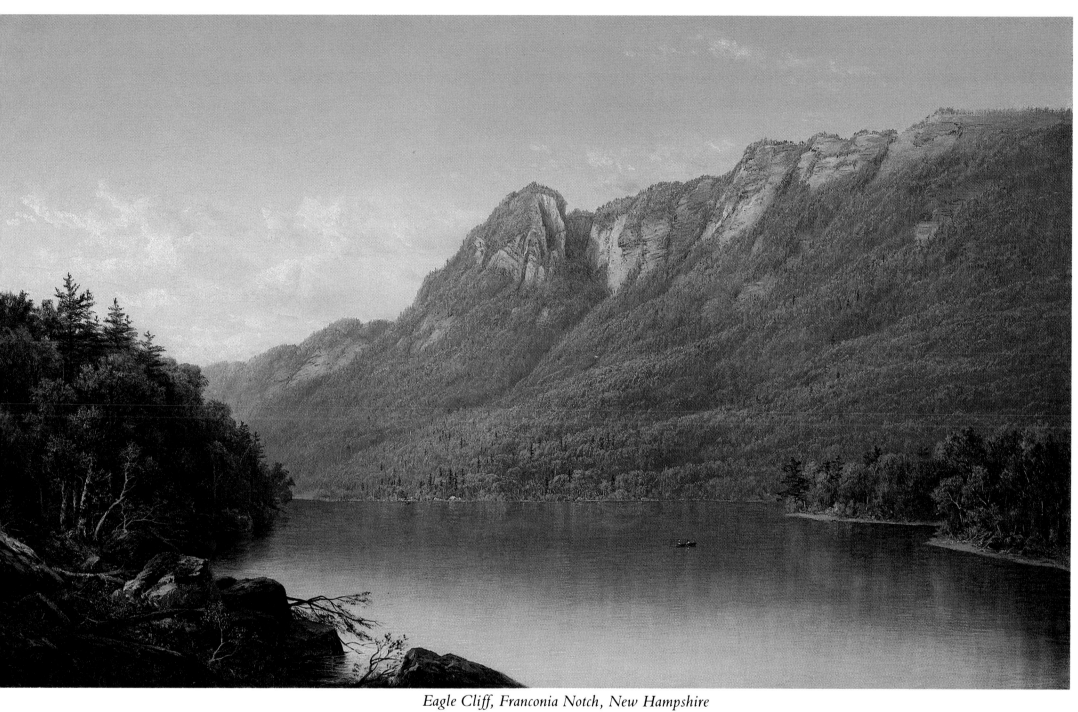

Eagle Cliff, Franconia Notch, New Hampshire

Albert Bierstadt (1830-1902)

Sunrise, Yosemite Valley, c. 1870

Oil on canvas, 36 1/2 x 52 3/8 in.
(92.7 x 133.0 cm)
Inscribed l.r.: "AB[monogram]ierstadt"

1 Gordon Hendricks, *Albert Bierstadt: Painter of the American West* (New York: Harry N. Abrams, Inc., Publishers, 1972), pp. 16-17, 19. The most recent and reliable source on Bierstadt is Nancy Anderson, "Albert Bierstadt: The Path to California, 1830-1870," Diss. University of Delaware, 1985.
2 Bierstadt received praise for his California paintings well past 1873. Nancy Anderson to Ron Tyler, 27 March 1986.
3 Benjamin Parke Avery, "Art Beginnings on the Pacific," *Overland Monthly,* August 1868, p. 114.
4 Fitz Hugh Ludlow, *The Heart of the Continent: A Record of Travel Across the Plains and in Oregon with an Examination of the Mormon Principle,* 2nd ed. (New York: Hurd and Houghton, 1871), pp. 412, 426.
5 Quoted in Hendricks, p. 141.
6 Quoted in Clarence King, *Mountaineering in the Sierra Nevada* (1872; rpt. Lincoln: University of Nebraska Press, 1970), p. 210; see also Thurman Wilkins, *Clarence King: A Biography* (New York: The Macmillan Company, 1958), p. 161.

Along with Frederic Edwin Church, Albert Bierstadt was one of the most popular landscape artists in America during the 1860s and early 1870s. *Sunrise, Yosemite Valley* was painted while he was at the height of his artistic powers.

Born in Solingen, near Düsseldorf, in 1830, Bierstadt came to the United States with his family in 1832, settling in New Bedford, Massachusetts. He began his artistic career at age twenty by advertising that he was prepared to teach drawing to all comers. Within a few years, he had exhibited paintings locally and had attracted enough support to be able to finance a return to Düsseldorf for further study.[1]

Back in America, Bierstadt arranged in 1859 to accompany Colonel Frederick W. Lander on an expedition as far west as the Continental Divide. Returning to his studio, Bierstadt produced, by 1860, his first important western painting, *Base of the Rocky Mountains* (unlocated), and within two years had painted his masterpiece, *The Rocky Mountains, Lander's Peak* (1863, Metropolitan Museum of Art, New York), appealing to the same public that was so enamored of Church's huge, wild landscapes of South America. By 1863, Bierstadt was once again in the West, this time in California and the Pacific Northwest, accompanied by his friend, writer Fitz Hugh Ludlow. The result of this trip was a series of paintings of the Yosemite Valley which are, today, among Bierstadt's most famous works.

Sunrise, Yosemite Valley probably was painted before or shortly after Bierstadt's third western trip in 1871-1872, although it is not dated, and there are no records of its exhibition during the artist's lifetime. It is clear, however, that the picture was completed during Bierstadt's prime and before his popularity succumbed to the declining public appeal of grandiose landscapes.[2] The competently rendered foreground serves only as the setting for the haze-shrouded mountain, brilliantly delineated by Bierstadt in a manner suggesting the majesty of the virgin West. An author for the *Overland Monthly* concluded that "Bierstadt's paintings have probably done more than all written descriptions to give persons abroad an adequate idea of the grandeur and beauty of that wonderful gorge."[3] Ludlow, who visited Yosemite with Bierstadt, verbalized the emotions that the artist captured in his paintings, describing their trip as "going to the original site of the Garden of Eden." Awed by the grandeur and distances in the Valley, Ludlow continued, "When Nature's lightning hits a man fair and square, it splits his yardstick."[4]

Some critics, meanwhile, had become appreciative of Bierstadt's efforts, praising his "great breadth and brilliancy."[5] But others were not so sure. With the arrival of Thomas Moran, Thomas Eakins, Winslow Homer, and Frederic Remington on the artistic scene, Bierstadt's reputation continued to decline. Clarence King, geologist and first director of the U.S. Geological Survey, probably put words into artist Hank G. Smith's mouth when he quoted him as saying that Bierstadt's "mountains are too high and too slim; they'd blow over in one of our fall winds." But those words echoed both the public and later the critical sentiment regarding Bierstadt's works.[6] The artist died in relative obscurity in 1902.

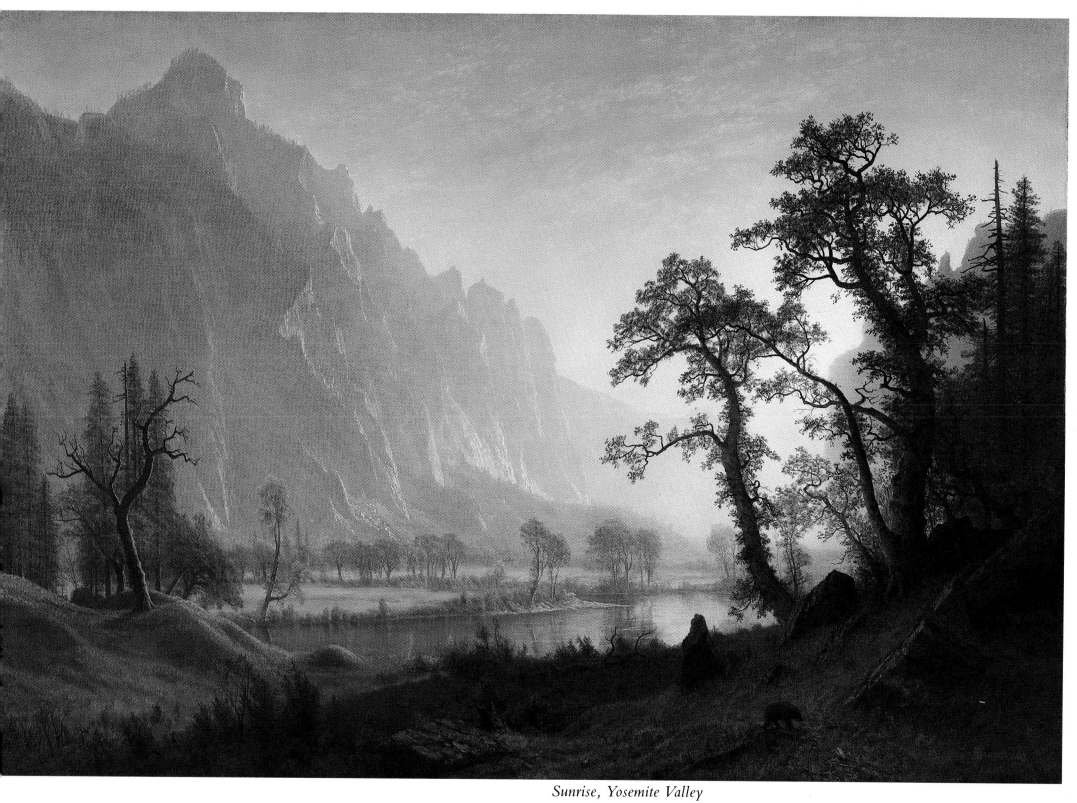

Sunrise, Yosemite Valley

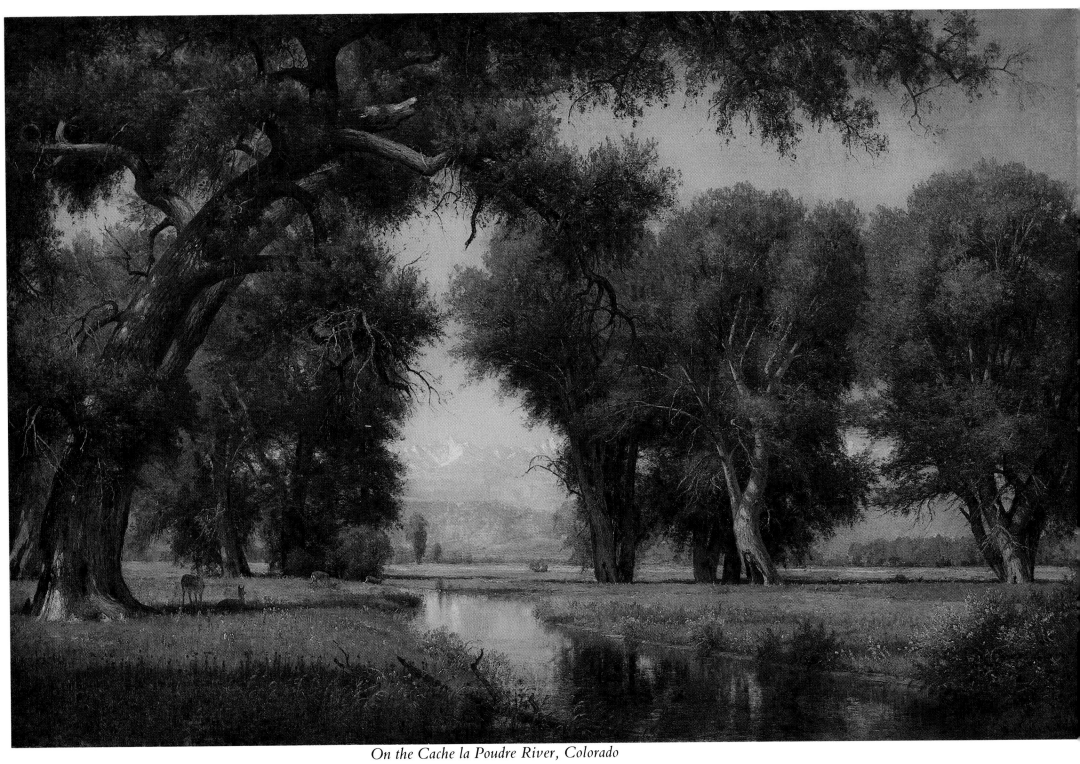

On the Cache la Poudre River, Colorado

22

Worthington Whittredge (1820-1910)

On the Cache la Poudre River, Colorado, 1876

Thomas Worthington Whittredge made three trips to the West between the years 1866 and 1871, and unlike his fellow artists Bierstadt and Moran, Whittredge was more impressed with the plains than the mountains. "Whoever crossed the plains at that period," he later wrote, "notwithstanding its herds of buffalo and flocks of antelope, its wild horses, deer and fleet rabbits, could hardly fail to be impressed with its vastness and silence and the appearance everywhere of an innocent, primitive existence."[1] His impressions resulted in a series of quiet landscape paintings depicting the plains and usually featuring figures or wildlife around a river. *On the Cache la Poudre River, Colorado* is one of the larger compositions created from Whittredge's western experience.

Whittredge might have been motivated to visit the West after returning from European study with the desire to "produce something new" that "might claim to be inspired by my home surroundings."[2] His first trip occurred in the summer of 1866 when he joined Major General John Pope on his tour of inspection of New Mexico and Colorado. He accompanied artists John F. Kensett and Sanford R. Gifford on his second trip in 1870 and visited the Denver and Greeley areas, sketching along the Platte, Thompson, Saint Vrain, and Cache la Poudre rivers, in 1871. It was during the final trip that a Greeley reporter noted Whittredge's presence and commented that the artist had "lingered lovingly along the Cache la Poudre" and in the process had discovered "a field almost wholly new to artists, for those who visit Colorado seem to think no studies worthy their attention below the mountains."[3]

It was during this third and final trip west that Whittredge did the sketches resulting in *On the Cache la Poudre River, Colorado*. The Cache la Poudre River joins the South Platte near Greeley, about fifty miles north of Denver. The "beautiful mountain views" from that perspective first attracted Whittredge, and he proceeded to make numerous sketches and studies there. Without using the figure groups that frequently flavored his Platte River compositions, Whittredge painted a delicate landscape depicting a stream flanked by a luscious grass field dotted with wildflowers and shaded by huge cottonwood trees that must have formed an oasis on the prairie. Rippling reflections dapple the surface of the water, while a small herd of white-tailed deer graze and laze in the shade. In the distance, beyond the foothills, the Rocky Mountains can be seen through the hazy light. The picture is one of Whittredge's best western landscapes.[4]

Oil on canvas, 40 3/8 x 60 3/8 in.
(102.6 x 153.4 cm)
Inscribed l.r.: "W. Whittredge/1876"

1 T. Worthington Whittredge, *The Autobiography of Worthington Whittredge, 1820-1910*, ed. John I. H. Baur (1942; rpt. New York: Arno Press, 1969), p. 45.
2 Whittredge, p. 42.
3 Patricia Trenton and Peter H. Hassrick, *The Rocky Mountains: A Vision for Artists in the Nineteenth Century* (Norman: University of Oklahoma Press, 1983), p. 214, quoting the *Greeley Tribune*, 19 July 1871.
4 Quote in Trenton and Hassrick, p. 214. Recently a smaller and almost identical version of this painting has been discovered. There is no information to support, without question, that it is the study for *On the Cache La Poudre River, Colorado*, but it would be logical to assume that it is. It has been dated 1871. See Trenton and Hassrick, p. 215. Illustrated as color plate 32.

Thomas Moran (1837-1926)

Cliffs of Green River, 1874

Oil on canvas, 25 1/8 x 45 3/8 in.
(63.8 x 115.3 cm)
Inscribed l.r.: "TM[monogram]oran. 1874"

1 Carol Clark, *Thomas Moran: Watercolors of the American West* (Austin: University of Texas Press, 1980), pp. 13-15, 153 (entry 289).
2 Entries 260-291 in Clark, pp. 155-158, list watercolors of Green River. A Jackson photograph entitled *Green River Bluffs, Utah*, #7257 in the collection of the Colorado Historical Society, Denver, was taken from almost the same perspective—Expedition Island, near the town of Green River, Wyoming.
3 There are many references to paintings of Green River in Moran's notebooks at the Gilcrease Institute of American History and Art Library, Tulsa, Oklahoma. One is to an 1878 picture 25″ x 52″ that went "to Major Powell" for $400. Another is to a 25″ x 42″ picture, the approximate size of *Cliffs of Green River*, which went "to J. H. Johnston," apparently in a trade. Moran valued it at $600. It might be added that Moran's records are not always reliable, for as he wrote on the same page as the reference to the Johnston picture, "Since the above date [1873] I have painted a great many pictures but can not recall them in the order painted nor the dates."
4 "Art," *Appleton's Journal*, 1 May 1875, p. 568.
5 *New York Herald*, 8 April 1875, p. 12, col. 1.
6 "National Academy Show," *New York Times*, 17 April 1875, p. 3, col. 3. *The Nation*, 5 Sept. 1872, p. 158.
7 *The Galaxy*, 20 (July 1875), 95.

As with Bierstadt, Thomas Moran established his artistic reputation by painting spectacular western scenery. Born in England, Moran immigrated to America in 1844 and subsequently settled with his parents and three brothers in Philadelphia, where the artistic climate complemented his family's aesthetic training. After apprenticing to a wood engraver, Moran established a studio with his brother Edward, and during the summers of 1861 and 1862, he traveled to England and Scotland to study the watercolors of J. M. W. Turner, while sharpening his own skills in drawing and watercolor.

His first opportunity to go West occurred after he completed an assignment to reproduce as wood engravings several drawings that had been submitted to *Scribner's* as part of an article on the Yellowstone country of Wyoming. The experience only enhanced Moran's curiosity about the West, and by the time the engravings were published in May and June 1871, he was an unpaid volunteer en route to Wyoming to join Dr. Ferdinand Vandiveer Hayden, the chief of the U.S. Geological Survey expedition into the Yellowstone. He traveled the Union Pacific Railroad through Green River, Wyoming, where he made his first sketch of the cliffs, which are within sight of the train station.[1]

Moran made several more trips to the West, including expeditions to Yellowstone, the Grand Canyon, the Tetons, and Yosemite. Still, the cliffs along the Green River fascinated him, just as they had photographers William H. Jackson and Timothy O'Sullivan, and he returned to them time and again.[2] Moran painted *Cliffs of Green River* in 1874, either after his return from an expedition to the Grand Canyon with Major John W. Powell or in the summer after returning from a trip to the Mount of the Holy Cross. It is an exuberant landscape featuring Toll-Gate Rock in the right center and a dramatic thunderstorm forming over the wall of the palisade, which completes the composition at the left. There has been conjecture that the expedition shown entering the river was that of Major Powell, perhaps because the picture might once have belonged to Powell, but it is more likely that Moran simply added the figures to heighten the viewer's romantic sensibilities at man's venture into the exotic.[3]

Moran's bright canvas aroused a great deal of interest at the spring 1875 National Academy of Design exhibition. The critic for *Appleton's Journal* suggested that Moran had "an accurate feeling for a true key of color [and] . . . a remarkably extensive range of tints . . . [that] give one an impression much like the effect of stirring music in a major key."[4] The reviewer for the *New York Herald* was no less positive, calling the canvas "remarkably picturesque."[5]

But the reviewers for the *New York Times* and *The Galaxy* echoed a sentiment first expressed in 1872 by a writer for *The Nation* in his review of *The Grand Canyon of the Yellowstone*: "The painter has the cruel advantage over his critics that he has seen the formation that he represents, and they have not."[6] The reviewers doubted the truthfulness of Moran's colors, with *The Galaxy* critic suggesting that the artist "try his hand at something a little nearer home so that we might have a chance to congratulate him with a good conscience, not only upon his brilliance, but upon his fidelity."[7] As the wonders of Yellowstone became known, Moran's colorful canvases were no longer doubted, and *Cliffs of Green River* stands as an early and characteristic example of his best work.

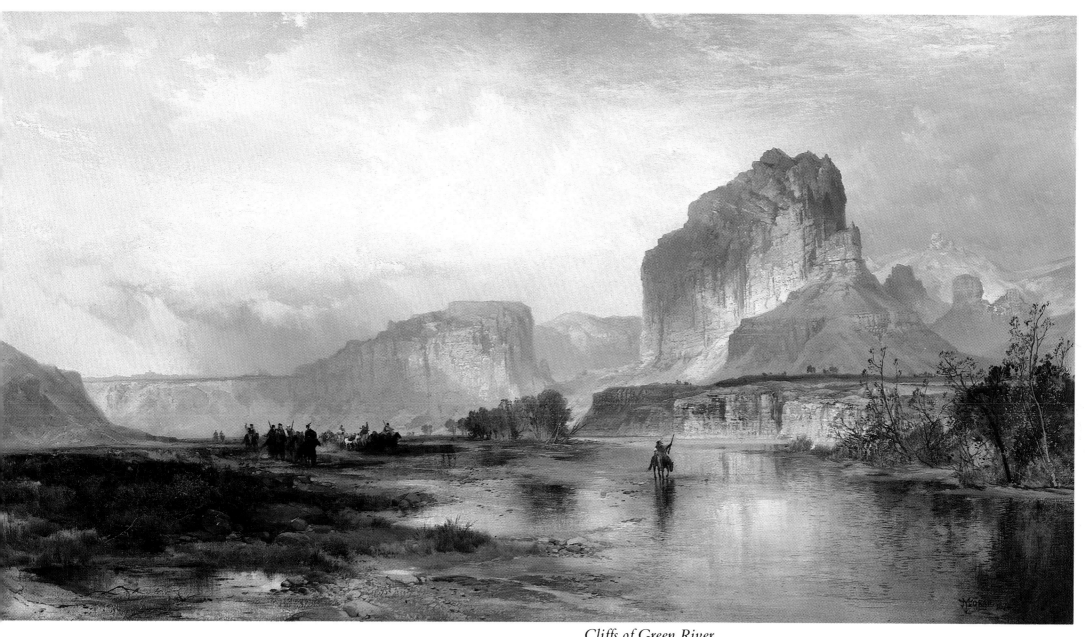

Cliffs of Green River

Charles Deas (1818-1867)

A Group of Sioux, 1845

*Oil on canvas, 14 1/8 x 16 1/2 in.
(35.9 x 41.9 cm)
Inscribed l.l.: "C. Deas 1845"*

1 *Missouri Republican* [Saint Louis], 6 June 1849, p. 2, col. 2, (quoting the *New York Express*).
2 Estimate by Carol Clark, Executive Fellow, Williams College Museum of Art, Williamstown, Massachusetts.
3 Henry Tuckerman, "Our Artists—No. V," *Godey's Lady's Book,* 33 (1846), pp. 250-253, which was reprinted with an additional paragraph of conclusion in Henry Tuckerman, *Book of the Artists* (New York: James F. Carr, 1867), pp. 424-429.
4 Peggy Samuels and Harold Samuels, *The Illustrated Biographical Encyclopedia of Artists of the American West* (Garden City, N.Y.: Doubleday & Company, Inc., 1976), p. 130.
5 Tuckerman, "Our Artists," p. 253.
6 J. Henry Carleton, *The Prairie Logbooks: Dragoon Campaigns to the Pawnee Villages in 1844, and to the Rocky Mountains in 1845,* ed. by Louis Pelzer (Chicago: The Caxton Club, 1943), pp. 100-101.

Many excellent artists painted western scenes during the 1830s and 1840s—George Catlin, Karl Bodmer, Alfred Jacob Miller, and Seth Eastman, to name only a few. But during the brief period from 1840 to approximately 1847, Charles Deas was perhaps the best of them all. Little is known of Deas, and even less is known of his painting because he went hopelessly mad in 1846 or 1847 and was placed in an insane asylum—suffering from "melancholy" as the *New York Express* put it.[1] Although he probably painted a hundred or more pictures, fewer than thirty paintings are known today.[2]

Most of what we know of Deas comes from an article written in 1846 by Henry Tuckerman, a painter himself and author of *Book of the Artists,* the most important source on early nineteenth-century American artists.[3] Deas was born in Philadelphia in 1818, the grandson of the Revolutionary War leader Ralph Izard. Deas hoped for a military career, but when he did not receive an appointment to West Point, he turned fully to his other love, painting. He frequented the Pennsylvania Academy of the Fine Arts and artist Thomas Sully's studio. He moved to New York, where he studied and exhibited at the National Academy of Design. After seeing an exhibition of Catlin's Indian Gallery in Philadelphia in 1838, Deas decided that he wanted "to visit the scenes of Nature's own children . . . and taste the wild excitement of frontier life."[4] In 1840, he headed west to visit his brother at Fort Snelling. The following year he visited Fort Winnebago and soon thereafter established his studio in St. Louis. It was there that Tuckerman found him, probably in 1845, where he had "all that a painter can desire in the patronage of friends, and general sympathy and appreciation." Deas was, at that time, working on a number of pictures, including *A Group of Sioux.*[5]

Deas apparently acquired much of his information with a manner that put the Indians at ease and permitted him to gather the necessary sketches and information for his work. Lieutenant J. Henry Carleton, whom Deas accompanied on an 1844 expedition to visit the Pawnee camps along the Platte River, reported that "Mr. Deas seemed to possess the whole secret of winning the good graces of the Indians. Whenever he entered a lodge it was with a grand flourish and a mock bow that would put even an Ottoman in ecstasies." After thus winning their confidence, "he would take out his portfolio and commence sketching; all the while rattling away at them in French to keep quiet. . . . Every now and then his conversation . . . would be interrupted by some remark to himself as a new idea of the subject . . . would strike him."[6]

A Group of Sioux may well be Deas's masterpiece of Indian life and is probably an amalgam of his experiences among the Sac and Fox, Winnebago, Sioux, and Pawnee. It is, on first glance, a quiet scene with serene elements such as the old man smoking a pipe, a brave in the foreground leaning to tie his moccasin, and various still-life objects—a leather helmet, a gun, a bullet pouch—strewn on the ground. But a closer look confirms the air of tension that Deas subtly built into the canvas: braves at the upper right signal with a blanket, while another, at the left, races off into the distance. The brave in the white buffalo robe seems transfixed, while fear is apparently the dominant emotion of the man in the rear center. The child at the lower right appears to be upset, and the horses are nervous. Perhaps this group is fleeing intertribal warfare.

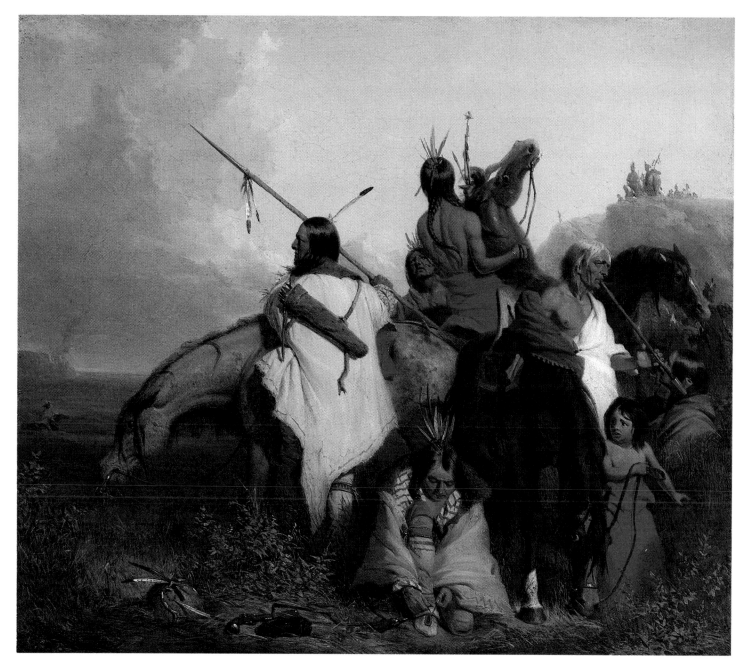

A Group of Sioux

There is no doubt that the painting is based on a thorough knowledge of western Indians, for Deas included many elements that can be documented. The braided hair, the gun, and the bullet pouch, for example, were typical of the Sioux. The bridle on the brown horse is characteristic of a white man's gear, rather than the Indian, suggesting that the horse may be stolen. The red blanket, the blue and red striped shirts or cloth, and the yellow and red striped shirt were probably all acquired through trade with white men.[7]

Deas likely realized that a small cabinet painting of this nature needed a strong focal point, so he composed a crowded composition that seems about to explode from its inherent power and emotion and tied it together with the skillful use of splotches of bright red throughout. It is a remarkable achievement.

7 Carol Clark interview with Herman Viola, Director, Bureau of American Ethnology, Smithsonian Institution, 25 September 1985.

27

Seth Eastman (1808-1875)

Ballplay of the Sioux on the St. Peters River in Winter, 1848

Oil on canvas, 25 3/4 x 35 1/4 in.
(65.4 x 89.5 cm)
Acquisition in memory of Mitchell A.
Wilder, Director, Amon Carter Museum,
1961-1979

1 John Francis McDermott, *Seth Eastman: Pictorial Historian of the Indian* (Norman: University of Oklahoma Press, 1961), Checklist of Works, pp. 228-249.
2 George Catlin, *Letters and Notes on the Manners, Customs, and Conditions of North American Indians: Written During Eight Years' Travel (1832-1839) Amongst the Wildest Tribes of Indians in North America,* (1844; rpt. New York: Dover Publications, Inc., 1973), II, 125.
3 Quotes in McDermott, p. 48. See also Henry R. Schoolcraft, *Information Respecting the History, Condition and Prospects of the Indian Tribes of the United States,* 2nd ed. (Philadelphia: J. B. Lippincott & Co., 1868), II, 78.
4 Tribal identification by Herman Viola, Director, Bureau of American Ethnology, Smithsonian Institution, in interview with Carol Clark, 25 September 1985.
5 Mary Eastman, *The American Aboriginal Portfolio* (Philadelphia: Lippincott, Grambo & Co., 1853), p. 56.
6 Schoolcraft and Catlin both describe wagering on the outcome of the game. See Catlin, p. 125; and Schoolcraft, pp. 78-79.
7 Eastman, p. 55.
8 *Bulletin of the American Art-Union,* Dec. 1850, opp. 143, 155; Catalogue of Works of Art, V; 163, 170.

Aside from George Catlin, Seth Eastman was perhaps the best known painter of the Plains Indians during the first half of the nineteenth century. Born in Brunswick, Maine, Eastman first went west in 1829 after a distinguished career at the U.S. Military Academy at West Point. During the next thirty years, he served in the Midwest, Florida, and Texas and produced over one hundred oils and more than four hundred watercolors of the West.[1] *Ballplay of the Sioux,* a cool and subtle rendering of one of the Indians' most exciting games, ranks among the best of Eastman's depictions of the West and was painted at the height of his artistic powers.

The ball game, which later developed into lacrosse, originated among the North American Indians before Columbus's voyage and occupied much of their leisure time. Often one village would challenge another to a game, and sometimes heavy wagers would be placed on the outcome. George Catlin, in fact, reported games in which perhaps six hundred or seven hundred players took part.[2] The field was approximately a quarter of a mile long and marked by stakes at either end. The ball consisted of "a piece of baked clay covered with deer skin," according to Mrs. Eastman, a chronicler of Indian life as well as wife of the artist. The object of the game was for one side to get the ball past the other team's stake. That could be done by carrying it in a ball stick, as the young man in the painting is doing, or by throwing it. Suffice it to say that the other team would often use any means at its disposal to stop the ball carrier, leading Mrs. Eastman to report that "this is a rough play, limbs are often broken and lives lost."[3]

The game was usually played in the summer on a stretch of prairie, so this match played by the eastern Sioux-Sautee on the St. Peter's River, now the Minnesota River, probably during the winter of 1847-1848, was somewhat unusual.[4] Mrs. Eastman recalled:

The surrounding hills were white with snow, and the ice, dark and heavy-looking. The scene was inexpressibly wild. The long, gaunt boughs of the trees, leafless, and nodding with the wind towards the dark, heavy evergreens among them; the desolate appearance of nature contrasted with the exciting motions and cries of the Indians. It was impossible even for the mere spectator to be unmoved; he must feel an interest in the game, until the ball has been at length thrown beyond one of the limits, and the tired and hard-breathing men receive the prizes awarded them.[5]

The buffalo robes, trade cloths, pots, spears, arrows and quiver, and medicine bundle in the lower left corner of this composition might simply have been laid down by the Indians as they prepared for the game, although it has been suggested that these were the items that had been wagered on the outcome.[6] Eastman has been precise in delineating the costuming for the major figures, for, as Mrs. Eastman pointed out, "In winter, the Indians adorn themselves with their choicest finery" for the game.[7]

Ballplay of the Sioux was included in the American Art-Union exhibition for 1850 and was etched by Charles Burt for inclusion as the frontis for the December 1850 Art-Union *Bulletin.*[8]

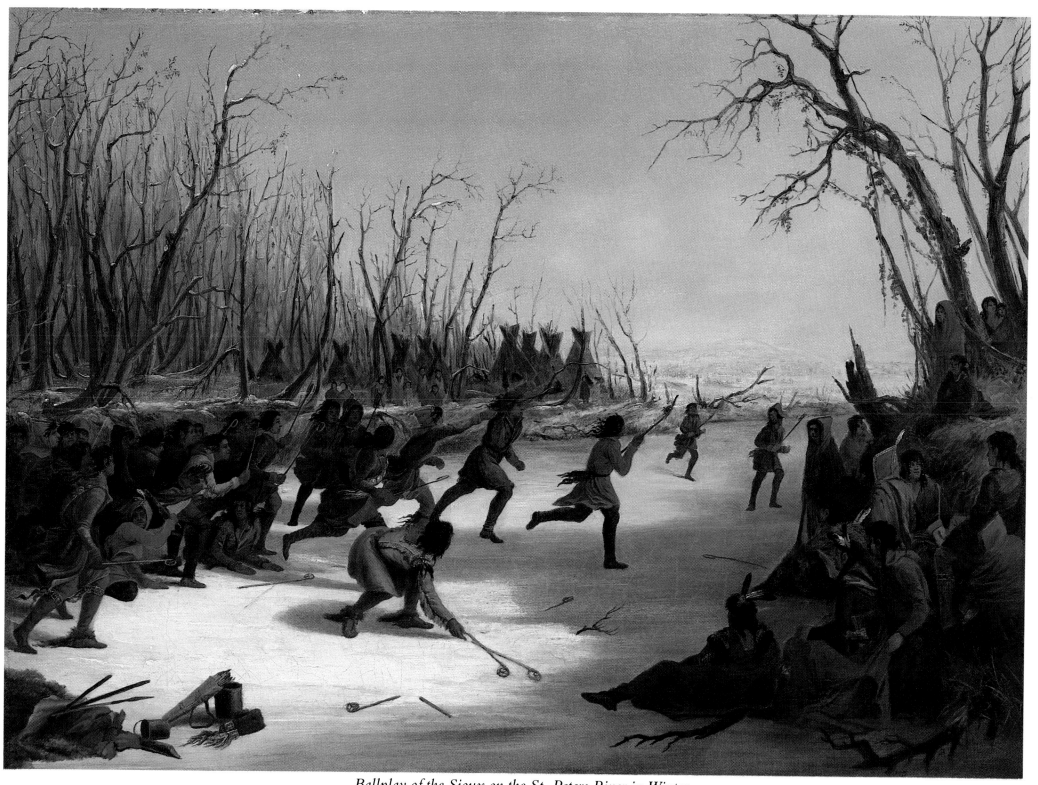

Ballplay of the Sioux on the St. Peters River in Winter

John Mix Stanley (1814-1872)

Oregon City on the Willamette River, c. 1850-1852

Oil on canvas, 26 1/2 x 40 in.
(67.3 x 101.6 cm)

1 Biographical information is taken from Julie Schimmel, "John Mix Stanley and Imagery of the West in Nineteenth-Century American Art" Diss. New York University 1983, pp. 1-24.
2 Peter Hassrick, *The Way West: Art of Frontier America* (New York: Harry N. Abrams, Inc., 1977), p. 60. *Oregon Spectator* [Oregon City], 8 July 1847, p. 2, col. 1.
3 *Portraits of North American Indians, with Sketches of Scenery, Etc., Painted by J. M. Stanley Deposited with the Smithsonian Institution* (Washington: Smithsonian Institution, 1852), p. 62.
4 *Portraits of North American Indians,* p. 61, entry 113 is entitled *Oregon City,* painted in 1848.
5 "Stanley's Indian Gallery," *The Daguerrean Journal,* I (Feb. 1851), 185-186.

John Mix Stanley spent as much time and effort in painting Indian portraits as did any other painter of that subject. But because virtually all of his Indian Gallery was destroyed in two tragic fires, he is better known today as a landscapist and genre painter. Stanley was born in New York State in 1814. He worked as an apprentice coach maker in his home state, and after moving to Detroit in 1834, he worked as a sign painter. It was in Detroit that he established himself as a portrait painter, developing the skills which would serve him in recording and interpreting Indian life during his first western journey to Fort Snelling, Minnesota, in 1839.[1]

The Fort Snelling visit began fifteen years of intermittent travel in the West. After a brief return to the East, where he polished his skills as a portraitist, Stanley was back in the West in 1842, traveling throughout Indian territory (Oklahoma) to paint the natives of a dozen different tribes. Like George Catlin, he envisioned a traveling show of his Indian material and exhibited his North American Indian Gallery in Cincinnati and Louisville in 1846 before embarking on a two-year journey throughout the Southwest and West.

Following the Santa Fe Trail to its destination, Stanley joined Major Stephen Watts Kearney's march to California during the war with Mexico. He served as a topographical artist under Lieutenant William H. Emory, observing, mapping, and sketching this little-known area. The lithographed illustrations for Emory's published report of Kearney's journey were based on Stanley's drawings.

Stanley left the Kearney expedition at San Diego and took a boat to San Francisco. From there he set out, in the spring of 1847, for Oregon Territory, following the Columbia River one thousand miles into the interior. It was during this journey, in February and March 1848, that he visited Oregon City on the Willamette River. The Amon Carter Museum painting entitled *Oregon City on the Willamette River* is Stanley's only extant landscape of that village. He painted the picturesque scene, twenty-five miles south of Fort Vancouver and just below the Willamette Falls, as an idyllic setting on the western frontier. By the time he arrived there, the twenty-year-old village had about three hundred inhabitants and one hundred houses, two churches, two gristmills, two sawmills, four stores, doctors, a lawyer, and its own newspaper, the *Oregon Spectator,* which welcomed the young artist for the "purpose of transcribing to canvas some portions of the beauty and sublime scenery with which our country abounds."[2]

Stanley's cityscape is classically composed, with a silhouetted knoll and tree to provide vantage and introduce a scene that unfolds in clear, bright light. A luminous landscape surrounds the charming town of neat frame buildings. In its lucent setting, the town appears calm, almost frozen, despite its apparent thriving growth as a lumbering community with trade and agricultural interests. Stanley was especially interested in the Willamette Falls Indians, many of whose portraits he included in his Indian Gallery.

Even though he had canceled a visit to the famous Whitman mission because of a Cayuse Indian massacre in November 1847, Stanley was aware of the problems faced by Oregon's native inhabitants and pictured the two Indians in the foreground turning away from the town below. The

Indians were losing their lands to lumber and fishing enterprises and had been decimated by epidemics introduced by the Anglo-American settlers. Stanley commented on one Willamette chief who, although "reduced in circumstances and degraded by dissipation, retains much of that dignity which gave him the ascendency over a brave band of warriors."[3]

It is possible that this painting was part of his Indian Gallery. A catalogue of the collection published in 1852 lists a painting of Oregon City done in 1848.[4] It is questionable whether this large and handsomely finished painting could have been completed while Stanley was traveling across the country or during the year he spent in Honolulu. More likely, it was finished after he returned east and took his Indian Gallery on the road to several cities.[5] The Gallery was deposited and exhibited at the Smithsonian Institution until its almost total destruction by fire in 1865. This tragic loss was compounded later that year when more of his paintings burned in a fire at P. T. Barnum's museum in New York. Stanley spent his later career in Washington, Buffalo, and Detroit.

Oregon City on the Willamette River

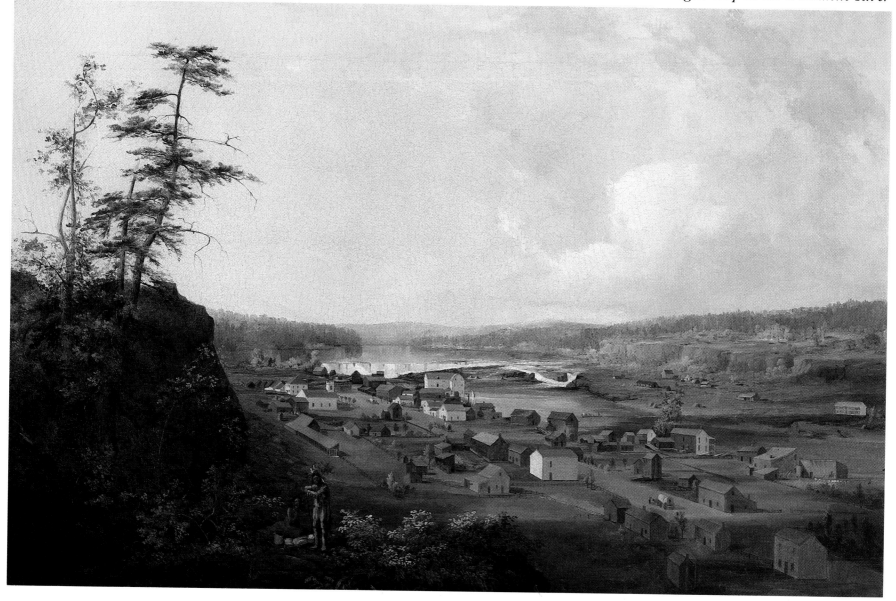

George Caleb Bingham (1811-1879)

Wood-Boatmen on a River (Western Boatmen Ashore by Night; Flatboatmen by Night), 1854

Oil on canvas, 29 x 36 1/4 in.
(73.7 x 92.1 cm)
Inscribed l.l.: "G. C. Bingham/1854"

1 Biographical information on Bingham is taken from E. Maurice Bloch, *George Caleb Bingham: The Evolution of an Artist* (Berkeley: University of California Press, 1967). Quote in Washington Irving, *Astoria, or Anecdotes of an Enterprise Beyond the Rocky Mountains . . .* , (Philadelphia: Carey, Lea & Blanchard, 1836), I, 141.
2 *M. and M. Karolik Collection of American Paintings, 1815 to 1865* (Boston: Museum of Fine Arts, 1949), p. 109.
3 Quote in Bloch, p. 104, regarding *The Wood-Boat* (Saint Louis Art Museum).
4 John Francis McDermott, *George Caleb Bingham: River Portraitist* (Norman: University of Oklahoma Press, 1959), p. 114 (see page 323 for reproduction of the drawing).
5 William C. Foxley, *Frontier Spirit: Catalogue of the Collection of the Museum of Western Art* (Denver: The Museum of Western Art, 1983), pp. 60-62.

George Caleb Bingham was born in Augusta County, Virginia, and moved to the frontier as a child. His family settled in Franklin, Missouri, on the Missouri River. Bingham returned to the East in 1838 to study at the Pennsylvania Academy in Philadelphia, where he probably saw how William Sidney Mount and his contemporaries were painting the local scene. After six years of portrait work in Philadelphia, Washington, and New York, Bingham turned to painting a subject he knew well, the rivermen along the Missouri and Mississippi rivers. During the ensuing twenty years, he produced a series of genre paintings that visually documented what Washington Irving called that "singular aquatic race that had grown up from the navigation of the rivers."[1]

Like George Catlin, who set out to capture the Plains Indian way of life on canvas, Bingham saw that the rivermen were disappearing before the onslaught of the steamboat and determined to paint them before they vanished. Based on his own experiences, these scenes of frontier life were destined to characterize an era indelibly stamped by President Andrew Jackson and the democratic principles for which he stood.

Wood-Boatmen on a River is one of a series of pictures of similar design that Bingham produced between 1850 and 1854. It is possible that he painted it during his stay in Philadelphia in 1853-1854: "I have painted two small pictures which I sold for three hundred and twenty-five dollars," he wrote John Sartain, who was at the time engraving his *County Election,* "and I shall continue to make the best use of my time as long as I shall be detained here."[2] Bingham pictured four rivermen gathered around a glowing campfire—"a group such as the traveller daily sees upon the navigable waters of the west," he wrote about a similar painting.[3] They have pulled their flatboat ashore for the night and are sharing a few moments of frontier conviviality before retiring for the evening: one reclines, listening to a companion as he plays the mouth harp, another sits with his arms wrapped around his knees, while a fourth leans on a pole. In the background, a fisherman dangles his line in the river from the back of the flatboat. The reclining figure (for which a careful study drawing exists) and the man with his back to the viewer are particularly characteristic of Bingham's mature work, while the dramatically lighted sky may mark the apex of his nighttime effects.[4] The picture is probably a pendant to *Watching the Cargo by Night* (1854, The Museum of Western Art, Denver), which together were the culminating paintings of Bingham's experiments with night lighting.[5]

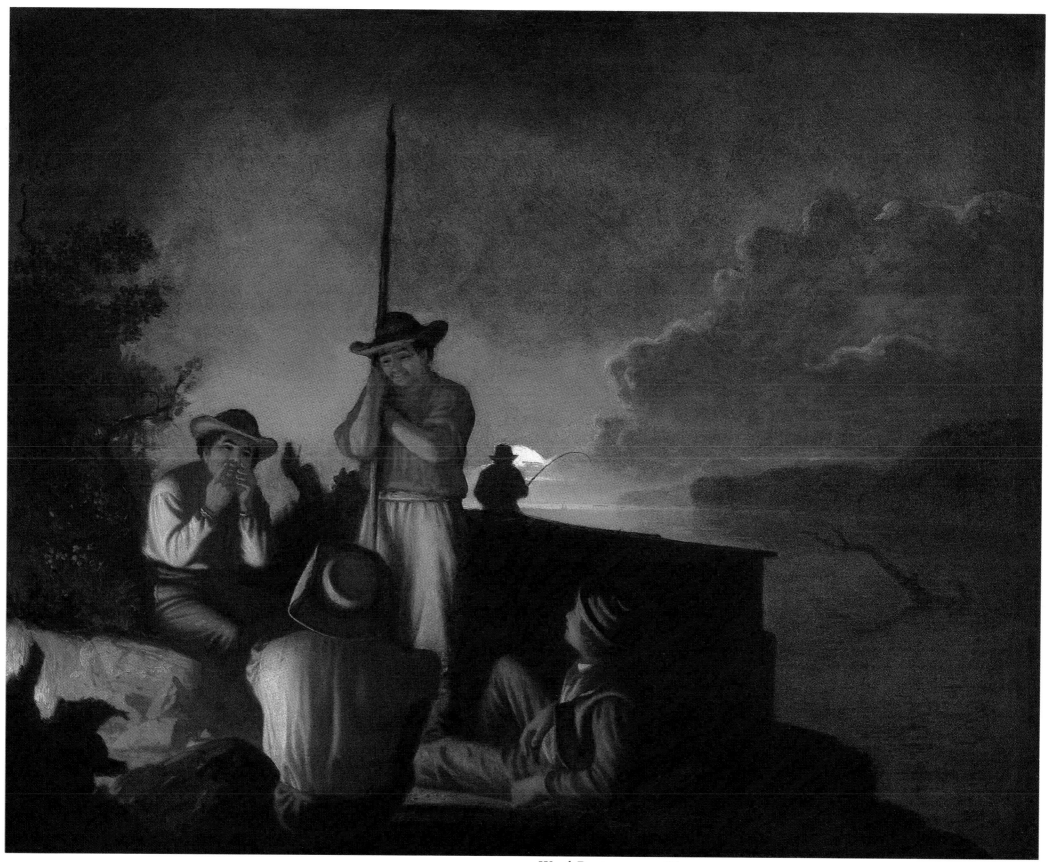

Wood-Boatmen on a River

William Ranney (1813-1857)

Marion Crossing the Pedee, 1850

Oil on canvas, 50 1/8 x 74 3/8 in.
(127.3 x 188.9 cm)
Inscribed l.c.(on boat): "W Ranney/1850"

1 Marion was a popular figure in the nine-teenth century. *The National Portrait Gallery of Distinguished Americans* (1836) devoted ten pages to him. Works such as William Gilmore Simms's *Life of Francis Marion* and William Cullen Bryant's poem "Song of Marion's Men" were published in the 1840s.

2 Modern maps identify the river as the Pee Dee. However, the records of the American Art-Union and other nineteenth-century sources refer to the painting as *Marion Crossing the Pedee,* using the variant spelling.

3 Perhaps Ranney's participation in the Texas war for independence and his interest in the Mexican War (1846-1848), precipitated by Texas's admission to the Union, provided the inspiration for these pictures.

4 For a nineteenth-century description of Marion, see William Dobein James, *A Sketch of the Life of Brig. Gen. Francis Marion* (Charleston: Gould and Riley, 1821), p. 46.

5 Düsseldorf paintings were exhibited at the American Art-Union in New York in 1849, and the popular Düsseldorf Gallery opened in that city in 1850.

6 For instance, paintings like Hans Fredrik Gude's *Brautfahrt auf dem Hardanger Fjord* (1848, Nationalgalerie, Oslo), whose work was shown in New York's Düsseldorf Gallery.

7 American Academy of Fine Arts and American Art-Union exhibition record, 1816-1852, p. 295.

There existed in mid-nineteenth century America a climate of appreciation for depictions of historic events and a resurgence of interest in the Revolutionary War in the form of new biographies and popular tales. One of the romantic heroes lionized was General Francis Marion, a South Carolinian who left his family plantation to lead a group of irregular troops against the British. Marion, who used his vast knowledge of the lowlands to his advantage in surprise attacks on Tory camps, was perhaps better known as "the Swamp Fox."[1]

William Tylee Ranney's *Marion Crossing the Pedee* is one of the artist's most impressive historical genre scenes and a rare portrayal of a Southern incident of the Revolutionary War.[2] Ranney, though born in Middletown, Connecticut, spent his adolescent years in Fayetteville, North Carolina, where he was apprenticed to a tinsmith. Following art instruction in Brooklyn and service in the Texas war for independence against Mexico in the 1830s, Ranney eventually settled in West Hoboken, New Jersey, where he became known for his vignettes of frontier life, duck hunting scenes, and a group of historical paintings of the American Revolution.[3]

Instead of depicting a dramatic, decisive battle, *Marion Crossing the Pedee* illustrates a frequent happening: General Marion and his motley guerrilla brigade leaving their retreat on South Carolina's Snow's Island, between the Lynches and Pedee rivers, in the fading light of day. The dense forests around the island made it a natural hiding place for this colonial Robin Hood. The large flatboat carries Marion, mounted on his sorrel horse, Ball, his chief officers (also on horseback), and his soldiers, each of whom is a careful study in individual expression, as are the animals who accompany them. Ranney carefully delineated the aquiline nose, projecting chin, and swarthy complexion for which Marion was known.[4] The painting reveals Ranney's talents as a colorist and draftsman and exemplifies the strong influence of the Düsseldorf School on American artists at mid-century.[5] The Düsseldorf artists' theatrical, highly finished, and precisely drawn paintings were much admired in America, and although there are precedents for *Marion Crossing the Pedee* in works such as Théodore Géricault's *Raft of the Medusa* (1818-1819, Louvre, Paris) and George Caleb Bingham's *Raftsmen Playing Cards* (1847, Saint Louis Art Museum), it is the Düsseldorf School which may have provided other sources.[6]

Completed in December 1850, *Marion Crossing the Pedee* was exhibited at New York's Art-Union where it was proclaimed to be "one of the very best works of the artist."[7] Engravings after the painting by Charles Burt were distributed to the Art-Union membership, while the painting itself was sold to William Webb, a collector who also owned a version of Emanuel Leutze's *Washington Crossing the Delaware*. After 1876 the painting disappeared for almost a century before being rediscovered in a hunting lodge on the Northwest Coast.

There is an oil study (16 x 21 inches), which contains the basic elements of the scene, in the collection of the Greenville County (South Carolina) Museum of Art.

Virginia Wedding, 1854

Another of Ranney's historical genre scenes in the Amon Carter Museum collection is *Virginia Wedding* which was executed four years after *Marion Crossing the Pedee*. A large, colorful, and ambitious composition, it is believed that this painting may have derived from an unknown literary source. It depicts a frontier scene with a joyful parade of nine couples in eighteenth-century attire on horseback. As in *Marion Crossing the Pedee*, careful attention is given to the figures' characterization, from the servants who await the festivities (one, who holds a fiddle, has a sprig of flowers in his waistcoat; another dances) to the elderly host who welcomes the new bride with outreached arms. Even the dogs and horses play an animated role.[1] An unidentified clipping describes the painting as exhibiting Ranney's "powers to advantage. What a pleasant cavalcade is that of the youths each with a partner pillioned behind. The horses enter into the spirit of the scene, and seem to enjoy their double burdens as much as the bridegroom his duplicated responsibilities."[2]

However, the iconography of the painting remains an enigma. Research has not yielded information on a specific Virginia tradition that relates to Ranney's scene, and the only obvious reference to a wedding is the gold ring on the hand of the woman being welcomed.[3] Instead, the focus is on the figures behind her, centrally placed in the composition. The prominence given them and the wild turkey they bring raises the question whether this painting could be *The Fowler's Return* which was exhibited by Ranney in 1854 at the National Academy of Design.[4]

The Amon Carter Museum painting was known by the title *Virginia Wedding* as early as 1858 (after Ranney's death), when it was exhibited by its owner, Dr. Thomas Edmondson of Baltimore, at the Maryland Historical Society. Whether the painting is *Virginia Wedding* or *The Fowler's Return*, it is a delightful example of mid-nineteenth-century American genre painting and ranks, with *Marion Crossing the Pedee*, as one of William Ranney's finest efforts.

Oil on canvas, 54 1/4 x 82 1/2 in. (137.8 x 209.6 cm) Inscribed l.r.: "Wm Ranney 1854"

1 Ranney loved horses and constructed his studio so that the animals could be brought inside to serve as models for his paintings. See *The Crayon*, January 1858, p. 26.

2 *The Ranney Collection*, New-York Historical Society, quoted in Francis S. Grubar, *William Ranney: Painter of the Early West* (Washington, D. C.: The Corcoran Gallery of Art, 1962), pp. 43-44.

3 Most wedding scenes of this period are interiors, such as Junius Brutus Stearns' *The Marriage of Washington to Martha Custis* (1849, Virginia Museum of Fine Arts, Richmond) and Richard Caton Woodville's *The Sailor's Wedding* (1852, Walters Art Gallery, Baltimore).

4 It seems unlikely that Ranney would not have submitted a painting of the size and importance of *Virginia Wedding* to the Academy, but there is no record of exhibition for a painting of that title.

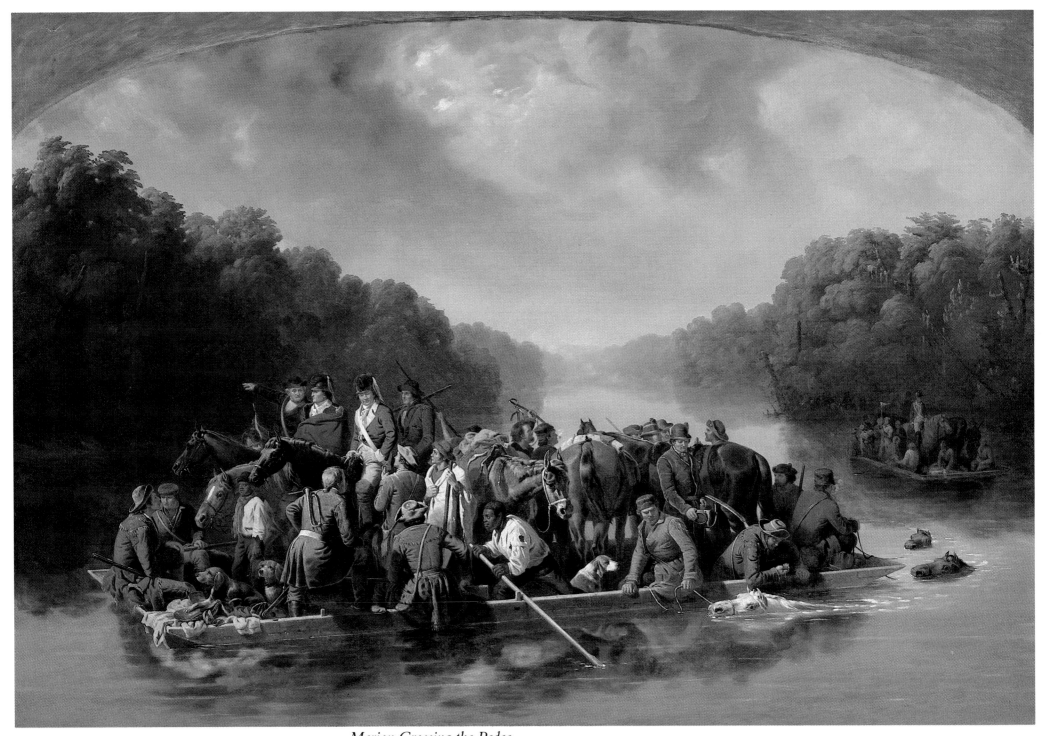

Marion Crossing the Pedee

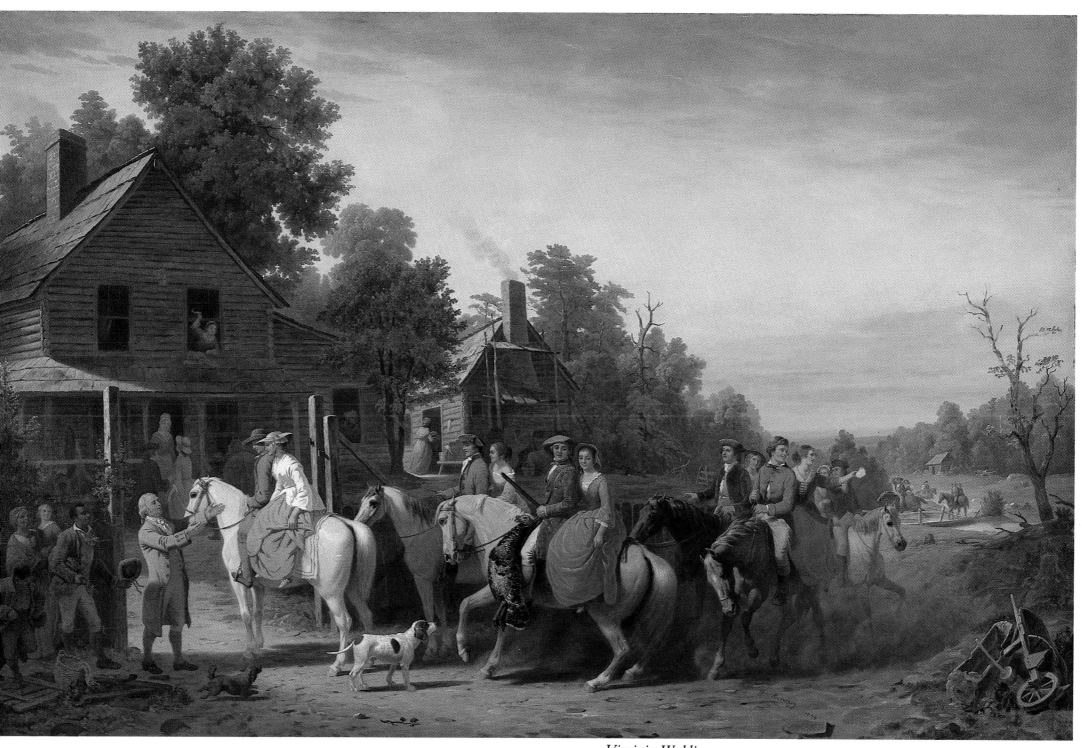

Virginia Wedding

Francis William Edmonds (1806-1863)

The Flute, c. 1859

Oil on canvas, 13 1/4 x 17 1/4 in.
(33.7 x 43.8 cm)
Inscribed l.l.: "Edmonds"
Gift of Mr. and Mrs. Louis J. Urdahl and
Mitchell A. Wilder Memorial Fund donors

1 See *The Art of Music: American Paintings & Musical Instruments, 1770-1910* (Clinton, New York: Fred L. Emerson Gallery, Hamilton College, 1984).
2 These observations were made by H. Nichols B. Clark during a lecture held at the Amon Carter Museum, 13 October 1984.
3 The painting remained undocumented from the time of its 1859 exhibition until 1976. See "New Discoveries in American Art: Long-'Lost' Edmonds Painting Found in a Private Collection," *The American Art Journal,* 13, No. 1 (Winter 1981), 90-91. For an in-depth discussion of the influence of Dutch painting on nineteenth-century American art, see H. Nichols B. Clark, *The Impact of Seventeenth-Century Dutch and Flemish Genre Painting on American Genre Painting, 1800-1865,* Diss. University of Delaware 1982 and H. Nichols B. Clark, "A Taste for the Netherlands: The Impact of Seventeenth-Century Dutch and Flemish Genre Painting on American Art 1800-1860," *The American Art Journal,* 14, No. 2 (Spring 1982), 23-38.

Music, a social phenomenon in which all classes participated, was a popular theme in nineteenth-century genre paintings.[1] *The Flute,* an undated canvas exhibited in New York in 1859, is an endearing portrayal of a young musician seated on an overturned wicker basket who performs for the entertainment of two children listening intently to his tune. The circumstances of their impromptu gathering in this outbuilding, perhaps a kitchen, are uncertain, although the stripe along the side of the youth's trousers suggests that he may be a member of one of the military bands which flourished during the period. His instrument, a one-keyed four-section flute, belongs to an earlier era, dating to the late eighteenth century.[2]

This intimate interior scene owes its overall conception to seventeenth-century Dutch genre paintings.[3] The indebtedness to Dutch prototypes is evident in the canvas's small scale, the clearly demarcated spatial organization defined by the wall paralleling the picture plane and the recessed alcove, the treatment of light which enters the room from the upper left and the rear window, and the warm tonality of the reds and browns employed by the artist. Edmonds's integration of prominent still-life elements—the assemblage in the lower right corner, as well as the other quotidian objects scattered about the room—is yet another reference to Dutch models.

Born in New York State's "Knickerbocker" country, Edmonds had a predilection for Dutch culture at an early age. As a young man, he sought to become an artist's apprentice, an attempt that was thwarted by his family's inability to finance his course of study. Instead, Edmonds became a banker, simultaneously pursuing his interest in painting by taking night classes at the National Academy of Design in New York City and submitting works for exhibition there. An eight-month trip to Europe in 1840-1841 exposed Edmonds to the work of the Old Masters and, importantly, to paintings by the Scottish artist Sir David Wilkie (1785-1841) who, like Edmonds, absorbed the tenets of seventeenth-century Dutch genre painting. In 1855, Edmonds was accused of embezzlement, a charge for which he was eventually acquitted, although he was forced to leave the banking profession. He devoted his remaining years to the New York art community.

Perhaps as a result of the charges imputing his character, Edmonds's genre paintings, which had to this time focused on incidental moments of everyday life, took on increasingly serious overtones. As a professional banker, Edmonds understood the economic and political climate of a country on the brink of war, and it may be that *The Flute* is an appraisal of contemporary social values. A casual scenario of considerable charm, *The Flute* is a reassuring statement on race relations at a troubled time.

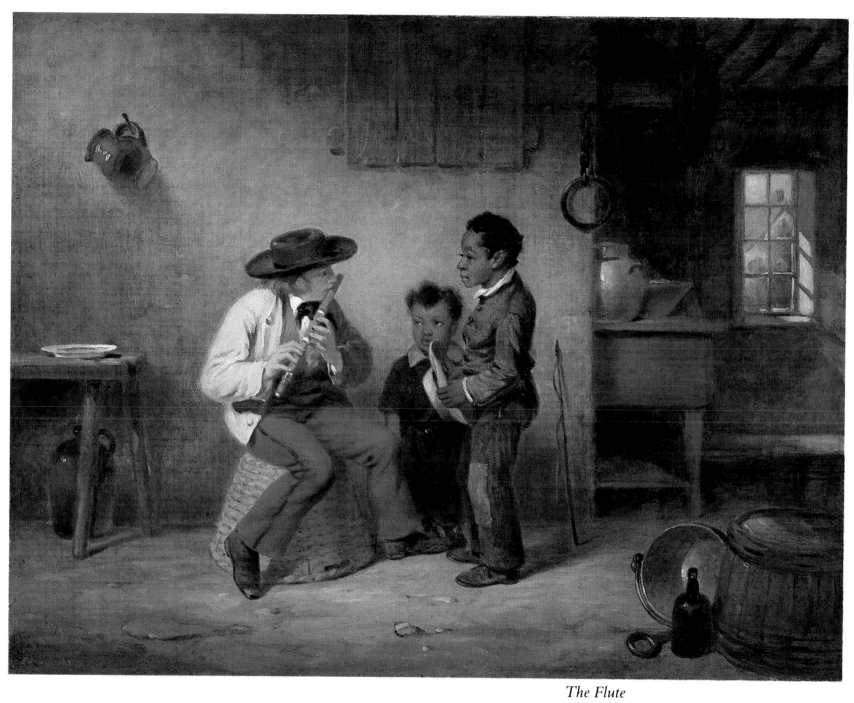

The Flute

Winslow Homer (1836-1910)

Crossing the Pasture, c. 1872

Oil on canvas, 26 1/4 x 38 1/8 in.
(66.7 x 96.8 cm)

1 According to Lloyd and Edith Goodrich, the setting is either Greene or Ulster Counties, also the site of *Snap the Whip, Entrance to Catskill Clove* (1872, private collection), and two watercolors in the collection of the Addison Gallery of American Art, Phillips Andover Academy—*The Rooster* (1875) and *Mountain Landscape* (1902). An undated letter (most likely from the early 1870s) reveals that Homer was visiting Hurley and Ellenville, a few miles south of Catskill Creek, and an illustration after Homer which appeared in *Harper's Weekly* on 14 September 1872 was captioned *Under the Falls, Catskill Mountains. Crossing the Pasture* likely depicts an actual, not composite place, as was Homer's custom. Letter from Edith Goodrich to Carol Clark, 10 May 1977, Amon Carter Museum curatorial files.

David Tatham (letter to Carol Clark, 10 October 1977, Amon Carter Museum curatorial files) believes that the painting was based on landscape sketches from several New England locations and composed to suit the artist's design needs.

2 Other works in which Homer joins two figures by a basket or a bucket include *A Basket of Clams* (1873, Arthur Altschul) and *The Cotton Pickers* (1876, Los Angeles County Museum of Art). See Michael Quick, "Homer in Virginia," *Los Angeles County Museum of Art Bulletin,* 24 (1978), 61-78. Several British and Prouts Neck works depicting pairs also share this device.

3 For information on this period in Homer's life and art, see Helen A. Cooper, "Cullercoats 1881-1882," in *Winslow Homer Watercolors* (Washington, D. C.: National Gallery of Art, 1986), pp. 92-123; William H.

Winslow Homer served an apprenticeship as a wood engraver in his native Boston before moving to New York in 1859. For the next eighteen years, he earned his living there primarily as a free-lance illustrator, notably working for *Harper's Weekly,* for whom he covered the Civil War. When he began to paint in the 1860s, his scenes usually had as their subject fashionably dressed young women at leisure and children, whom he often placed in a rural setting. At the time, he had received little formal artistic instruction.

Homer lived in the city during the 1860s and 1870s, but he spent each spring, summer, and fall in the countryside of upstate New York, New Jersey, and New England. The result of those visits was some of the finest paintings of his early career. *Crossing the Pasture* is one of the most successful of that group of paintings and serves as a pendant to *Snap the Whip* (1872, Butler Institute of American Art, Youngstown, Ohio). While the latter is an animated scene of children at play, *Crossing the Pasture* exudes an air of sober contemplation. Both are set against the same mountainous background, thought to be the Catskills (possibly around Hurley or Ellenville, New York, west of the Hudson River).[1] The sloping hills envelop the two children in a protective way, although the long switch one carries and wary expressions on the young boys' faces indicate an awareness of a possible charge by the bull in the left background. Fresh air and bright, clear light permeate the scene. The play of sunlight on areas such as the metal pail linking the two boys is deftly rendered, while the proliferation of wildflowers creates a decorative pattern across the picture plane.[2]

Children had long been seen as the hope and promise of America, but following the Civil War, many writers (such as Louisa May Alcott in *Little Women* and Mark Twain in *The Adventures of Tom Sawyer*) and artists (John George Brown and Seymour Guy) featured children as protagonists. Homer's pastoral scenes are less sentimental and anecdotal than many other genre painters' work of this period, but they can be interpreted as nostalgic views of American rural life in an era of increasing industrialization.

Crossing the Pasture was exhibited at the National Academy of Design in 1872 and likely remained in Homer's possession until his death. A charming painting of rural life, *Crossing the Pasture* served as a forerunner for Homer's renowned Houghton Farm series at the latter part of the decade, which featured children and livestock.

Winslow Homer's long sojourn in England in 1881-1882 brought about a profound change in his art that is manifested in such works as *Blyth Sands* (1882), also at the Amon Carter Museum. Homer spent twenty months in Cullercoats, a small fishing village on the Northumberland coast near Newcastle upon Tyne, whose fisherfolk—daily battling for survival against the sea—were known for their dignity, heroism, and strength of character. While there, Homer worked mainly in watercolor and in charcoal and depicted the hardy girls who followed the fishing fleets and cleaned and sold the catch brought ashore by the fishermen.[3]

While Homer remained for the most part in Cullercoats, which was also an artist's colony, the titles of his works indicate that he traveled to other coastal areas: Flamborough Head, Yarmouth, Scarboro, and Blyth (which is located twelve miles from Newcastle, where the mouth of the Blyth

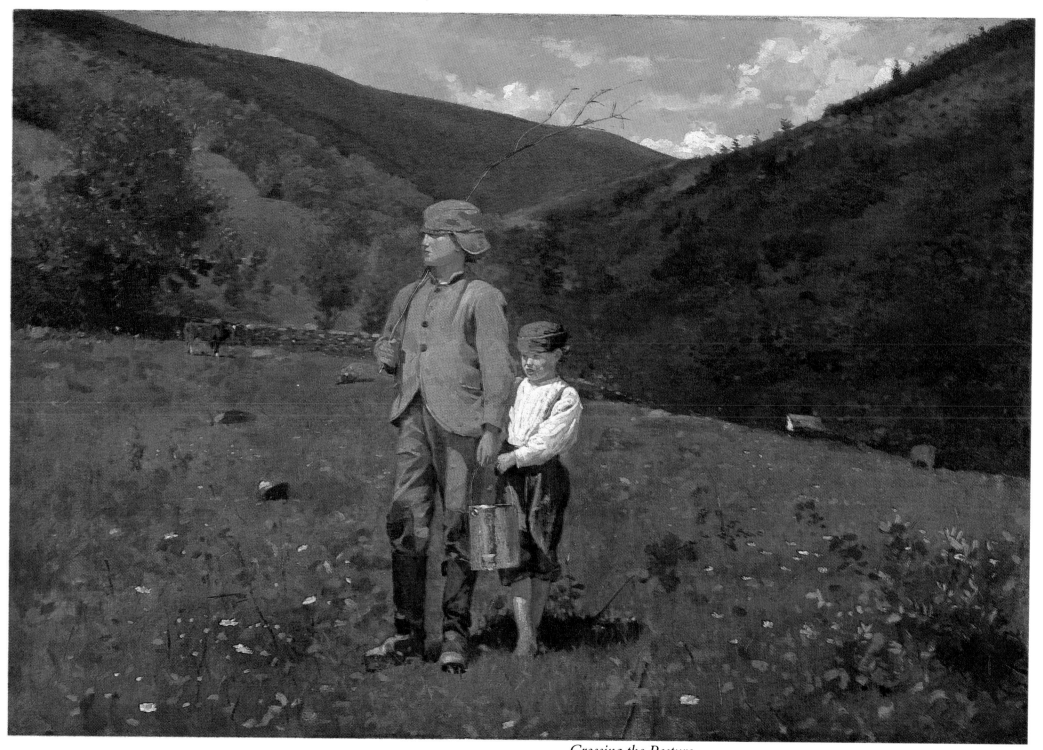

Crossing the Pasture

Gerdts, "Winslow Homer in Cullercoats," *Yale University Art Gallery Bulletin,* 36, No. 2 (Spring 1977), 18-35; and John Wilmerding, "Winslow Homer's English Period," *The American Art Journal* (November 1975), pp. 60-69.

4 Lloyd Goodrich, *Winslow Homer* (New York: The MacMillan Company, 1945), p. 79. Mary Storey, a Cullercoats woman, seen to the right in *Blyth Sands,* also appears in *Flamborough Head* (1882, Art Institute of Chicago).

River reaches the North Sea). Homer's models, however, appear repeatedly, set in various locations, perhaps indicating that Homer completed such works as *Blyth Sands* from sketches made in England after he returned to the United States.[4]

Homer's art during this period took on a greater maturity and severity than in many previous works. Instead of gaily colored scenes of elegant women at the American seashore (as seen in *Long Branch, New Jersey* [1869, Museum of Fine Arts, Boston]), *Blyth Sands* is a monochromatic depiction of working-class women who dominate the scene and somberly contemplate the return of their loved ones from the sea. These figures (paired as in *Crossing the Pasture*), despite their sturdy physiques and unfashionable dress, reveal a natural grace in their pose and rhythmic movement. Their masses are carefully balanced by the churning wave, ship, and land mass in the distance.

The heavy gray atmosphere of the English coast is palpable in this large-scale work on paper, which has the presence of a painting. Homer's technical abilities are evident, in the deft way he uses the raw tan paper to create the sand and sky, in his use of forms to produce a balanced and harmonious composition, and in his contrast of media—from delicate pencil lines to vigorous strokes of charcoal and painterly opaque highlights of Chinese white or gouache.

Following his return to the United States in the fall of 1882, Homer settled in the remote village of Prouts Neck, Maine, where he continued to paint nature's awesome forces and man's struggle for survival.

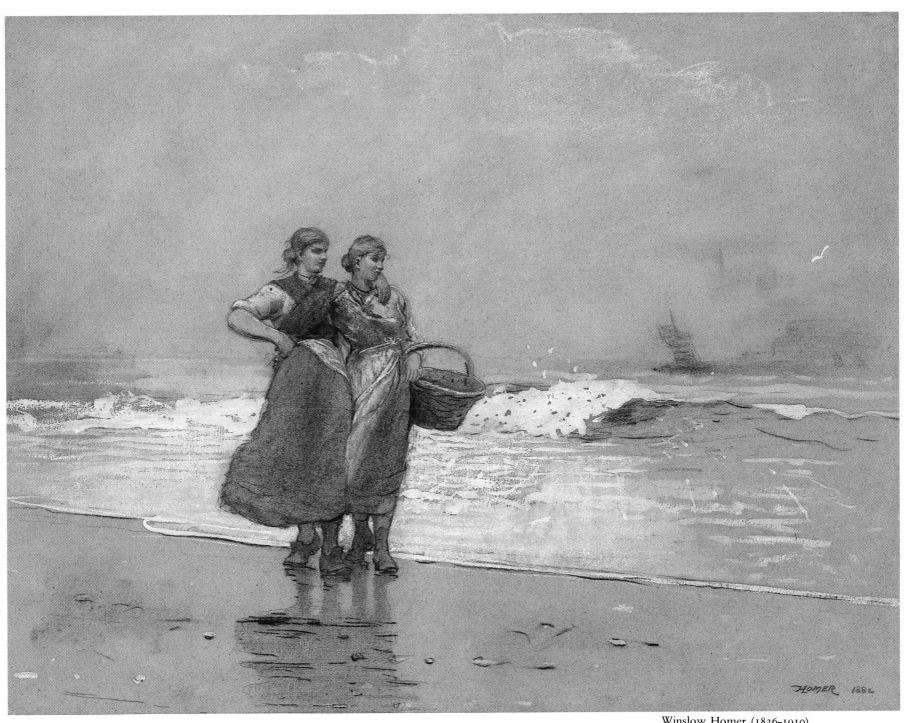

Winslow Homer (1836–1910)
Blyth Sands, 1882
Charcoal, brown chalk, graphite, and white
gouache on gray paper,
17 x 22 5/8 in.
(43.2 x 57.5 cm)
Inscribed l.r.: "HOMER 1882"

43

Eastman Johnson (1824-1906)

Bo-Peep, 1872

*Oil on composition board mounted on panel,
22 1/8 x 26 1/2 in. (56.2 x 67.3 cm)
Inscribed l.l.: "E. Johnson 1872"*

1 Patricia Hills, *The Painter's America:
Rural and Urban Life, 1810-1910* (New York:
Praeger Publishers, 1974), p. 74.

2 Patricia Hills, *Eastman Johnson* (New
York: Clarkson N. Potter, Inc., 1972), p. 76.
Hills calls attention to the fact that Johnson's
own daughter, Ethel, would have been about
the same age as the child in the painting when
it was finished.

3 For a discussion of another version of the
painting, see Linda Ayres, "The American
Figure: Genre Paintings and Sculpture," in
John Wilmerding, Linda Ayres, and Earl
Powell, *An American Perspective: Nineteenth-
Century Art from the collection of Jo Ann and
Julian Ganz, Jr.* (Washington, D. C.: National
Gallery of Art, 1981), pp. 51-52.

4 "Art: Composition Pictures at the Acad-
emy," *Appleton's Journal*, 11 (16 May 1874),
636. An oil study is owned by Cornelia and
Meredith Long of Houston, while the other
completed painting is in the collection of Jo
Ann and Julian Ganz, Jr., Los Angeles.

5 Patricia Hills agrees that the Carter Mu-
seum version is the first one and points out
that Eastman Johnson is known to have made
copies of his work on commission. Patricia
Hills, conversation with Carol Clark, 7 April
1980, recorded in the Amon Carter Museum
curatorial file.

An interesting comparison to Winslow Homer's *Crossing the Pasture* is *Bo-Peep* by Eastman Johnson, another major genre painter of the nineteenth century. Like Homer, Johnson was a New Englander (born in Maine) who trained as a lithographer in Boston (presumably also at Bufford's). After six years of study in Europe (in Düsseldorf, The Hague, and Paris), Johnson returned to America, where he and Homer maintained studios in the same building in New York City in the 1860s and early 1870s.

Although Johnson's major output was portraiture, he is perhaps best remembered for his genre paintings dating from the mid-1850s to the mid-1880s: scenes of cornhusking, cranberry picking, and maple sugaring; the Civil War; American Indians; and, in the 1870s, intimate interiors depicting women and children. Johnson's marriage in the early years of that decade may have inspired the domestic scenes, but they are also typical of the post-Civil War years in American art. One such scene, *Bo-Peep*, depicts the dark interior of a refined nineteenth-century home with all the trappings of middle-class life. The painting reflects Victorian culture, with its emphasis on material possessions and also on the importance of children and the virtues of home life.[1]

Bo-Peep features a mother, interrupted from reading by her young child who wants to play the Elizabethan game "bo-peep" (which we know as peekaboo). The figures, placed in the center of the canvas, form a strong triangular shape, the apex of which is the head of the golden-haired girl, strongly lit by an unseen window to the right. The light serves not only a structural function but a symbolic one as well.[2] Indeed, this tender scene of maternal affection takes on religious overtones with the halo effect around the child's head, the outline of a cross on the shutters behind, and the Bible prominently placed on the prie-dieu to the right.[3]

Johnson's debt to European artists (specifically to those in Holland and Düsseldorf) is evident throughout the painting, from the everyday domestic subject matter, rendered in muted colors, to the dramatic lighting that highlights not only the child but the mahogany secretary with its brass drawer pulls and the mother's jewelry. A consummate draftsman, the artist employs a variety of brushstrokes: fine, wispy lines that create the little girl's hair, smooth strokes on the wooden furniture, and painterly patches of impasto on the papers at the left.

Eastman Johnson created one other version of this painting, and it is difficult to ascertain which completed work, when exhibited in New York in 1874, elicited this response from a writer for *Appleton's Journal:* " 'Bo-Peep,' is a most graceful and spirited painting of a child, who has bound a handkerchief round her mother's eyes, the child full of life and laughter, and the mother so sweet and tender as to recall one's pleasantest impressions of such situations and such a relation."[4]

Since the Amon Carter Museum painting is slightly larger than the other finished painting and contains a pentimento (the artist altered the size and shape of the delftware pot), it is believed that the Museum's *Bo-Peep* is, indeed, the first version that Johnson created.[5]

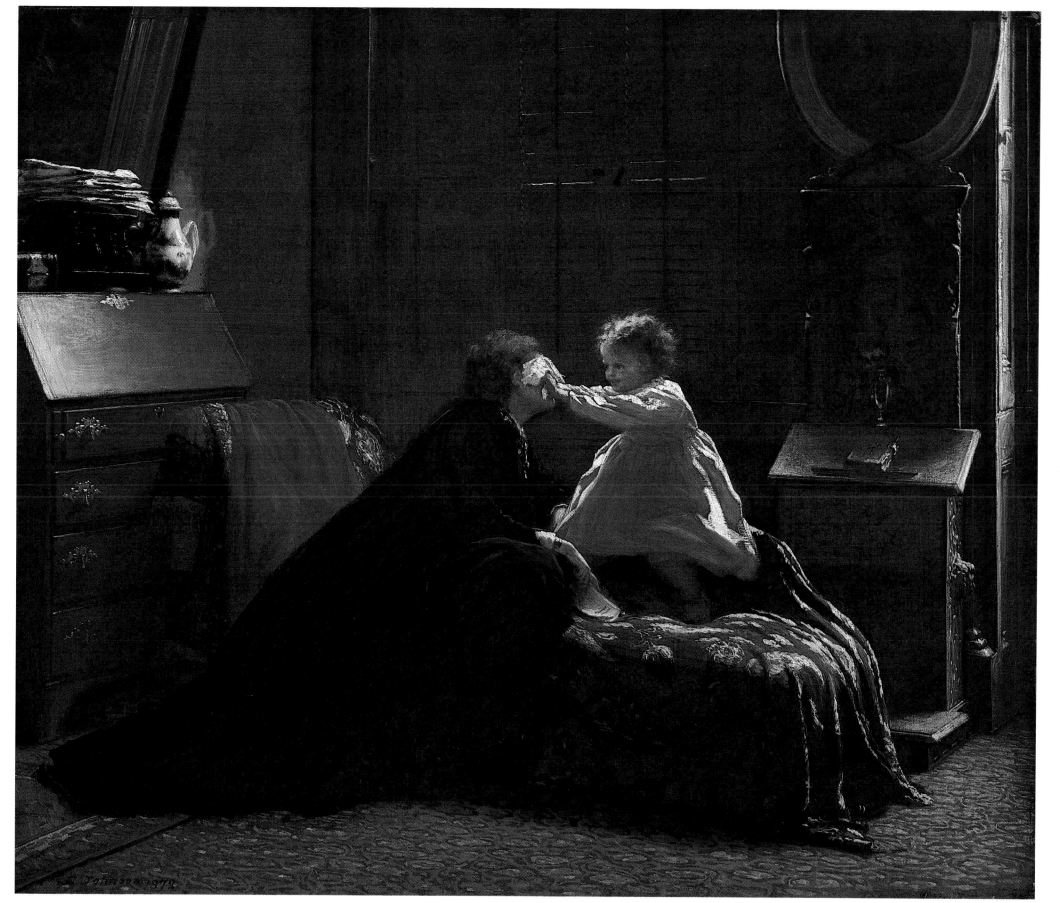

Bo-Peep

William Michael Harnett (1848-1892)

Attention, Company!, 1878

Oil on canvas, 36 x 28 in. (91.4 x 71.1 cm)
Inscribed u.l.:
"WMH[monogram]ARNETT/1878."

1 Prior to the discovery of this inscription, which is no longer visible, the painting had been identified as Harnett's lost work entitled *Front Face*. See Alfred Frankenstein, "Harnett's *Front Face*," *Auction*, November 1970, pp. 48, 51.
2 The sign directly behind the figure of the boy appears to include the words "Grand Excursion." Alfred Frankenstein, *After the Hunt: William Michael Harnett and Other American Still Life Painters, 1870-1900*, 2nd ed. (1953; rpt. Berkeley, Los Angeles, and London: University of California Press, 1969), p. 47.
3 This body of pencil sketches is described in Frankenstein, *After the Hunt*, pp. 33-34.

William Michael Harnett earned renown in the last quarter of the nineteenth century for his still-life evocations of the prosperous middle class. A contrast in both subject matter and spirit is *Attention, Company!*, one of the artist's rare figural works. The painting is a sympathetic portrait of a Philadelphia street urchin posed against a wall displaying the graffiti of his urban environment.

The Irish-born Harnett spent his own childhood in Philadelphia where his family had immigrated around 1849. His formal art training commenced at age nineteen when he enrolled at the Pennsylvania Academy of the Fine Arts, and it continued in New York, where he moved in 1869. In New York, Harnett supported himself by working as an engraver (a trade he had learned in Philadelphia), while attending classes at the National Academy of Design and the Cooper Union. In the mid-1870s, Harnett embarked on his hallmark still-life style, executing tabletop arrangements of commonplace objects—pipes, mugs, newspapers, books, and musical instruments. He submitted these paintings to academy exhibitions in New York and in Philadelphia, where he returned in 1876.

By 1878, the date of *Attention, Company!*, Harnett was adept at both portraiture and still-life painting, as evidenced by his skillful rendering of the young boy and trompe l'oeil backdrop. The title of the work, taken from an inscription on the reverse of the canvas, alludes to the boy's imaginary game of soldier for which he has fashioned a hat out of the *Philadelphia Ledger* (inscribed with the date 1878) and appropriated a broomstick or mop handle as his rifle.[1] His jaunty hat of crisply folded newspaper held together with a shiny pin and adorned with pink and green paper plumes belies the boy's mean circumstances. The child's vest has been hastily repaired with a mismatched button, and his jacket is torn. The boy's demeanor—his drooped shoulders and his distant and preoccupied gaze—suggests that he is posing against his will, heightening the emotional distance between the subject and the viewer.

The wooden wall backdrop afforded the young Harnett an opportunity to exhibit his skills at rendering a two-dimensional surface with verisimilitude. Reminiscent of childhood pranks are the torn signs with paint built up along the edges to simulate curling paper, the smudged fingerprints, and the chalk and crudely carved inscriptions which remain enigmatically incomplete.[2]

Although Harnett did not continue to paint genre subjects, the artist's curiosity about the people inhabiting his environment is confirmed by his sketchbooks which contain drawings of figures engaged in everyday activities.[3] Harnett's selection of a black child as his subject may have been influenced by the artist's contemporaries, Winslow Homer and fellow Philadelphian Thomas Eakins, both of whom represented blacks in a variety of genre scenarios during the 1870s.

Like Homer and Eakins, Harnett's treatment of his subject was free of anecdotal overtones, and his honest and confrontational portrayal of the boy sets the painting apart from the large body of sentimentalized genre scenes of children popular in the mid- to late nineteenth century. The nearly flat backdrop with trompe l'oeil elements sets a realistic stage for a serious appraisal of the young boy and anticipates both Harnett's renderings of inanimate objects and, especially, the rack paintings of John Frederick Peto.

Ease, 1887

In 1887, James T. Abbe, a Holyoke, Massachusetts, paper manufacturer, commissioned William Michael Harnett to paint the monumental still life, *Ease*. Executed in one of Harnett's last productive years (the artist died in 1892 at age 44), the work represented a major commission for the artist and is one of his largest canvases. Upon its completion, the painting hung in Abbe's office for only a short time before it was sold to Collis P. Huntington, the California railroad magnate. Subsequently lost for over fifty years, *Ease* was discovered in a California private collection in 1971.[1]

Ease dates to the period following Harnett's extended stay abroad in the early 1880s, when he lived and worked in London and Frankfurt and spent four years in Munich. In Europe, the artist had expanded upon the tabletop format of his earlier still-life renderings. Exposure to the Old Masters inspired Harnett to undertake more ambitious compositions, characterized by dark tonalities and strong chiaroscuro effects. The velvet drapery and ornamental rug table covering of *Ease* were traditional elements that Harnett began to incorporate in his paintings under the sway of European examples. These bric-a-brac paintings appealed to the artist's European clientele and later, following his return to New York in 1886, to Harnett's American patrons, many of whom collected the seventeenth-century Dutch masters emulated by the artist.[2]

Harnett imparts a tactile quality to his subject by rendering the objects in a hard-edged style, firmly fixing them in a three-dimensional space. Although Harnett does not render all the details with precision (the newspaper print, for example, is a blur of indistinct characters), he adroitly conveys the appearance of legibility. Heightening the sense of immediacy is the mysteriously implied presence of the patron himself, whose smoldering cigar lying on the edge of the table has already burned a hole in the newspaper. In a subtle reference to Abbe's place of residence and his occupation as a manufacturer of envelopes, Harnett inscribes the blue and white envelopes in the foreground with a Holyoke, Massachusetts, postmark and the date of the painting, 1887. Also identifiable are some of the well-used books whose titles, Scott's *Poetical Works*, Homer's *Iliad*, and Bryant's *Popular History of the United States, Vol. 1,* attest to Abbe's eclectic literary tastes.

Carefully chosen to convey the refinement of a Victorian gentleman, the artifacts serve as a composite portrait of their owner. The repoussé vase and ewer, which represent classical and biblical subjects, recall Harnett's early training as a metal engraver and further describe Abbe's broad education. The flute with cracked ivory mouthpiece, violin, and stained sheet music were specific props favored by Harnett and reflect a love of music that may be as attributable to the artist as to the patron. Thus, autobiographical as well as biographical elements commingle in this elegant metaphor of learning and the pleasures of contemplation.

Oil on canvas, 48 x 52 3/4 in.
(121.9 x 134 cm)
Inscribed verso l.c.: "Painted to order/by/W<u>m</u>. M. Harnett./<u>1887</u>./Studio. 28 E. 14<u>th</u> St/<u>New</u> <u>York</u>."

1 Prior to its reemergence, the work was known through a lengthy newspaper description (*Springfield Daily Republican,* 7 November 1887) and a photograph discovered by art historian Alfred Frankenstein in the possession of the artist John Haberle. The year after the completion of *Ease,* at Abbe's request, Haberle painted *Grandma's Hearthstone* (The Detroit Institute of Arts), a life-size mantelpiece adorned with family heirlooms. The two works commissioned by Abbe are discussed in Jane Marlin, "John Haberle, A Remarkable Contemporaneous Painter in Detail," *The Illustrated American,* 30 December 1898, pp. 516-517. When the painting reappeared in 1971, it had been cut down from the original on all four sides, leaving the central composition intact.
2 William H. Gerdts, *Painters of the Humble Truth: Masterpieces of American Still Life 1801-1939* (Columbia and London: University of Missouri Press, 1981), p. 158.

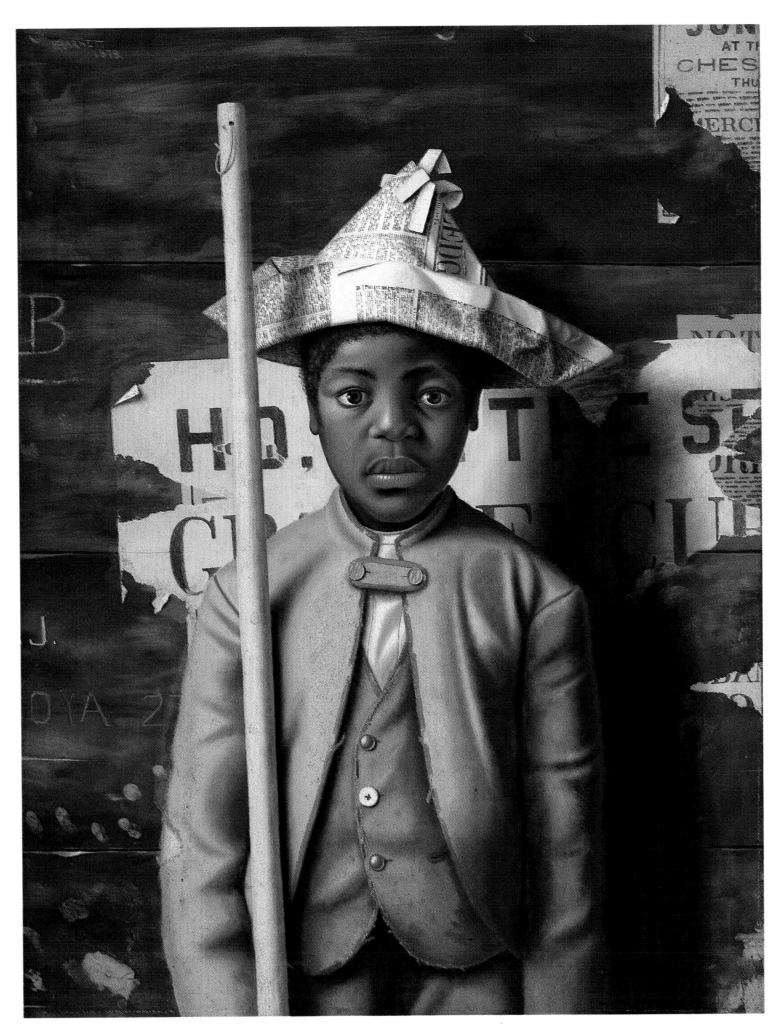

Attention, Company!

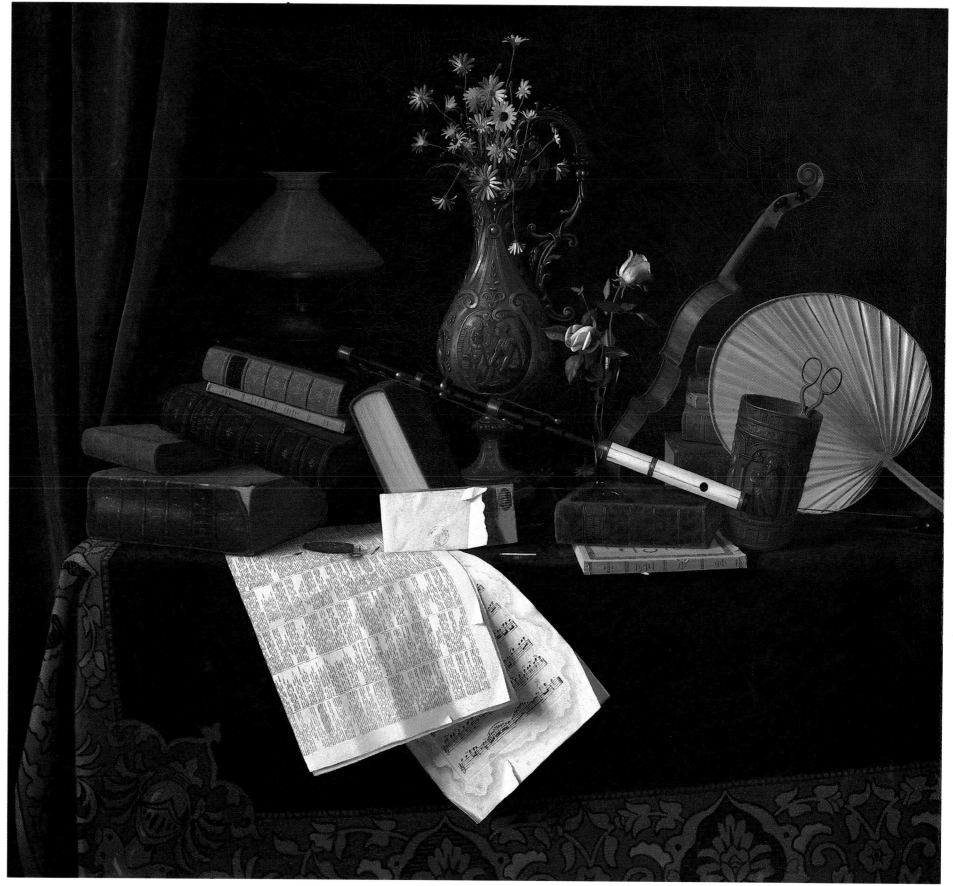

Ease

Severin Roesen (1815 or 1816 – after 1872)

Abundance, after 1848

Oil on canvas, 35 3/8 x 49 1/4 in.
(89.9 x 125.1 cm)
Inscribed l.r.: "SR[monogram]oesen."

1 *Fruit and Flower Still Life* (private collection, State College, Pennsylvania). See Judith H. O'Toole, "New Discoveries in American Art: Search of 1860 Census Reveals Biographical Information on Severin Roesen," *The American Art Journal,* 16, No. 2 (Spring 1984), 90-91.
2 In the nineteenth century, most of Roesen's paintings carried generic titles. *Abundance* is likely a modern designation.
3 William H. Gerdts, *Painters of the Humble Truth: Masterpieces of American Still Life 1801-1939* (Columbia and London: University of Missouri Press, 1981), p. 87.

Severin Roesen, one of the most accomplished and prolific still-life artists of the nineteenth century, immigrated to the United States from Germany following the revolutions of 1848. Establishing residence in New York City, Roesen began painting elaborate and lush fruit and floral still lifes which he exhibited at the American Art-Union. Some years later, Roesen left his family, eventually settling in the north central Pennsylvania community of Williamsport. Although neither his birth date nor his death date is known, one of his few dated canvases, inscribed "1872," indicates that Roesen lived into the 1870s.[1]

Like other nineteenth-century artists, Roesen selected as his subject the bountiful resources of America, a view conveyed in contemporaneous landscape paintings which exuberantly captured the country's varied topography. The products of America's fertility are arranged in Roesen's *Abundance* on a richly veined, double-tiered tabletop.[2] Drawing upon German and Dutch prototypes, an array of fruits exhibited from different aspects fills the canvas. Emphasizing the organic quality of the fruit, moist with droplets of water, the artist depicts three varieties of both plums and grapes, strawberries, peaches, blackberries, apples, and pears (one ripe, one green), a pineapple, a cantaloupe, an orange, and a lemon. As if to underscore the proximity of this arrangement to a natural setting, three insects—a ladybug, a bee, and a fly—have been inserted into the composition, and a small nest holding three eggs rests among the profusion of fruit and leaves. The champagne bubbles rise effervescently to the top of the glass flute. Tempering the freshness of the scene, however, is the deteriorating state of the watermelon and strawberries, alluding to the passage of time. The entire ensemble is framed by broad grape leaves and serpentine tendrils, which, in the lower right corner, form the artist's signature.

Roesen repeated stock motifs in as many as three to four hundred paintings. This reappearance of certain groupings suggests that the artist used templates or prints as compositional aids.[3] As a result of Roesen's repetitive method, fruits and flowers that are grown in different seasons coexist in his still lifes. In contrast to his contemporary Martin Johnson Heade, Roesen chose not to dwell on the individual botanical character of his subjects, creating instead a glorious and abundant whole.

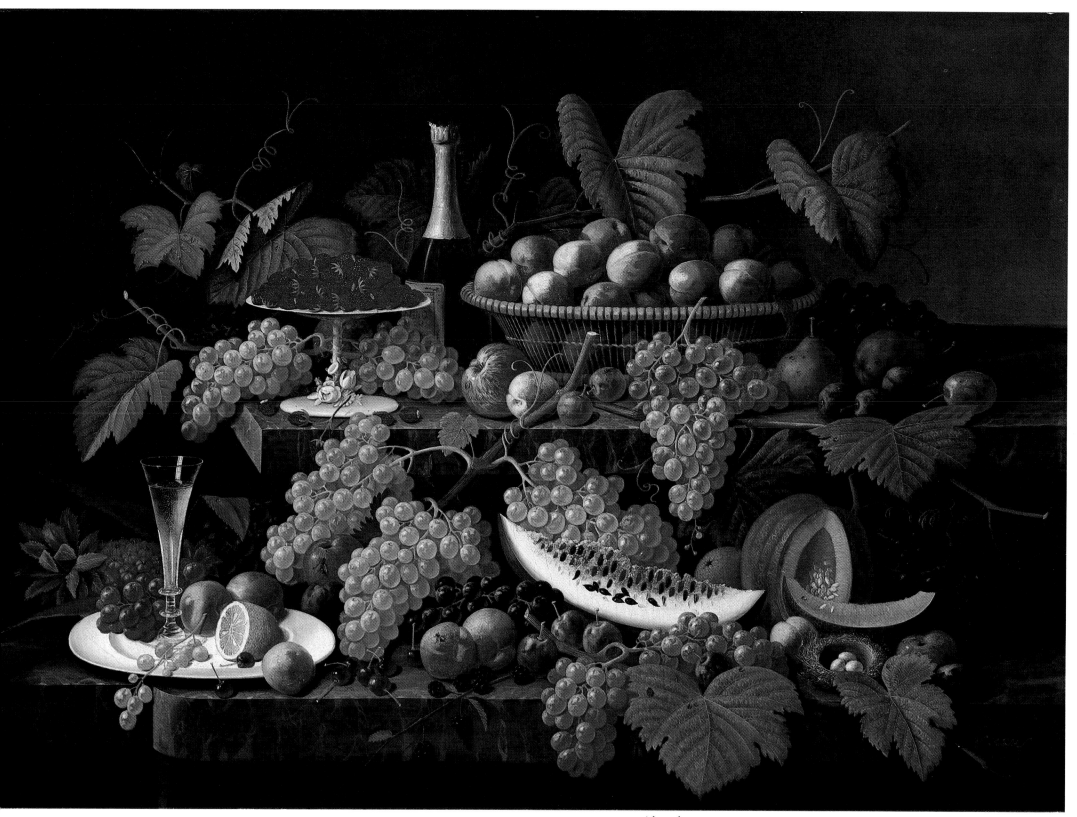

Abundance

John Haberle (1853-1933)

Can You Break a Five?, c. 1888

Oil on canvas mounted on board,
7 3/8 x 11 1/4 in. (18.7 x 28.6 cm)

1 After Harnett was arrested on counter-feit charges, he apparently stopped painting currency. See Alfred Frankenstein, *After the Hunt : William Harnett and Other American Still Life Painters, 1870-1900,* 2nd ed. (1953; rpt. Berkeley, Los Angeles, and London: University of California Press, 1969), pp. 56, 82-83. Haberle was warned to cease representing United States currency in his paintings (Frankenstein, p. 117).

*C*an You Break a Five? is a deceptively simple rendering of ordinary articles—two postage stamps (one canceled), a dilapidated five dollar bill covering fragments of a one dollar bill, a newspaper clipping, and a pair of spectacles hanging by a piece of string—all "attached" to a painted wooden panel. Popular in the late nineteenth century, trompe l'oeil paintings afforded John Haberle and other still-life artists the opportunity to portray ubiquitous items, such as currency, in their true size and color. By de-emphasizing the brushwork, the artist could "fool the eye" of the observer, making him believe that he was viewing an actual object rather than paint on canvas. A masterpiece of illusionistic painting, *Can You Break a Five?* reveals the clever wit of Haberle which distinguishes him from other still-life artists of his era.

Haberle spent most of his life in his birthplace, New Haven, Connecticut. His early occupations undoubtedly helped to prepare him for his career as an artist. Working for a lithography and engraving firm, he developed the meticulous drawing technique which he would later use to advantage in his paintings of currency. Through his position as an assistant to Othniel Charles Marsh, a famous paleontologist at Yale University, Haberle gained an understanding of the underlying structure of natural forms. He also studied at the National Academy of Design in New York in 1884 and taught drawing at the New Haven Sketch Club. Representations of paper bills, a favorite subject, were produced by Haberle for only a few years, from about 1886 to 1890. It was about that time that failing eyesight began gradually to curtail Haberle's ability to continue his exacting techniques.

Can You Break a Five?, exhibited at the Pennsylvania Academy of the Fine Arts in 1889, represents the artist at the apogee of his illusionistic skills. The artist himself calls attention to his talents by the inclusion of a newspaper clipping describing a lost painting, *Imitation,* exhibited by Haberle at the National Academy of Design in 1887. The clipping reappears in several of the artist's works and asserts that *Imitation,* "one of those clever pieces of artistic mechanism showing an old greenback and other objects," was painted "entirely with a brush and the naked eye." The clipping, a playful reflection of his representational abilities, is the only place Haberle's name appears in the Amon Carter Museum's painting.

In spite of the fact that William Michael Harnett's portrayals of money had run him afoul of the law in 1886, Haberle accelerated his production of currency paintings at that time.[1] Alluding to his defiance of authority, the portion of the one dollar bill that the artist reveals in *Can You Break a Five?* contains a stern warning against forgeries.

In addition to the painted inscriptions he integrated into his work, Haberle engages the viewer through other, even more subtle means. The title, *Can You Break a Five?*, is a double entendre referring both to making change and to the fact that the five dollar bill is clearly already tattered and "broken." Trompe l'oeil details enhance the deception, and the glass spectacles which magnify a small section of newspaper type are provided for the spectator requiring assistance in his assessment of the deception. The postage stamps, built up slightly with applications of gesso so that they protrude from the surface of the painting, appear to be glued onto the panel.

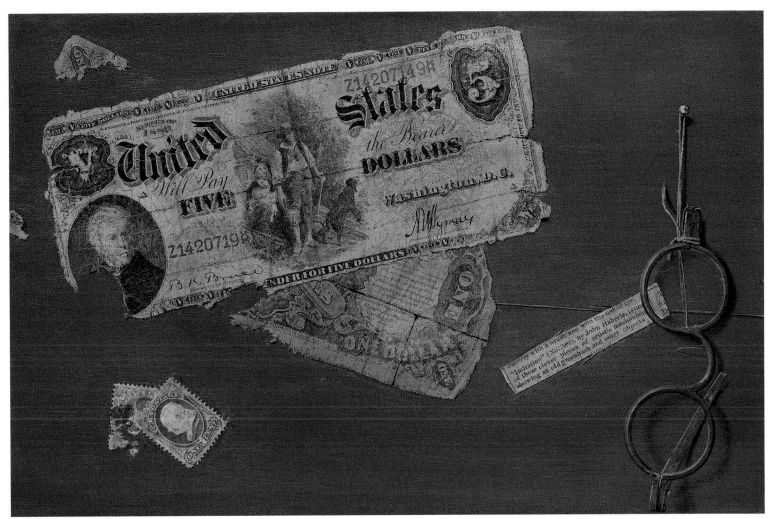

Can You Break a Five?

53

De Scott Evans (pseudonym S. S. David) (1847-1898)

Free Sample/Try One, 1887/1898

Oil on canvas, 12 1/4 x 10 1/8 in.
(31.3 x 25.7 cm)
Inscribed l.r.: "S. S. David"
u.l.: "Free Sample/Try One"

1 Listings in the 1859 New York City business directory and the National Academy of Design exhibition records for an "S. S. David" leave open the possibility that an artist by that name, distinct from De Scott Evans, could have been responsible for the series of trompe l'oeil still lifes signed with variations on "S. S. David." Current research indicates, however, that Evans had a chameleonlike ability to emulate other artists and issued paintings in a variety of styles. See Nannette V. Maciejunes, *A New Variety, Try One: De Scott Evans or S. S. David* (Columbus, Ohio: Columbus Museum of Art, 1985), pp. 11-12.

2 In tandem with his still lifes, Evans continued his academic and decorative subjects. Evans died in a shipwreck in 1898 while en route to Paris to execute a ceiling decoration.

John Haberle and John Frederick Peto were among a growing number of artists in post–Civil War America who painted still lifes featuring nuts. In the 1880s, under a variety of pseudonyms, the artist De Scott Evans painted as many as eighteen small trompe l'oeil canvases of peanuts or almonds. *Free Sample/Try One* exemplifies Evans's favorite format which depended upon the illusion that the painting itself was a three-dimensional object, a deception the artist created by leaving the canvas exposed on all four sides of the stretcher. This "block of wood" in which a shallow recess has been "carved" is scored on two sides as if the wood were freshly cut, and the top edge is painted in a darker tone to simulate the appearance of dirt accumulation. The employment of the S. S. David signature, which is found on similar nut paintings, is another form of game playing on the part of the artist. Its precise significance remains a mystery.

Evans's body of about twenty still-life paintings is distinct from his other artistic pursuits, genre and portrait painting.[1] Born David Scott Evans, the Indiana native opened a studio in Cleveland in 1874. A few years later he spent a year in Paris, where he studied with William Bouguereau, a leading French academician widely admired in the United States. Evans was schooled in the allegorical subject matter and sleek, representational style for which Bouguereau was known. In 1878, Evans returned to Cleveland, changed his name to De Scott Evans, joined the faculty of the Cleveland Academy of Fine Arts, and continued to produce genre scenes and portraits. It was not until he moved to New York in 1887 that Evans undertook depictions of nuts and suspended fruit against backdrops painted to simulate wood grain.[2]

In *Free Sample/Try One,* the artist employs a number of pictorial tricks to fool the spectator into accepting the "reality" of this modest vignette. The wood panel is splintered and discolored. The misshapen nails which seem to protrude from the painted surface precariously secure the shattered glass, a European conceit demonstrating the artist's skills at illusion. By subtly varying the paint, Evans imparts a cloudy appearance to those areas covered by the fragmented glass. Surmounting this carefully conceived deception, a stained card in the upper left corner invites the spectator to accept a "free sample"—a captivating and, ultimately, unfulfillable challenge.

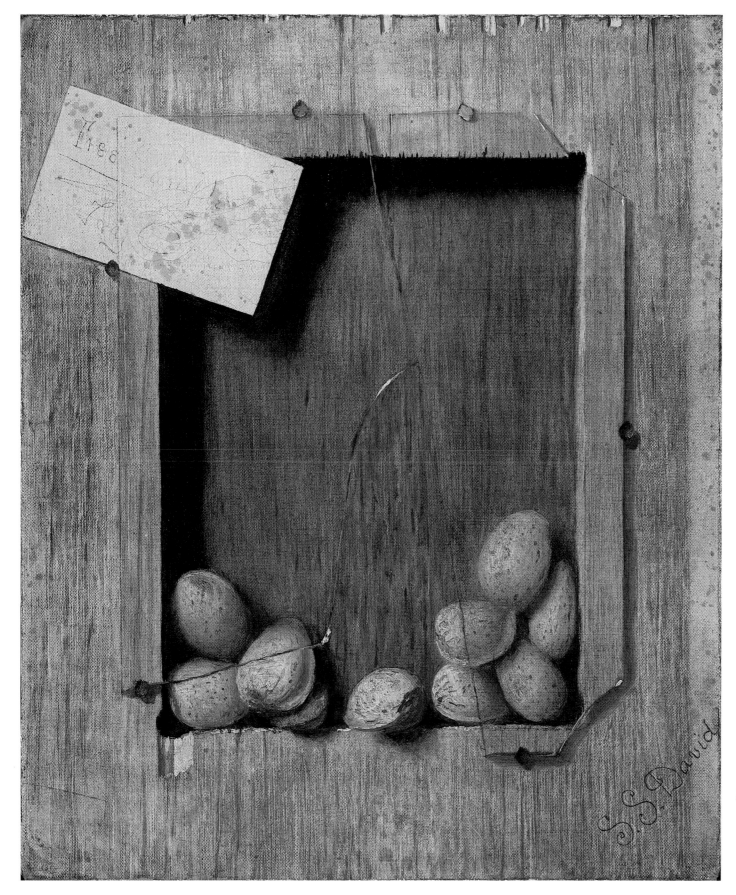

Free Sample/Try One

55

William J. McCloskey (1859–1941)

Wrapped Oranges, 1889

Oil on canvas, 12 x 16 in. (30.5 x 40.6 cm)
Inscribed l.r.: "W. J. McCLOSKEY N.Y. 1889
COPYRIGHT"
Acquisition in memory of Katrine Deakins,
Trustee, Amon Carter Museum, 1961–1985

1 Nancy Dustin Wall Moure, *Dictionary of*
Art and Artists in Southern California before 1930
(Los Angeles: privately printed, 1975), p. 157.
2 William H. Gerdts and Russell Burke,
American Still-Life Painting (New York,
Washington, and London: Praeger Publishers,
1971), pp. 166, 167.

Although biographical information on William McCloskey is scant, it is known that he was a young student at the Pennsylvania Academy of the Fine Arts in the late 1870s during the tenures of two influential instructors in the Philadelphia art community, Christian Schussele and Thomas Eakins. Schussele and Eakins were responsible for instituting still-life classes at the Academy in order to encourage students to sharpen their skills in modeling, light, and texture. McCloskey's adaptation of the theories he gleaned as a student, combined with another Philadelphia legacy—the elegant and simple still lifes of the Peale family—magnificently coalesce in *Wrapped Oranges,* a painting of richly colored fruit wrapped in delicate folds of crisp tissue paper.

Eakins's dictum to master problems of modeling and color through a study of simple still lifes and his use of dramatic light and dark transitions are reflected in the perfectly rounded forms of the citrus fruit set against the deep Prussian-blue velvet backdrop. McCloskey emphasizes the contrast between the cool tonalities of the oranges where they are covered by the tissue paper and the bright, exposed fruit. He skillfully mirrors this ensemble in the highly polished surface of the mahogany table on which the oranges rest.

Details of McCloskey's life remain incomplete owing, in part, to the fact that he rarely stayed in one location for a long period of time. In 1883, McCloskey was in Denver, where he married fellow artist Alberta Binford, a student of William Merritt Chase.[1] City directories, however, indicate that he also lived in Philadelphia in the early 1880s. In 1889, the artist was in New York, where he painted *Wrapped Oranges.* McCloskey and his wife lived at various times in England, Paris, Salt Lake City, San Francisco, and Los Angeles. The couple eventually separated. For about the last twenty years of his life, McCloskey was a moderately successful portrait painter in southern California and Oregon.

Only in recent years has McCloskey been recognized for his wrapped-citrus paintings. In addition to his paintings of oranges, he also depicted lemons wrapped in pastel tissue paper. Like other late nineteenth-century artists, McCloskey took advantage of the increasing accessibility of citrus fruit (probably owing to growth in the industry and advances in transportation systems) and featured them in his simple, yet masterful, still lifes.[2]

56

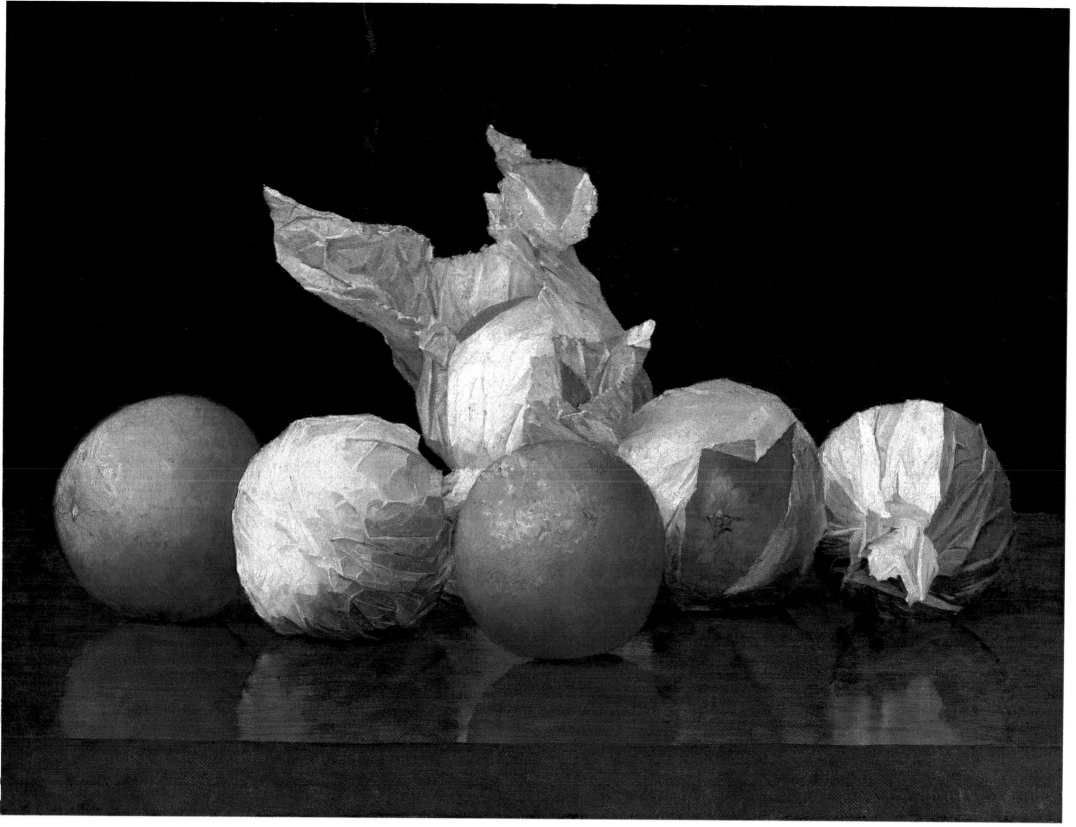

Wrapped Oranges

John Frederick Peto (1854-1907)

Lamps of Other Days, c. 1900

Oil on canvas, 27 1/8 x 36 in.
(68.9 x 91.4 cm)

1 John Wilmerding, *Important Information Inside: The Art of John F. Peto and the Idea of Still-Life Painting in Nineteenth-Century America* (Washington, D. C.: National Gallery of Art, 1983), p. 25.

For a few years in the late 1870s when the two artists maintained studios in Philadelphia, the artistic development of John Frederick Peto was intertwined with that of the preeminent still-life painter of the period, William Michael Harnett. Peto, a Philadelphia native, studied at the Pennsylvania Academy of the Fine Arts and participated in their annual exhibitions. Unlike the well-traveled Harnett, however, he was never active in the mainstream artistic community and in 1889, Peto moved with his family to the shore community of Island Heights, New Jersey. There Peto executed still lifes in his home, which also served as his studio, and earned local renown as a professional cornet player at camp meetings. In this relatively isolated environment, Peto painted well-worn, commonplace objects in the tabletop format of Harnett, or he painted vertical canvases of objects which appeared to be affixed to wooden panels. The artist remained in Island Heights most of his life, giving away or selling many of his paintings to neighbors and summer residents.

Peto's distinctive style can be seen in *Lamps of Other Days,* a thematic cluster of old lighting devices and a single dilapidated book stuffed with papers. The discarded lanterns, candlesticks, and oil lamps, obsolete by the turn of the century when the painting was executed, have been eloquently resurrected by Peto. The artist's repetition of familiar imagery, devoid of apparent extraneous connotations, adds a personal dimension to these ordinary, dented, rusted, and tallow-encrusted objects. Setting Peto apart from those who sought a true trompe l'oeil effect, including artists De Scott Evans and John Haberle, is Peto's softly focused, imprecise style whereby he eschews clarity and detail in favor of an overall diffusion of light which selectively picks out the metallic highlights of tin, brass, and pewter.

The dense concentration of objects rendered in a limited palette and set within a dark green, shallow recess is enlivened by the variety of curious forms jutting out at wildly pitched angles. On the left side of the canvas, a lantern and tin sconce precariously defy gravity, and the candlestick and lantern dangling from the bottom of the shelf appear, like the newspaper in Harnett's *Ease,* to enter into the spectator's space. These stalwart symbols of Peto's very personal vision also carry traditional connotations of decay and mortality and are climaxed by the conical-shaped lantern with its door ajar which serves as the focal point of the composition. As the forms recede on either side, they become indistinct, hinting at the artist's diminishing energy, perhaps owing to his affliction late in life with Bright's disease.[1]

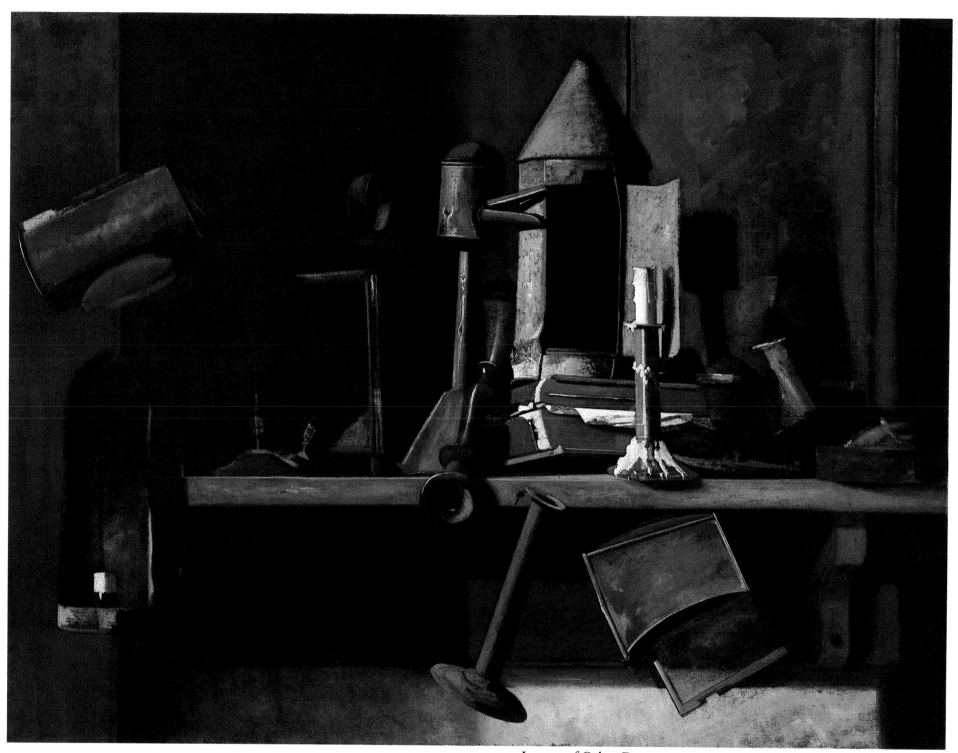

Lamps of Other Days

John Frederick Peto (1854–1907)

A Closet Door, 1904/1906

Oil on canvas, 40 1/4 x 30 1/8 in.
(102.2 x 76.5 cm)

1 John Wilmerding, *Important Information Inside: The Art of John F. Peto and the Idea of Still-Life Painting in Nineteenth-Century America* (Washington, D. C.: National Gallery of Art, 1983), p. 209.
2 See Samuel Lewis's *A Deception* (c. 1805–1809), formerly attributed to Raphaelle Peale, discussed in William H. Gerdts, "*A Deception* Unmasked; An Artist Uncovered," *The American Art Journal*, 18, No. 2 (1986), 4–23.
3 Wilmerding, pp. 172, 187.
4 *A Closet Door* seemed to have special significance for Peto. He included it in his late *Self Portrait with Rack Picture* (1904, private collection). Illustrated in Wilmerding, p. 6.

Among American still-life painters of the late nineteenth century, John Frederick Peto was the undisputed master of the letter rack canvas, a type of painting in which he may have preceded his prominent contemporary William Michael Harnett.[1] Rooted in European tradition, the rack motif made a brief appearance in early nineteenth-century America, but it was not until Peto undertook this subject, which he painted from about 1879 until the time of his death, that the genre had a major practitioner.[2] In these works, letters, booklets, and scraps of paper are tucked under a ribbon which is tacked onto a wooden panel. Peto's highly developed sense of design is apparent in the geometric underpinnings of *A Closet Door,* which consists of the stretched ribbon grid, three vertically cut wooden boards, and a triangular arrangement of hardware. Onto this foundation, the artist has imposed a miscellaneous conglomeration of objects, the whole rendered in a subtle range of colors. Peto delighted in the imperfections of the weathered door with its deteriorating hardware and "protruding" nails, conveying the incessant passage of time.

Although Peto's early rack paintings were often commissioned by local businesses who utilized them as trade signs, the later works such as *A Closet Door,* executed at his home in Island Heights, New Jersey, contain an increasingly personal, often undecipherable, iconography. Indeed, Peto's rack paintings lend themselves to biographical interpretation.[3] In *A Closet Door,* the visage of George Washington replaces, for the first time in Peto's work, that of Abraham Lincoln who may have served as a father figure for the artist. Furthering the biographical element is the envelope postmarked Philadelphia, from which Peto had been removed since 1889, and the prominent carving of his name in block letters in the upper left corner.[4] Items which might have been found in any Victorian home include an almanac and a fictional work entitled *Adventures of a Beauty*. Other objects have a more enigmatic presence—the parallelogram, a series of faint chalk numerals, and scraps of paper with illegible inscriptions. These commonplace items may have symbolic content, but like the painted key offered by the artist, the viewer can never unlock the clues to ascertain the precise meaning of the work.

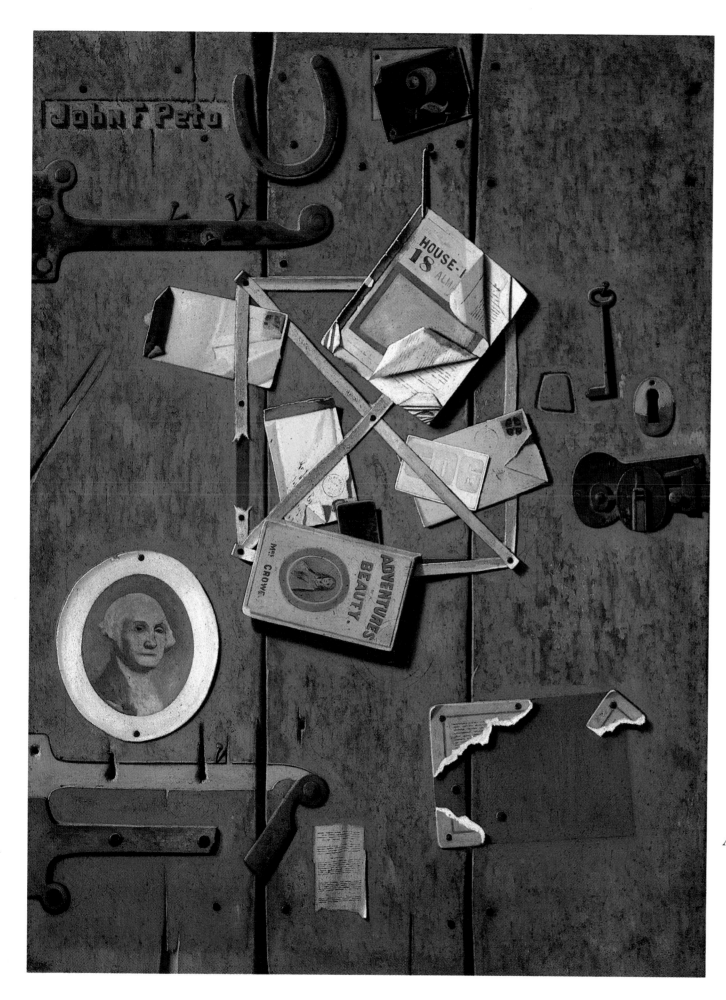

A Closet Door

61

William Merritt Chase (1849-1916)

Idle Hours, c. 1894

*Oil on canvas, 25 1/2 x 35 1/2 in.
(64.8 x 90.2 cm)
Inscribed l.l.: "Wm. M. Chase."*

1 Ronald G. Pisano, *A Leading Spirit in
American Art: William Merritt Chase 1849-1916*
(Seattle: University of Washington, Henry Art
Gallery, 1983), p. 154.
2 Ronald G. Pisano, *William Merritt Chase*
(New York: Watson-Guptill Publications,
1979), p. 24.

In 1891, William Merritt Chase opened his Shinnecock Summer School of Art on Long Island. For the next eleven years, the charismatic Chase introduced hundreds of students to the dynamics and pleasures of plein air painting. No finer example exists of Chase's own facility in capturing the immediacy of light, atmosphere, and place than his *Idle Hours*.

Prior to the establishment of the summer school in the Shinnecock Hills, the Indiana-born Chase had studied painting in his home state (1867-1869), the National Academy of Design in New York (1869-1871), and the Royal Academy in Munich (1872-1877). Although in the mid-1880s he abandoned the dark palette championed by the Munich school, Chase always retained the bravura brushwork technique that he acquired there. He returned to New York in 1878 to begin teaching at the newly formed Art Students League. During the next decade, through successful exhibition of his work, inspiring teaching, active participation in numerous art organizations, and his flamboyant and self-confident personality and life-style, Chase contributed greatly to making American art more respectable and more cosmopolitan. When Chase painted *Idle Hours* around 1894, few American artists were more highly regarded and admired.

Broadly rendered in order to emphasize the momentary, *Idle Hours* wonderfully conveys the salutary effect of a summer day in the country. The figures—two of Chase's daughters, his wife (in the red bonnet), and possibly his sister-in-law—comfortably rest on the hills above the shore, probably very near the McKim, Mead, and White house Chase had built in 1892.

As an image of man existing harmoniously with nature, *Idle Hours* continues an earlier nineteenth-century American tradition and resembles various French Impressionist compositions, as well. Despite the painting's obvious affinities with Impressionism—short brushstrokes, broken surface, bright palette, sense of immediacy, and depiction of leisure—Chase never considered himself an Impressionist, finding the movement more "scientific than artistic" (although in 1902 he joined the group of American Impressionist painters known as The Ten).[1] Nevertheless, a typically Impressionist vitality characterizes *Idle Hours*, contrasting with and heightening the response of the figures. Chase animates the composition by his painterly technique and by the illusionary lateral and recessive movement of the gloriously modulated clouds. Further, the actively expansive space opens up toward the viewer, then narrows in the middle ground, only to open again, in a panoramic way, in the background, leading the eye out the composition at the right. Although the figures may be idling away the hours, Chase catches them in a fleeting moment. The idyllic beauty the artist conveys here indicates why his numerous Shinnecock scenes enjoyed popular and critical acclaim.

An inveterate traveler (he once exclaimed, "My God, I'd rather go to Europe than to heaven"[2]), Chase closed his successful summer school at Shinnecock in 1902 in order to conduct summer art classes abroad. From 1903 until 1913, he taught during the summer months in Holland, England, Italy, Spain, and Belgium. Internationally esteemed as a superior artist and teacher, Chase died unexpectedly in 1916.

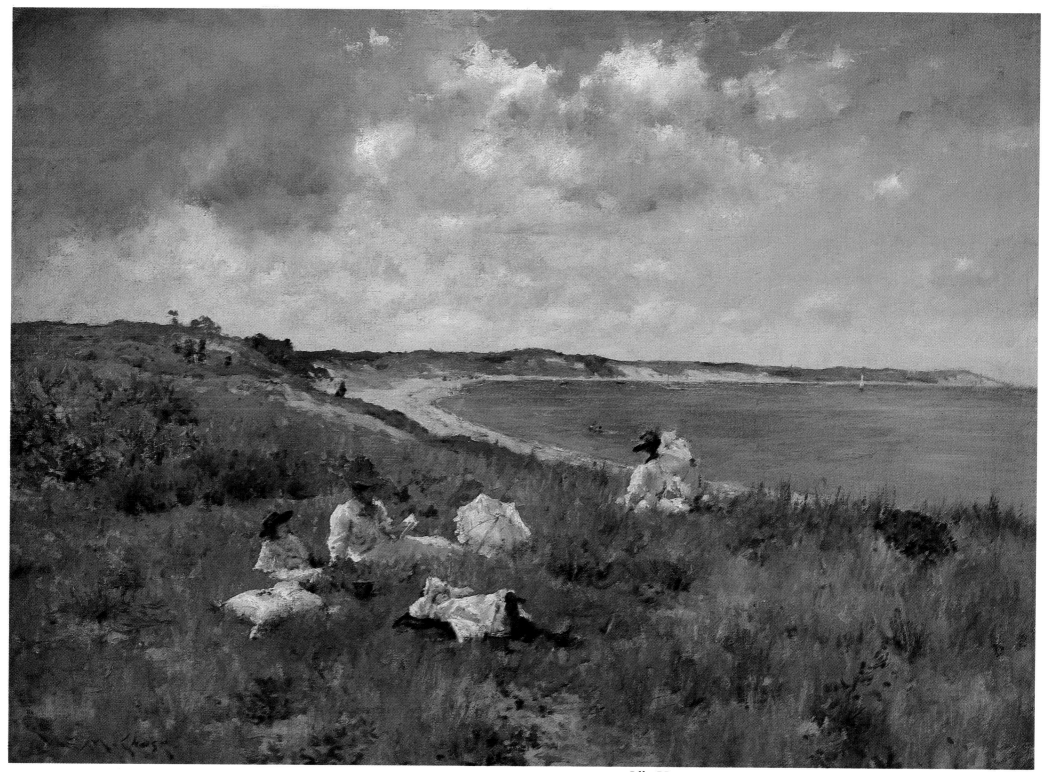

Idle Hours

Frederic Remington (1861-1909)

A Dash for the Timber, 1889

Oil on canvas, 48 1/4 x 84 1/8 in.
(122.6 x 213.7 cm)
Inscribed l.l.: "FREDERIC
REMINGTON-/1889."

1 The best biography of Remington is Peggy Samuels and Harold Samuels, *Frederic Remington: A Biography* (Garden City, N.Y.: Doubleday & Company, Inc., 1982). The book has been reprinted by the University of Texas Press.

2 Peter H. Hassrick, *Frederic Remington: Paintings, Drawings, and Sculpture in the Amon Carter Museum and Sid W. Richardson Collections* (New York: Harry N. Abrams, 1973), p. 68.

3 Letter from Remington to Clarke, 2 April 1889, in the Clarke Collection, Missouri Historical Society, St. Louis.

4 See comment regarding "the broken country of western Arizona" in Remington's 1886 summer journal, in Robert Taft Papers, Kansas State Historical Society, Topeka.

5 *The Wounded Bunkie* is in the collection of the Amon Carter Museum, which also includes all but three of Remington's bronzes.

6 *New York Times,* 16 Nov. 1889, p. 4, cols. 1-2; Samuels, pp. 83-84.

7 National Academy of Design, *Catalogue of the Eighth Autumn Exhibition* (New York: John C. Rankin, Jr., 1889), p. 24. Entry number 318 is *A Dash for the Timber,* with E. C. Converse listed as owner. See also Remington to Clarke, 1 Dec. 1889, in Clarke Collection. The Gravure Etching Company published black and white prints of *Dash* in 1889-1890.

Frederic Remington was probably the most popular painter in America when he died in 1909, and one reason for his popularity was his subject: the cowboy. Remington had honed his artistic skills at Yale College and at the Art Students League in New York. He furthered his knowledge of the cowboy during a three-year stint in Kansas—first as a sheep rancher, then as a saloonkeeper—and in subsequent trips to the West. He gained his popularity by providing illustrations of cowboys, soldiers, and Indians for *Harper's, Century, Scribner's,* and many other popular journals of the day; but as *A Dash for the Timber* (one of Remington's first great cowboy paintings) demonstrates, the twenty-eight-year-old artist had been developing his painterly abilities as well.[1]

The painting developed out of a commission from the inventor and industrialist Edmund Cogswell Converse, who ordered a large, mural-sized picture in celebration of his promotion to general manager of the family company.[2] "I have a big order for a cow-boy picture," Remington wrote his friend Powhatan H. Clark in Arizona, "and I want a lot of 'chapperras'—say two or three pairs . . . and also that pistol holder which I left down there." With authenticity in mind, Remington wanted to supplement his growing collection of props; thus, he drew a picture of the chaps that he wanted and explained that "as soon as I can get them [I] will begin the picture."[3]

Remington chose a frontier life-and-death struggle as the subject for the painting. Set perhaps in Arizona (a passage in one of his journals describes terrain similar to that in the foreground), *A Dash for the Timber* pictures eight cowboys or perhaps prospectors—character types that Remington came to call "men with the bark on"—as they race headlong toward a small stand of timber, seeking shelter from what could be dozens of pursuing Indians.[4] Three of the group are firing weapons over their shoulders to ward off the Indians, while two reach out to aid a companion who has been hit. The "disabled friend" is a motif that Remington returned to in 1896 with his second bronze sculpture, *The Wounded Bunkie,* in which a soldier leans from his horse to support his unconscious companion.[5]

Perhaps Remington's most astonishing accomplishment in the painting is the realistic depiction of the six horses as they bear their hard-bitten riders toward a hoped-for refuge in the trees. The viewer is placed in front of the stampeding herd, staring directly into the face of one of the horses, as the other horses veer off to the right and left. It is a trick of perspective and foreshortening that belies Remington's reliance on photography just as surely as does another aspect of the painting, the correct positioning of the horses' legs. *A Dash for the Timber* is one of the first major paintings in which Remington drew horses in convincing poses and with all their hooves off the ground, a composition surely influenced by Eadweard Muybridge's landmark photography in *The Horse in Motion* or in one of the many journals that reproduced the studies. Remington considered the horse his subject and undoubtedly was pleased when a *New York Times* critic commented that his horses were drawn "extremely well."[6]

Proud of the finished painting, Remington arranged with Converse to exhibit it in the fall exhibition at the National Academy of Design. It hung prominently in the South Gallery and received what Remington called "a grand puff in the papers."[7] *The New York Times* reported that

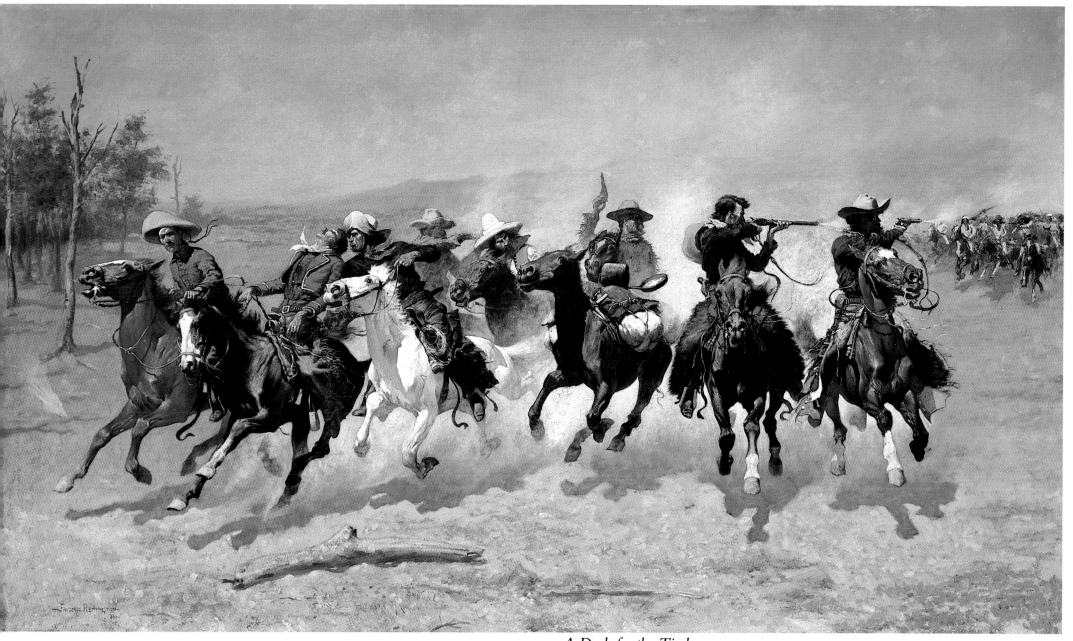

A Dash for the Timber

"the largest number of people" stood before Remington's painting, which shows the "harsher aspect of western life on the plains, with little attempt to soften the edges of reality." The reviewer continued:

> [The eight cowboys] are not flattering representatives of the race . . . and do not enlist our full sympathies during the struggle for life in which they are engaged. . . . But the hurry and rush of the stampede to cover is certainly admirable. . . . And . . . he renders with unusual truth effects of strong sunlight, registering in the heavy shadows thrown on the foreground by the advancing horsemen that shade of violet which exists in a shadow thrown on light sands and soil.[8]

8 *New York Times,* 16 Nov. 1889, p. 5, col. 5.

9 *New York Herald,* 16 Nov. 1889, p. 4, cols. 1-2.

10 See letter from Remington to F. Edwin Elwell, 16 July 1902, in Autograph Letters from American Sculptors Written to F. Edwin Elwell, The Metropolitan Museum of Art, New York; Hassrick, p. 68. The painting was owned by Washington University and displayed in the Saint Louis Art Museum until 1945, when it was acquired by Amon G. Carter.

The *New York Herald* critic was equally flattering, concluding that "the drawing is true and strong" and "marks an advance on the part of one of the strongest of our younger artists, who is one of the best illustrators we have."[9]

A Dash for the Timber does not possess the maturity of theme or technique that Remington exhibited in his later paintings, but it stands as the supreme accomplishment of his early career and a classic painting of the American West. Remington considered it one of his major works and listed it in a biographical sketch that he prepared in 1902. It was his only painting in a public collection (owned by Washington University and exhibited at the City Art Museum of St. Louis) until 1909, when a donor presented Remington's *Fired On* (c. 1907) to what is now the National Museum of American Art, Smithsonian Institution.[10]

The Fall of the Cowboy, 1895

Oil on canvas, 25 x 35 1/8 in.
(63.5 x 89.2 cm)
Inscribed l.r.: "Frederic Remington."

1 Quoted in Ron Tyler, *Frederic Remington* (Fort Worth: Amon Carter Musuem, 1981), p. 5.

2 Wister quoting Remington and Remington to Wister, in September or October 1894, in Ben Merchant Vorpahl, *My Dear Wister: The Frederic Remington-Owen Wister Letters* (Palo Alto: American West Publishing Company, 1972), pp. 38, 47.

3 *New York Herald,* 20 Nov. 1895, p. 7, cols. 1-2.

By the time he painted *The Fall of the Cowboy* in 1895, Remington had earned a reputation as the preeminent illustrator of the American West. He "supports five or six large magazines," reported Richard Harding Davis, the editor of *Harper's Weekly,* "and keeps them living well."[1] But Remington yearned for acceptance as an artist, rather than an illustrator, and with *The Fall of the Cowboy* he moved a step closer to that goal and to his ultimate understanding of the West. As an artist, Remington was gradually moving away from his reliance on authenticity and actual events, such as those he illustrated, and toward a metaphorical understanding of the West and how its characters would figure in his work.

The occasion for painting *The Fall of the Cowboy* came when Owen Wister, with whom Remington had collaborated on several projects, finally succumbed to the artist's plea to "write me something where I can turn myself loose. Tell the story of the cow puncher, his rise and decline." After further correspondence, Remington even suggested to Wister the outline of the idea, including this comment which contained the theme that he would employ in *The Fall of the Cowboy:* "Yankee ingenuity killed the cattle business as much as anything—the Chicago packers—the terrible storms . . . &c."[2]

The painting features two weary cowboys on a snow-covered range who have just encountered a fence. One has dismounted and is opening the gate, while the other patiently waits. Remington portrays the embattled heroes with empathy in what seems almost to be a reverential setting. The horses appear to be suffering even greater fatigue and exposure than the men. Included in the picture are two of the elements that brought about the decline of the cowboy: the barbed wire fences ("Yankee ingenuity") that crisscrossed and bisected the open range and the terrible winter blizzards of the late 1880s that killed thousands of cattle and drove dozens of ranchers into bankruptcy. *The Fall of the Cowboy* also expresses the metaphorical message that the Old West was passing with the cowboy. It is one of Remington's most sophisticated and painterly compositions.

Remington sold the painting for $195 in his 1895 sale at the American Art Galleries.[3]

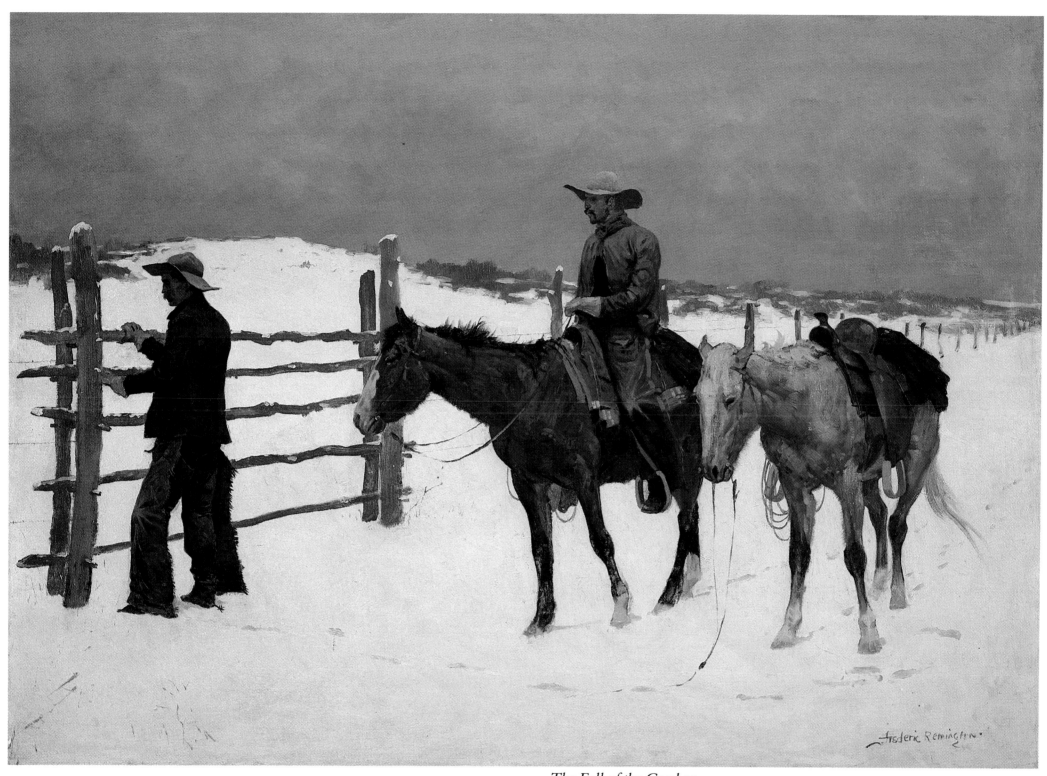

The Fall of the Cowboy

Frederic Remington (1861-1909)

His First Lesson, 1903

Oil on canvas, 27 1/4 x 40 in.
(69.2 x 101.6 cm)
Inscribed l.r.: "Copyright 1903 by Frederic Remington-"

1 Edwin Wildman, "Frederic Remington, the Man," *Outing,* March 1903, p. 715.
2 Quote in Peggy Samuels and Harold Samuels, *Frederic Remington: A Biography* (Garden City, N. Y.: Doubleday & Company, Inc., 1982), pp. 347-348.
3 Harold McCracken, *Frederic Remington, Artist of the Old West* (Philadelphia: J. B. Lippincott Company, 1947), pp. 114-117.

Remington painted *His First Lesson* as he reached the peak of his artistic abilities. It is an excellent example of his mature style and embodies his fully developed thematic approach to painting: a simple but powerful composition featuring his "men with the bark on" and containing an overriding metaphor that grows naturally out of the image. By 1903, Remington realized that both he and the West had changed, that the West was only a backdrop for his creativity rather than the subject itself. It would never again be the romantic place that he had visited as a youngster, nor would it nurture the types of characters who populated his paintings. "My West . . . put on its hat, took up its blankets, and marched off the board," he said.[1]

Meanwhile, as the message that he wanted to convey—the universal elements of life's struggle in the historic West—formed in his mind, Remington sharpened his concept of painting. "Big art is the process of elimination," he theorized. "Cut down and out—do your hardest work outside the picture, and let your audience take away something to think about—to imagine."[2] As these ideas matured, the opportunity to work the problems out on canvas arrived. *Collier's Magazine* offered Remington twelve thousand dollars for the right to reproduce one painting a month for a year. The paintings would appear in the magazine in color and did not have to relate to any specific theme or story.[3]

His First Lesson was Remington's first painting under the new contract. It is an authentic incident of western life that any experienced hand would recognize. The raw bronc, haltered and with his right rear leg tied up, is about to be broken to the saddle. One cowboy holds the reins tightly as another cinches up the saddle, while maintaining a respectable distance. A third, on horseback at the right, chuckles as he anticipates the show that is about to begin. The scene is beautifully painted, with Remington combining an impressionistic technique (developed after study of modern French paintings) with a compositional simplicity created with desert colors bleached by the intense southwestern light.

The picture lacks his former attention to detail, for Remington was now more interested in conveying message than subject matter. Despite all the activity in the scene, Remington's technique focuses the viewer immediately on the wild horse that is about to be broken to the saddle. The terror in his face changes the mood of the painting from humor to deep sympathy for the horse as the viewer realizes that this wild and formerly free pony is representative of the West that Remington had seen in 1881. It, too, had been roped, tied, and civilized.

His First Lesson was the first oil painting that Amon G. Carter purchased when he began his collection in 1935.

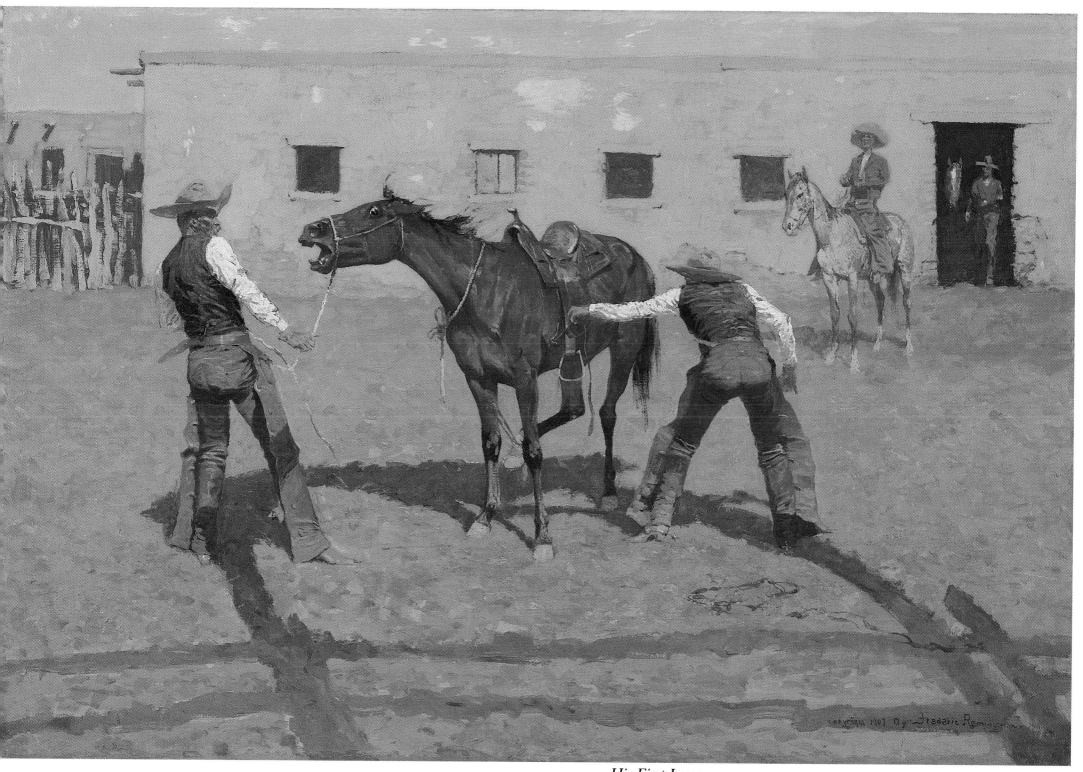

His First Lesson

Charles Marion Russell (1864-1926)

Lost in a Snowstorm—We Are Friends, 1888

Oil on canvas, 24 x 43 1/8 in.
(61.0 x 109.5 cm)
Inscribed l.l.: "C M Russell/1888"

1 Frederic G. Renner, *Charles M. Russell: Paintings, Drawings, and Sculpture in the Amon G. Carter Collection: A Descriptive Catalogue* (Austin: University of Texas Press, 1966), opp. p. 26.
2 Sid A. Willis to Fred M. Mazzulla, Great Falls, Montana, 5 Nov. 1952, reproduced inside front cover of *Souvenir Illustrated Catalogue* (1928; rpt. Denver: Fred M. Mazzulla, 1978).

Charles M. Russell had no credentials other than a love of art, self-taught techniques, and eight years' experience on the range when he painted *Lost in a Snowstorm—We Are Friends*. He had sketched and drawn from an early age as he grew up in St. Louis. Although he had virtually no formal training, he began to paint with watercolors soon after he arrived in Montana in 1880. He was a cowboy during his first few years there, and his initial paintings were naive scenes that included portraits of his friends as they engaged in the roundup or some other familiar activity that Russell had witnessed.

While apparently not a record of a real incident, *Lost in a Snowstorm* is, nevertheless, a scene that any Montana cowboy would have recognized. There were few roads, fences, or other landmarks in central Montana's Judith Basin in the 1880s, and riders could easily have become lost during one of the numerous winter blizzards. These cowboys are fortunate enough to have encountered some friendly Indians who are informing them by signs that their friends are "on the other side of the mountain."[1] Shortly after finishing this painting, Russell spent almost six months with the Blood Indians of Alberta, Canada, where he also learned to "talk sign." The Indians called him "picture writer."

Lost in a Snowstorm embodies at least two themes that Russell continually depicted in his work: the untrammeled wilderness that he prized and friendly Indians, whom he saw as assisting rather than fighting the early settlers. His appreciation for both the land and the Indians came from personal experience. He had fallen in love with central Montana when he first arrived there and had gained an appreciation for the Indian way of life during his time with the Blood Indians. *Lost in a Snowstorm* combines his heavily romanticized view of the West, developed as a child in urban St. Louis, with an exactness of detail and a believability that his aesthetically unsophisticated peers demanded.

The painting also represents a remarkable artistic achievement for the twenty-four-year-old artist as he demonstrated measurable improvement in his ability to depict anatomy and in his draftsmanship, with the brightly colored Indian blankets contrasting against the silver-gray snow drifts and cloudy sky.

Amon G. Carter purchased his first Russell watercolors in 1935. With the acquisition of The Mint saloon collection in 1952, he completed one of the largest and best collections of Charles Russell's paintings, drawings, and sculpture.[2]

In Without Knocking, 1909

Oil on canvas, 20 1/8 x 29 7/8 in.
(51.1 x 75.9 cm)
Inscribed l.l.: "C M Russell/(skull) 1909"

In Without Knocking is a colorful and freely painted example of Russell at his best: a spirited scene of cowboy fun presented with Russell's characteristic flair for storytelling and humor. It was a scene that Russell did not witness (but heard many accounts of) because he was the "nighthawk"

with the outfit involved in the fracas and had to remain in camp to watch the horse herd while his friends went into town for an evening of leisure before departing on a trail drive.

The incident occurred in the fall of 1881 when several Judith Basin ranchers pooled their crews and herds to organize a drive to the Northern Pacific railhead (which was building toward Glendive, Montana) and expected to be there before the first snows of winter.[1] The cowboys went into the nearby town of Stanford for a little relaxation before beginning the drive the next day. They must have had a good time—at least that is the way they described the excursion to Russell.

By the time Russell painted *In Without Knocking,* he was a self-supporting artist who was also trying his hand at writing and illustrating for eastern magazines. He had also exhibited at the St. Louis World's Fair in 1904 and the Pennsylvania Academy of the Fine Arts and would soon have his first New York exhibition. Some journalists were comparing him with the recently deceased Remington, while others were speculating that he would be the next Remington.[2] His cowhand friends would have voted him that laurel, pointing out that although Russell did not paint *In Without Knocking* until 1909, those who were there claimed that he accurately depicted the scene.[3]

A Tight Dally and a Loose Latigo, 1920

As Russell matured, his palette brightened, his brushwork became looser, and he developed a flair for dramatic and complicated scenes played out in a spectacular setting. There are probably several reasons for this change, the most obvious being that as Russell became a better painter he could concentrate less on "teck neque," as he disdainfully put it, and more on getting his soul and personality into the picture.[1] Russell was an incurable romantic who felt the loss of the historic West in such an emotional way that he could never analyze it as Remington had. He could only paint brighter and happier pictures, images that earned him even greater fame and monetary rewards and that would soon tutor film directors such as John Ford as they prepared their cinematic paeans to the Old West.

A Tight Dally and a Loose Latigo is a superb example of Russell's late work and is one of his best cowboy paintings. The scene is his beloved Judith Basin of central Montana, shown in the background. The Bar Triangle brand on the horse in the right center identifies these riders as being from the Greely Grum outfit south of Judith Gap. The drama and title of this picture have their origin in the fact that the central rider's dally (the half hitch that he took around his saddle horn after roping the steer) is tighter than his latigo (Spanish for the long leather strap that held the saddle on). The cowboy's seemingly hopeless condition is complicated by the calf tripping over the rope and his horse beginning to buck.[2]

Ironically, *A Tight Dally* did not earn Russell much of his fame, for his wife, Nancy, kept it in her personal collection, and it was not even illustrated until 1949.[3]

1 Frederic G. Renner, *Charles M. Russell: Paintings, Drawings, and Sculpture in the Amon G. Carter Collection: A Descriptive Catalogue* (Austin: University of Texas Press, 1966), opp. p. 87.
2 Karl Yost and Frederic G. Renner, *A Bibliography of the Published Works of Charles M. Russell* (Lincoln: University of Nebraska Press, 1971), pp. 117, 132, list newspaper articles from the *Great Falls Tribune,* 6 January 1910, and the *St. Louis Republican,* 6 March 1910, which speculate about Remington and Russell.
3 Renner, opp. p. 87.

Oil on canvas, 30 1/4 x 48 1/4 in. (76.8 x 122.6 cm)
Inscribed l.l.: "C M Russell/(skull) ©"
l.c.: "1920"

1 Brian W. Dippie, *Remington & Russell: The Sid Richardson Collection* (Austin: University of Texas Press, 1982), p. 15.
2 Frederic G. Renner, *Charles M. Russell: Paintings, Drawings, and Sculpture in the Amon G. Carter Collection: A Descriptive Catalogue* (Austin: University of Texas Press, 1966), opp. p. 105.
3 Karl Yost and Frederic G. Renner, *A Bibliography of the Published Works of Charles M. Russell* (Lincoln: University of Nebraska Press, 1971), p. 76.

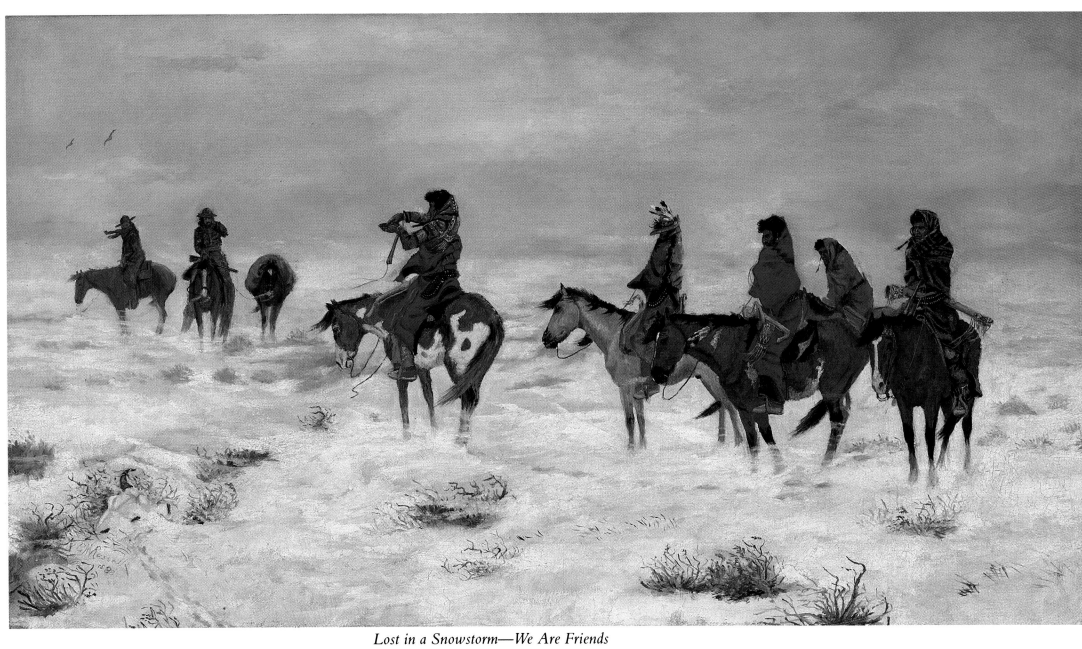

Lost in a Snowstorm—We Are Friends

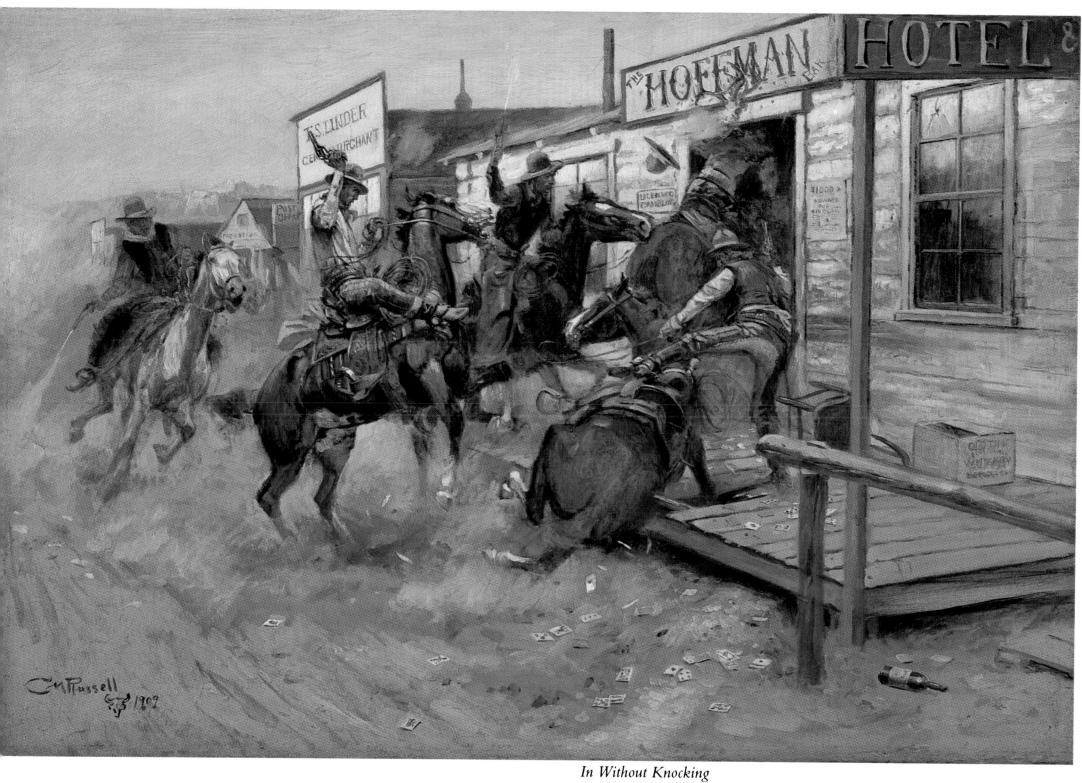

In Without Knocking

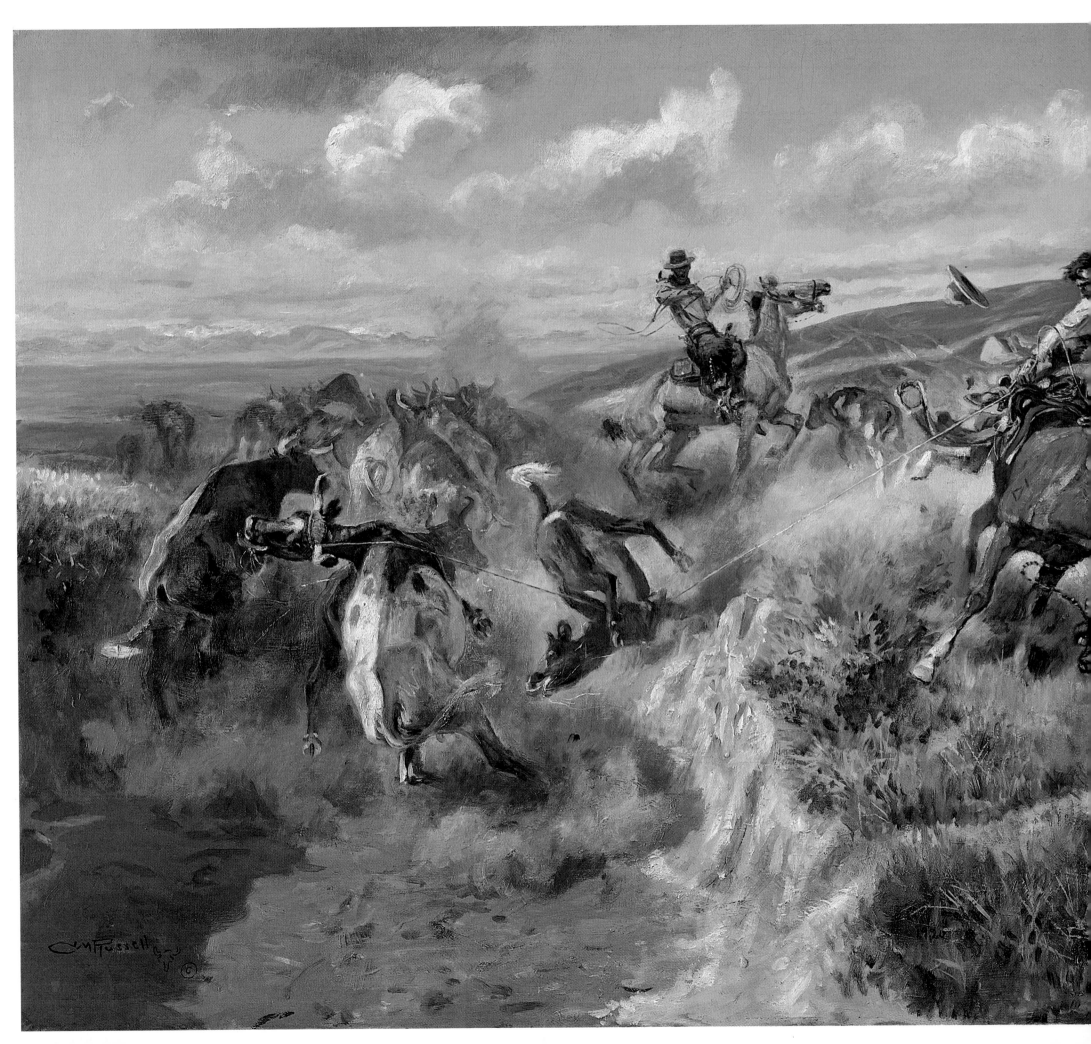

A Tight Dally and a Loose Latigo

75

Childe Hassam (1859-1935)

Flags on the Waldorf, 1916

Oil on canvas, 36 1/4 x 30 1/4 in.
(92.1 x 76.8 cm)
Inscribed l.l.: "Childe Hassam 1916"
verso u.l.: "C.H. [in a circle]/1916"

B orn in Dorchester, Massachusetts, Childe Hassam was one of the founders of the Ten American Painters and was the best known of the American Impressionists. He worked first as a bookkeeper and then as a wood engraver in Boston, attended classes at the Boston Art Club and the Lowell Institute, and then studied with Ignaz Gaugengigl before establishing a studio in Boston in the early 1880s. Hassam made his living primarily as an illustrator during those years. After two trips to Europe in 1883 and 1886 (when he studied in Paris for three years), Hassam moved to New York. The change in his style at that time reflected his admiration for the French Impressionist artists: his views of the city combined a light palette, loose brushwork, cropped viewpoints, and an interest in the effects of light and atmosphere.

After subsequent trips to Europe in 1897 and 1910 (where he again saw the work of Camille Pissarro and Claude Monet), Hassam began to create a small group of pictures featuring a flag motif and depicting the French celebration of Bastille Day.[1] But it was not until the years 1916-1919 that Hassam truly took up the flag theme with great energy in his important series of approximately thirty paintings collectively called "Avenue of the Allies."[2] The surge of patriotism during World War I resulted in a colorful display of flags along New York's streets, especially Fifth Avenue which became known as the "Avenue of the Allies." New York proudly flew the flags of the countries who joined in the fight against Germany, as well as those of the armed services and the Red Cross. However, Hassam's *Flags on the Waldorf,* dated 1916, displays only American flags and most likely represents a scene which followed the sinking of the Lusitania and New York's subsequent preparedness parade held in May 1916, when "the city blossomed out in a wealth of our red, white, and blue."[3]

The painting was one of Hassam's earliest efforts in the series and depicts a slightly elevated view looking down Fifth Avenue from 35th Street. The original Waldorf-Astoria Hotel is the prominent, flag-bedecked building on the right.[4] The decorative patterns of the flags and the bustling sidewalk and street traffic lend a sense of vitality to the scene, and indeed, it was Hassam's skill in rendering this type of street scene (whether of Paris in the 1880s or New York in the twentieth century) which brought him renown. In *Flags on the Waldorf,* the artist successfully captured the city's steep verticality and wet pavement. Painted with loose brushstrokes in an overall cool blue tonality, the surface of the canvas shimmers; the carriages and flags in the distance draw the viewer into the painting's deep perspective.

Flags on the Waldorf is not only a beautiful aesthetic statement in the American Impressionist style but an important historical document, recording the patriotic pageantry on display in New York prior to America's entry into World War I.

The "Avenue of the Allies" paintings were among Hassam's most popular works and were shown together in several major exhibitions in 1918 and 1919. Although a committee of prominent New Yorkers tried to raise funds for the purchase of twenty-two of Hassam's flag paintings (including this one) as a permanent war memorial, their campaign was unsuccessful, and the paintings eventually were sold separately to museums and to private collectors.

1 For instance, *July Fourteenth, Rue Daunou,* 1910, The Metropolitan Museum of Art, New York. See the discussion of this painting and *Avenue of the Allies, Great Britain, 1918* in Doreen Bolger Burke, *American Paintings in the Metropolitan Museum of Art* (New York: The Metropolitan Museum of Art, 1980), III, 360-362, 363-364. In these paintings Hassam returned to the type of cityscape composition he had used in the late 1880s. Pissarro was known for his bird's-eye views of crowded city streets, and Monet painted several works showing streets hung with flags (for instance, *La rue Saint-Denis, fête du 30 juin* [1878, Musée des Beaux-Arts, Rouen]).

2 Hassam also used the flag motif in etchings and lithographs between 1916-1919 and in other paintings and watercolors during the last part of the decade.

3 William A. Coffin, "The Flag Pictures by Childe Hassam, N.A.," unpaged essay in the catalogue for the 1918 Durand-Ruel *Exhibition of a Series of Paintings of the Avenue of the Allies by Childe Hassam.* The painting could also depict an Independence Day celebration. A similar work by Hassam, entitled *Flags, 4th of July 1916,* is illustrated in Hirschl & Adler Galleries, *A Gallery Collects,* 1977, cat. no. 56.

4 The Waldorf was demolished in 1929; the Empire State Building now stands on that site. The building with columns in the right foreground was designed by Stanford White and housed the Columbia Trust Company when Hassam painted this scene.

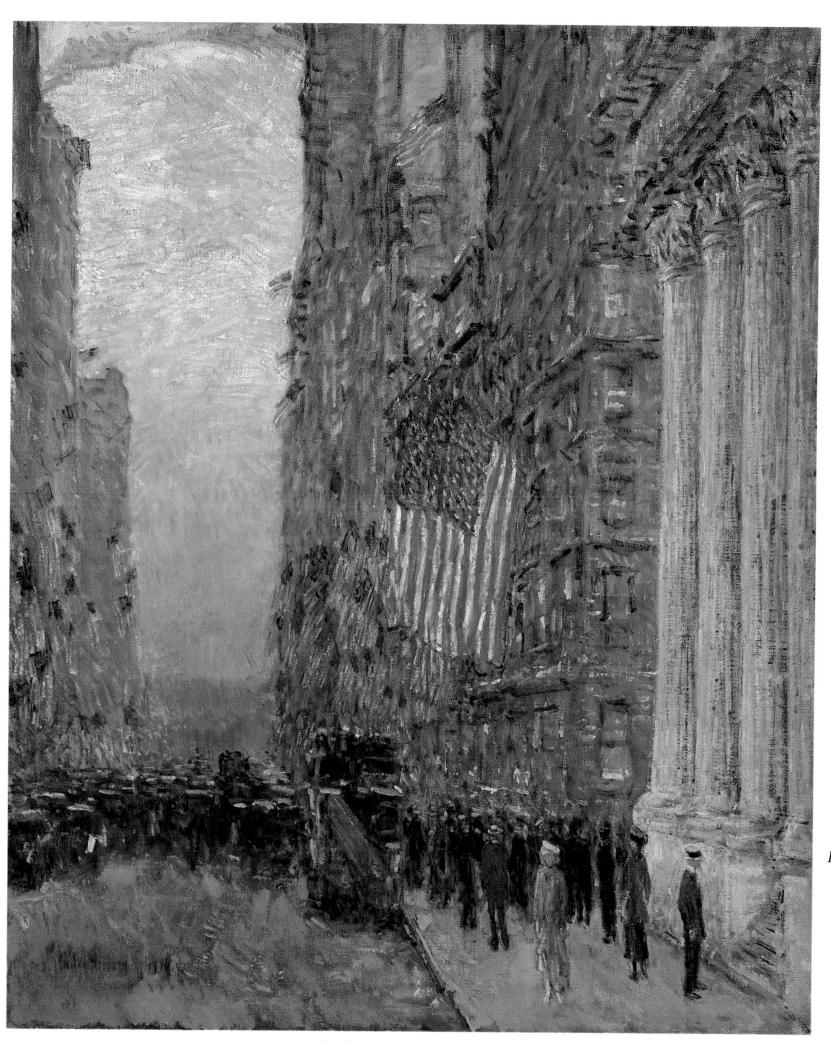

Flags on the Waldorf

77

Cecilia Beaux (1855-1942)

Mother and Son (Mrs. Beauveau Borie and Her Son Adolphe), 1896

Oil on canvas, 57 1/4 x 40 in.
(145.4 x 101.6 cm)
Inscribed l.l.: "Cecilia Beaux"

1 Quoted in Frank H. Goodyear, Jr., *Cecilia Beaux: Portrait of An Artist* (Philadelphia: Pennsylvania Academy of the Fine Arts, 1974), p. 7.

2 In 1871, at the age of sixteen, Beaux began to study with Catherine Drinker and continued her study in classes given by the Dutch artist Adolf Van der Whelen. Beaux's name appears twice in the registry of students at the Pennsylvania Academy, 1877-1879. From 1881-1883, she studied under the supervision of William Sartain. Beaux first exhibited at the Pennsylvania Academy in 1879.

3 "Pictures by Cecilia Beaux," *New York Times*, 22 December 1897. Cecilia Beaux Papers, Archives of American Art, Smithsonian Institution, Roll 429, frame 24.

4 The Bories were bankers. Following the failure of their bank in 1905, Adolphe Borie—who had studied at the Pennsylvania Academy of the Fine Arts (1896-1899) under William Merritt Chase and Thomas Anschutz and at the Royal Academy in Munich (1899-1902)—supported himself as a portraitist.

5 Beaux was selective in choosing her sitters, reportedly declining lucrative commissions because she felt the subject's face was not strong enough. She felt that a portraitist should not paint a stranger or speculate on specific human relationships. See Goodyear, pp. 30, 95.

6 This change in style is discussed in the catalogue entry for Beaux's portrait of *Mr. and Mrs. Anson Phelps Stokes* in Doreen Bolger Burke, *American Paintings in the Metropolitan Museum of Art* (New York: The Metropolitan Museum of Art, 1980), III, p. 204.

"Miss Beaux is not only the greatest living woman painter, but the best that has ever lived," proclaimed William Merritt Chase in 1898.[1] Renowned portraitist Cecilia Beaux was born in Philadelphia, and it was there that she received private instruction from several artists. Although she later denied it, she also attended classes at the Pennsylvania Academy of the Fine Arts, where she undoubtedly came into contact with the great portraitist Thomas Eakins.[2] Beaux's studies continued during a nineteen-month trip to Europe in 1888-1889. On her return to America, she established a studio in Philadelphia, and although she began to spend an increasing amount of time in New York after 1892, she maintained close ties to her native city.

Beaux's powerful double portrait, *Mother and Son*, was one of the paintings which won the artist a gold medal at the Exposition Universelle in Paris in 1900. "There is a refinement which might also be called Quakerish," a *New York Times* critic wrote of the painting, "and a nameless something in the pose, expression, and the dress which would identify the subjects to any one at all familiar with the life and social atmosphere of the larger American cities, as Philadelphians."[3] Indeed, the painting depicts Patty Neill Borie of Philadelphia and her son, Adolphe, who later became a painter and instructor at the Pennsylvania Academy.[4] Despite the identity of these specific sitters, Beaux's title underscores the fact that the artist sought to portray a universal relationship as well as to define individual likenesses.

The emphasis is clearly on the strong presence of Mrs. Borie whose figure is bathed in light and bracketed by the rich reddish orange color of the settee on which she sits. Her face, with its dignified yet gentle bearing, is sympathetically portrayed, while her luxurious gown of creamy white (a color favored by Beaux, which reflects blue, green, and lavender) is a tour de force in the fluid handling of paint. Beaux depicts Adolphe (then in his late teens) in a subordinate pose as a sensitive, refined young man, dressed in a dark suit and seated at a piano in the shadowy background. He gazes pensively to the side. This type of portrait, with the woman in the foreground light and the man in background shadow, was used to advantage the following year by John Singer Sargent in his *Mr. and Mrs. I. N. Phelps Stokes* (1897, The Metropolitan Museum of Art, New York). The composition of *Mother and Son* is reminiscent of some of Whistler's arrangements, but the additional psychological relationship expressed here brings to mind the double portraits of the French painter Edgar Degas.[5]

Painted in her studio at 1710 Chestnut Street in Philadelphia, *Mother and Son* stands as a transitional work in Beaux's career. This painting links the works which feature daring compositions and strong use of black and white (such as *Ernesta [Child with Nurse]* [1894, The Metropolitan Museum of Art, New York]) to the series of fashionable, full-length double portraits begun in 1898 (like that of *Mr. and Mrs. Anson Phelps Stokes* [The Metropolitan Museum of Art, New York]) that are more influenced by Sargent and the international style of portraiture.[6]

A preparatory oil sketch, in which Beaux worked out her compositional arrangement of lights and darks, is in the collection of the Harvard University Art Museums (Fogg Art Museum). *Mother and Son* remained in the sitters' family until its recent acquisition by the Amon Carter Museum.

Mother and Son

Mary Cassatt (1844-1926)

Mother and Daughter, Both Wearing Large Hats (Fillette au grand chapeau), 1900-1901

Oil on canvas, 32 x 26 in. (81.3 x 66 cm)
Inscribed l.r.: "Mary Cassatt"
Gift of Ruth Carter Johnson in honor of
Adelyn Dohme Breeskin, Trustee, Amon
Carter Museum, 1972-1982

1 When first exhibited (at the Durand-Ruel Galleries in New York in 1903) the painting bore the title *Fillette au grand chapeau*. This earlier title does not describe the painting as fully as does the current title. Cassatt authority Adelyn Dohme Breeskin, while certain that the figures in the painting were models and perhaps not actually related, felt, nevertheless, that the mother-and-daughter title should be maintained (12 December 1981 memorandum, curatorial files). The current title clearly expresses the image, while signifying Cassatt's larger interest in the subject of mother and child.

Although the mother-and-child motif did not become a major thematic concern until the 1890s and comprised only about a third of her entire oeuvre, it has become popularly identified as Cassatt's "subject." Frequently, Cassatt painted either the mother or child wearing a hat; only very rarely did she, as here, depict both figures with hats. The hat worn by the child also appears in four other paintings (all from 1904) by the artist and in a 1910 sketch.

2 Nancy Mowll Mathews, *Cassatt and Her Circle: Selected Letters* (New York: Abbeville Press, 1984), p. 269.

Mother and Daughter, Both Wearing Large Hats offers a splendid example of the subject matter most closely associated with Mary Cassatt—maternity.[1] The artist characteristically presents rather loosely painted figures in a pleasant, intimate, yet unsentimental relationship. Such treatment of form and content signals Cassatt's close connections with the French Impressionists.

Born into a wealthy Pennsylvania family, Mary Cassatt, who studied art first at the Pennsylvania Academy of the Fine Arts (1861-1865) and then in Europe, became the only American to exhibit with the radical French artists, the Impressionists. Of the group's eight exhibitions, four included work by Cassatt. Among the Impressionists, the one whom she most admired and who most affected her was Edgar Degas. As her mentor, Degas reinforced and influenced Cassatt's stylistic and thematic inclinations and development by the example of his work, interests, and friendship. Both artists shared a concern for draftsmanship, which prevented the dissolution of form so often, and so bitterly, criticized in the work of their peers. In portraying psychological relationships between figures in their compositions, both minimized sentimentality, aiming instead for straightforwardness or, at times, ambiguity. Degas inspired Cassatt to explore pastel and printmaking, media in which she created extraordinary images. After viewing an exhibition of Japanese prints with Degas in 1890, Cassatt produced ten intaglio color prints which combined the techniques of aquatint, drypoint, and soft ground etching and which clearly embraced the Japanese aesthetic of cropped, flat, linear forms. These works appeared along with paintings and pastels in Cassatt's first individual exhibition, held at the Galerie Durand-Ruel, Paris, in 1891. One of the prints, *Maternal Caress*, reflects the theme with which she is so closely identified and with which much of her art after 1890 is concerned.

In *Mother and Daughter, Both Wearing Large Hats,* Cassatt subtly ties the figures together, formally and thematically, through the use of hands. Beginning with the mother and child's joined hands, the viewer's eyes follow a counter-clockwise movement up and around the mother to her other hand on the child, along the child's arm, and back to the starting point. This enveloping compositional arrangement, so naturalistic in appearance, emphasizes the physical and psychological closeness of the two figures. Cassatt heightens this quality by using the shared pinkish covering draped across their laps to merge the figures' bodies into one. Yet, Cassatt avoids the potential mawkishness of the figural relationship by acknowledging the sitters' individuality through their differently directed glances. This device, along with the painterliness typical of her later style, enhances the informality and realism of the moment.

Cassatt very likely painted *Mother and Daughter, Both Wearing Large Hats,* at her country home outside Paris. Prior to beginning work on this canvas, Cassatt had returned from a visit to the United States, her first since 1875. She always considered herself an American, despite working and living abroad. Like the other major American expatriates, John Singer Sargent and James Abbott McNeill Whistler, Cassatt enjoyed international prestige as an artist and, in her case, as an art advisor. Acting in the latter capacity, she played a crucial role in introducing the work of the French Impressionists to American collectors. When she painted *Mother and Daughter, Both Wearing Large Hats,* Mary Cassatt reigned as the grande dame of the art world.[2]

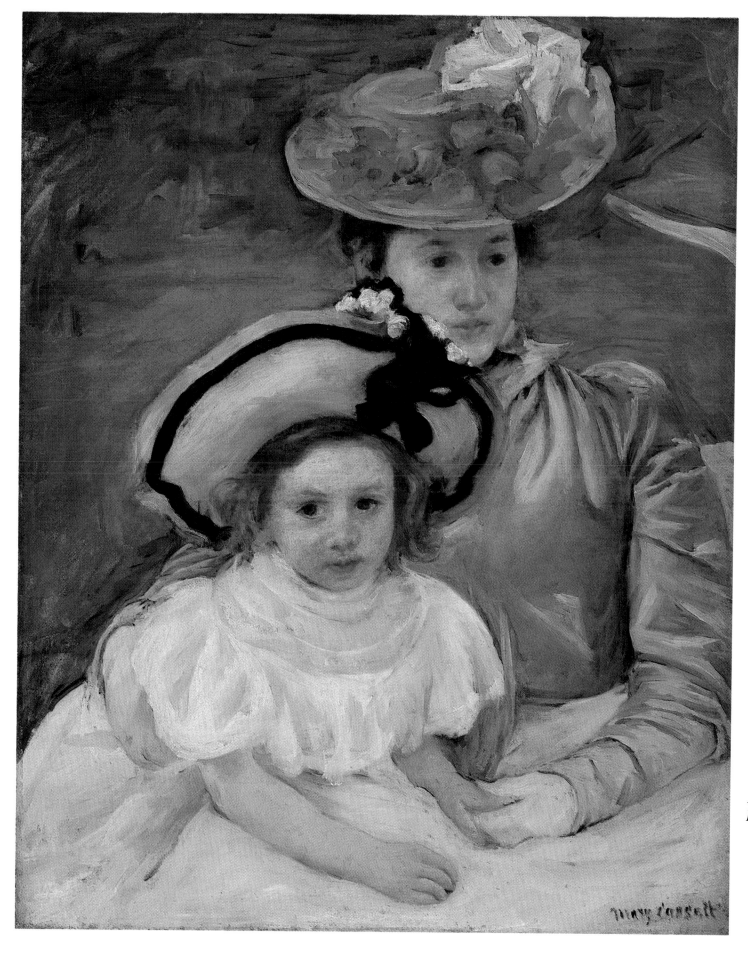

Mother and Daughter,
Both Wearing Large Hats

81

Arthur G. Dove (1880-1946)

The Lobster, 1908

Oil on canvas, 25 7/8 x 32 in.
(65.7 x 81.3 cm)
Inscribed l.r.: "DOVE/08"
Acquisition in memory of Anne Burnett
Tandy, Trustee, Amon Carter Museum,
1968-1980

1 Ann Lee Morgan, *Arthur Dove: Life and
Work, with a Catalogue Raisonné* (Newark: University of Delaware Press, 1984), pp. 93-95,
lists twenty-three; seventeen are unlocated.
2 *New York World*, 14 March 1910.

In 1904, shortly after graduation from Cornell University and contrary to his family's wishes, Arthur Dove moved to New York City to become an artist. There he married a girl from his hometown, Geneva, New York, and for five years, like so many of his contemporaries, made a living as a magazine illustrator. Having saved enough money from his illustration work, Dove and his wife sailed for Europe in 1908. In Paris, he met Alfred Maurer and Arthur B. Carles and joined a group of Americans who were intrigued by the work of the Impressionists and the Fauves. During visits to the countryside outside Paris and near Cagnes-sur-Mer in the south of France, Dove painted a number of landscapes, each reflecting Impressionist and Fauve ideals of color and fluid composition.[1]

Dove similarly drew upon French prototypes in a still life of the same period entitled *The Lobster*. This work, which the artist exhibited at the Salon d'Automne of 1909, shows the influence of Cézanne in the freely applied paint and the choice of vivid colors. The flower and vine motif, which Dove used in the background of *The Lobster* and in one other still life he painted about the same time, is also reminiscent of the many colorful backdrops which Henri Matisse introduced into his pictures.

Dove's French Post-Impressionist styles were largely abandoned shortly after he returned to America in 1909, although his paintings retained the bold coloration of the Fauve palette. *The Lobster* was among the first paintings he showed Alfred Stieglitz, director of the Little Galleries of the Photo-Secession, known as 291, when they met in late 1909 or early 1910. It was exhibited a few months later in Stieglitz's influential exhibition of "Younger American Painters," which was held in March 1910. The freshly killed lobster, which fills the lower left corner of the canvas with its broad, curving claws and relaxed body, was appreciated for subject as well as style and elicited the following comment from one art critic: "Do you want your optic nerve stimulated so that you will see life with a new vision? Go and see Dove's delineation of a diabolical lobster who died a horrible death."[2]

This exhibition was pivotal in Dove's career, for it marked the beginning of his long friendship with Stieglitz and pointed to the artist's break from European modernism and to the beginning of his own distinctively personal artistic vocabulary.

The Lobster

Arthur G. Dove (1880-1946)

Team of Horses, 1911 or 1912

Pastel on composition board mounted on plywood, 18 1/8 x 21 1/2 in. (46.0 x 54.6 cm)
Inscribed l.r.: "Dove"

1 "Dove and His Father, 1919," unpublished material; Stieglitz, as dictated to Dorothy Norman, February 1937 (cited in Suzanne M. Mullett, "Arthur G. Dove [1880-], A Study in Contemporary Art," Master's thesis, American University, Washington, D.C. 1944, p. 9.
2 Downtown Gallery, New York, artists' files, Arthur Dove, index card inscribed: "*Horse and Cart* (1911-1912) Picture about which Bert Lester [sic] wrote." Also cited in Frederick S. Wight, *Arthur G. Dove* (Los Angeles: Art Galleries, University of California, 1958), p. 35. Dove avoided assigning titles to his work, preferring the image to have no external associations imposed upon it.
3 Ann Lee Morgan, *Arthur Dove: Life and Work, with a Catalogue Raisonné* (Newark: University of Delaware Press, 1984), p. 110.
4 Paul Rosenfeld, *Port of New York* (1924; rpt. Urbana and London: University of Illinois Press, 1966), p. 172.

Arthur Dove's vigorous experimentation with abstract forms in the period from 1910-1912 was carried out in both the oil and pastel media. In 1911, the artist was working almost exclusively in pastel, and Alfred Stieglitz included ten of these important and innovative works in Dove's first one-man show at Stieglitz's 291 gallery the following year. Stieglitz later reported that "a series of abstracts . . . went up and of course they were over the heads of the people . . . they were beautiful, they were not reminiscent of anyone else."[1] After the exhibition of the pastels, either Dove or Stieglitz gave the ten works one comprehensive title, *The Ten Commandments*—an appropriate designation since as a group the works appear to have served as the foundation for all the artist's future work.

Team of Horses, also referred to in early records as *Horse and Cart*[2] and *Horses in Snow,*[3] was one of the ten. One critic in the 1920s observed that in *Team of Horses* the "pastel of the reds and blacks and yellows about the gray egg-like shape comes out of the inner feelings of giant horses dragging a load up a yellow-loamed hill, and gives in the cog-like shape and gray mass the working of straining backs and the downward will of the heavy inert bulk."[4]

A true color technician, Dove ground his own pastels, which gave him added freedom to select and mix his colors. Never settling for simple primary and secondary, more or less "pure" colors, he broadened his experimentation into subtle variations of the tertiary colors. He favored earth tones, an unusual choice at this time when other American artists, like his friends Alfred Maurer and Arthur B. Carles, were experimenting with more vivid palettes, as had Dove himself in *The Lobster*. Although the pastels, including *Team of Horses,* often appear as flat designs, close observation reveals a very elementary yet discerning use of plane over plane with light and dark values imparting a sense of depth.

Dove's love of the land and everyday subjects, reflected in his work throughout his career, was illustrated early in *The Ten Commandments* series, which was created when he was living on a farm in Westport, Connecticut. There, he struggled to make a living from farming, lobster fishing, and commercial illustration.

By the end of the decade, Dove was estranged from his wife. He left home and purchased a forty-two-foot yawl, the *Mona*. For the next seven years, Dove shared this unusual living situation with Helen Torr, "Reds," an artist he had met in Westport. During this period, Dove painted and experimented with collage and assemblages, often incorporating materials he found on his boat or along the shoreline, as seen in the Amon Carter Museum's hauntingly beautiful abstraction, *Untitled*.

In 1938, Dove and Reds, who had since married, settled into a small house in Centerport, Long Island. The artist died there in 1946, close to the land and water he loved and which inspired his work for much of his career. *Thunder Shower,* also in the Amon Carter Museum collection, was painted in the last few years of his life and appears to recall the days on the *Mona*. It is a consummate example of Dove's innate ability for painting the mood, emotion, sound, and effects of natural phenomena without the use of specific details.

Team of Horses

Morton Livingston Schamberg (1881-1918)

Figure B (Geometrical Patterns), 1913

Oil on canvas, 32 1/4 x 26 1/8 in.
(81.9 x 66.4 cm)
Inscribed u.r.: "Schamberg/1913"

1 The secondary title, *Geometrical Patterns,* has become associated with the paintings since the artist's death. These works are illustrated in William C. Agee, *Morton Livingston Schamberg* (New York: Salander-O'Reilly Galleries, Inc., 1982), Nos. 24-26 and in the Supplement to the Checklist, No. 62.
2 Agee, p. 8. *Le Luxe II* is illustrated in Alfred H. Barr, Jr., *Matisse: His Art and His Public* (New York: The Museum of Modern Art, 1951), p. 341. Schamberg himself exhibited five paintings in the Armory Show.
3 See William C. Agee, *Morton Livingston Schamberg (1881-1918): The Machine Pastels* (New York: Salander-O'Reilly Galleries, Inc., 1986).

Figure B (Geometrical Patterns) is one in a series of four abstract compositions painted by Philadelphia artist Morton Livingston Schamberg in 1913 and 1914. Titled by the artist simply *Figure,* these works stand as Schamberg's most complete statement of the modernist aesthetic and attest to his confident assimilation of the tenets of avant-garde European art.[1]

Recalling the Cubists' fragmentation of the human form, in *Figure B,* interlocking color planes describe the contours of a seated figure. Integrated into the pictorial space through the employment of parallel color and linear pattern, the figure, rendered in profile, is reduced to a network of geometric forms. An oval placed slightly off-center, the figure's head, leads into the sweeping arc of the back extending down the right side of the canvas, while a succession of red segments emanating from the shoulder and tapering into an orange triangle suggests the configuration of an arm. Echoing the outline of the back are the broad curvilinear divisions of one leg, while the other bends beneath the figure. Such contemporary artists as Henri Matisse and Max Weber shared Schamberg's fascination with the contortions of the abstracted human form. Indeed the posture of one of the figures in Matisse's *Le Luxe II* (1908), a work Schamberg would have seen at the Armory Show in New York, is similar to that in *Figure B.*[2] The first major exhibition of modernism in the United States, the Armory Show opened in 1913, the year Schamberg initiated his *Figure* series.

Schamberg's conversion to an avant-garde style began nearly a decade prior to the Armory Show, when as a young art student he was introduced to a broad spectrum of European art. Upon receiving a degree in architecture at the University of Pennsylvania, Schamberg embarked upon a three-year course at the Pennsylvania Academy of the Fine Arts. His teacher, William Merritt Chase, conducted study trips to England, Holland, and Spain for Schamberg and his classmates. Following graduation from the Pennsylvania Academy in 1906, several extended trips to France and Italy exposed Schamberg to the work of the Post-Impressionists, Fauves, and Cubists, providing an artistic foundation on which he formulated his theories of modern painting. Abandoning his early style, which was characterized by the atmospheric renderings of Chase's Impressionist school, Schamberg increasingly emphasized structure over subject, allowing line and bold color to assume a dominant role in his work.

Like Matisse, Schamberg favored an intense palette of primary colors. In *Figure B,* Schamberg applies color unevenly in a dry pastel-like manner. Patterns emerge through the placement of primary and complementary hues—red describes the major anatomical divisions, blue and green fill the voids around the figure, and orange is contiguous to the colors red and yellow. The modulation of color within the anatomical divisions imparts a sense of volume; the extremities of the figure appear to bend and twist in space.

Schamberg continued his color experiments to the end of his career when his work took on the hard-edged style and mechanical imagery of Precisionism. A group of simple pastels depicting textile and book binding equipment dating to 1916 recall Schamberg's early training as an architectural draftsman and are unique in their vivid and unconventional coloration.[3] Schamberg's career was cut short when he died suddenly at the age of thirty-six in the 1918 influenza epidemic.

Morton Livingston Schamberg (1881-1918)
Composition, c. 1916
Pastel and graphite on paper,
8 x 5 1/2 in.
(20.3 x 14.0 cm)
Inscribed l.r.: "Schamberg"

Morton Livingston Schamberg (1881-1918)
Composition, c. 1916
Pastel and graphite on paper,
9 3/4 x 6 5/8 in.
(24.8 x 16.8 cm)

Figure B

87

Charles Demuth (1883–1935)
Three Acrobats, 1916
Watercolor and graphite on paper,
13 x 8 in.
(33.0 x 20.3 cm)
Inscribed l.l.: "C. Demuth. 1916."

In the Province #7

Charles Demuth (1883-1935)

In the Province #7, 1920

The title of this work refers to Lancaster, Pennsylvania, the lifelong home of Charles Demuth. One of the most sophisticated of America's early modern masters, Demuth amiably described this Pennsylvania Dutch settlement to his New York friends as "the province" or "my province." The artist could justifiably assume a proprietary attitude since his family traced its residence in the town back to the eighteenth century. Lancaster not only provided Demuth with subject matter but also with a sense of security, a feeling especially important to him when he began to suffer from diabetes.

Painted in 1920, *In the Province #7* appeared at an important juncture in the artist's life and career.[1] In this year, his illness was diagnosed, and his art underwent significant changes. Turning from his favorite medium, watercolor, Demuth explored other media, often mixing them as in *In the Province #7*. Further, this composition forms part of the series of paintings for which Demuth is best known today: images of architecture, especially the industrial landscape.

In the Province #7 depicts St. John's German Reformed Church, a structure which stood only three blocks from the house the artist shared with his mother.[2] Demuth emphasizes the soaring verticality of the church's slender spire as it pierces a sky activated by Cubist fragmentation and Futurist lines of force. This delicate tautness of the lines in *In the Province #7* differs from the suppleness frequently seen in earlier Demuth works, such as *Three Acrobats,* which was part of a 1916-1919 series of watercolors depicting circus and vaudeville performers. A later Demuth work, *Cineraria,* also in the Amon Carter Museum, combines and balances the crisp linearity of *In the Province #7* with the fluidity of *Three Acrobats.*[3]

Demuth, who had studied for five years at the Pennsylvania Academy of the Fine Arts, knew avant-garde European art firsthand from his frequent trips to New York and abroad and from his friendships with artists like Marcel Duchamp and Francis Picabia. Largely under the sway of Cubism, Demuth's art grew increasingly modern in style from 1917 on, and as is evident in *In the Province #7,* it became more highly refined as well.

Once, when asked "What do you look forward to?", Demuth replied, "the past."[4] In its modernist interpretation of an old (and, for him, familiar) building, *In the Province #7* neatly encapsulates Demuth's Janus-like attitude toward the past and the present and his ability to see and render beauty in each.

Tempera, watercolor, and graphite on composition board, 20 x 16 in. (50.8 x 40.6 cm)
Inscribed l.c.: "C. Demuth Lancaster Pa"
verso, u.c.: "In the Province #7—/C. Demuth/Lancaster Pa 1920"

1 Two other paintings titled "In the Province" and also dating from 1920 are known today. They are found in the Philadelphia Museum of Art and the Museum of Fine Arts, Boston.
2 Betsy Fahlman, *Pennsylvania Modern: Charles Demuth of Lancaster* (Philadelphia: Philadelphia Museum of Art, 1983), p. 39.
3 During his lifetime, Demuth's most popular works were his flower paintings. See Fahlman, p. 56.
4 Fahlman, p. 11.

Marsden Hartley (1877-1943)

Provincetown Abstraction, 1916

Oil on composition board,
19 7/8 x 15 7/8 in.
(50.5 x 40.3 cm)
Inscribed verso, l.c.: "*Marsden Hartley*"

1 Barbara Haskell, *Marsden Hartley* (New York: Whitney Museum of American Art, 1980), pp. 54-56. Hartley stayed in Provincetown with Charles Demuth in September and October. He and Demuth went to Bermuda together in the winter of 1916-1917.
2 Related works painted by Hartley in 1916 include *Abstraction Provincetown* (The Art Institute of Chicago, Stieglitz Collection), *Movement No. 9* (Walker Art Center, Minneapolis), *Sailboat* (Columbus Museum, Howald Collection), and *Elsa* (University Art Museum, University of Minnesota, Walker Collection).

In the summer of 1916, the journalist and political radical John Reed invited Marsden Hartley to his house in Provincetown, Massachusetts. With the war in Europe making travel abroad impossible, many artists and writers gravitated to this Cape Cod town. Among the stimulating personalities with whom Hartley socialized, later causing him to refer to this time as "the Great Provincetown Summer," were the collector Leo Stein, Louisa Bryant (who later married Reed), Eugene O'Neill, and Charles Demuth.[1] The summer was artistically productive for Hartley as well, with *Provincetown Abstraction* being an excellent example of the work he created.[2]

Provincetown Abstraction relates to but also differs significantly from the compositions Hartley had been making from 1913 to 1915. The affinity to his earlier work lies in the painting's abstract forms being derived from nature, in this case the movement of sailboats, and in the inclusion of a concentric semicircular motif, which had frequently appeared in his work. The differences from the earlier paintings include *Provincetown Abstraction*'s greater flatness and distillation of forms, its more purely abstract quality, and more subdued colors.

Prior to Provincetown, Hartley, a member of Alfred Stieglitz's 291 circle since 1909, had spent much of his time in Europe painting and studying avant-garde art. Especially important to him were two stays in Berlin, one from May to November 1913 and the other from March 1914 to December 1915. Friendly with "Blue Rider" artists Wassily Kandinsky, Gabriel Münter, and Franz Marc, Hartley painted a number of highly decorative abstract works which treated mystical subject matter as well as German military pageantry. His work found favor in Germany, and a large exhibition of his paintings and drawings opened in Berlin in October of 1915. Soon afterwards, however, wartime conditions necessitated his leaving Germany. When these works appeared in a 291 exhibition in April 1916, Hartley, recognizing the strong anti-German sentiment of the day, denied any hidden symbolism in his images, stressing their pictorial concerns.

In the Provincetown paintings, Hartley freely explored the expressive possibilities of abstract forms. Although initially inspired by nature, the works move close to being entirely nonobjective, with interlocking and interpenetrating planes floating in an indefinite sea of space. The artist's keen understanding of Synthetic Cubism shapes these pictures, as is evident in *Provincetown Abstraction*'s centralized composition, collagelike appearance, textured surface, flattened forms, and muted, multiple colors. Hartley's skillful manipulation of this modernistic aesthetic, in *Provincetown Abstraction* and other works painted in the summer of 1916, clearly places him among the front ranks of early twentieth-century American avant-garde artists.

Earth Cooling, 1932

Ever restless (as an adult he never stayed in the same lodging more than twelve months), Marsden Hartley traveled to Mexico in 1932.[1] A grant from the Guggenheim Foundation, which required him to work outside the United States, made the trip possible. Given his uncertain health at the time, Hartley's selection of Mexico probably related to its proximity and to his recollections of the salubrious climate of New Mexico, which he had experienced in 1918 and 1919. Hartley stayed in Mexico for one year, living in Mexico City and Cuernavaca. For Hartley, the year proved to be one of mixed blessings. While the opportunity to study the Aztec and Mayan cultures stirred his imagination, and the sculptural quality of the landscape pleased him, he came away dissatisfied: "Mexico was a place that devitalized my energies—was the one place I shall always think of as wrong for me. . . ."[2] Despite such sentiments, the artist produced some remarkable images during this period, including the powerful *Earth Cooling*.

In painting this stark landscape, Hartley employs an intentionally primitive style to pare away detail and reduce the natural configurations—even the clouds—to imposing, elemental forms. He wanted the image to "approach the solidity of the landscape itself," an ambition he had set forth earlier in an 1918 article he wrote called "America as Landscape."[3] His primitive style also appropriately conveys the primordial character of the land. Indeed, *Earth Cooling* represents not only the coming relief of evening after a scorching desert day, but also suggests the cooling and quieting down of the earth after the boiling eruptions of its very creation. Although the composition displays a wide range of colors, the hot reds—glowing like lava—clearly dominate. Hartley shows this frantic energy, locked into the landscape forms, giving way to the evening calm.[4] In rendering this moment of transformation, the artist succeeds in capturing the timelessness of the land and his own sense of awe in seeing it just as it must have appeared when first formed.

From the 1930s until his death in 1943, the artist worked in the style seen in *Earth Cooling*: an expressionist manner conditioned by a primitive directness about its forms and content. Another Hartley painting in the Amon Carter Museum's collection, *Sombrero and Gloves* (1936), displays these same characteristics. This still life surely relates to Hartley's earlier stays in Mexico and the Southwest, and may be, in a broad sense, a self-portrait. Painting still lifes occupied his attention at this time and had since a summer trip to Bermuda in 1935. The year after he executed *Sombrero and Gloves*, Hartley returned to his home state of Maine, where he spent his final years painting often brooding images of its rugged landscape.

Oil on cardboard mounted on masonite,
24 1/2 x 33 7/8 in.
(62.2 x 86.0 cm)
Inscribed verso:
"EARTH-COOLING/MARSDEN/HARTLEY/
MEXICO/1932."

1 Barbara Haskell, *Marsden Hartley* (New York: Whitney Museum of American Art, 1980), p. 8.
2 Haskell, p. 93.
3 Sharyn Rohlfsen Udall, *Modernist Painting in New Mexico 1913-1935* (Albuquerque: University of New Mexico Press, 1984), p. 43.
4 In 1932, Hartley also painted a work entitled *Earth Warming, Mexico* (Private collection; illustrated in Haskell, p. 104). The similarity of this composition's title and dimensions (25 1/2 x 33 1/4 inches) to the Amon Carter Museum painting suggests that Hartley may have conceived the two works as pendants.

Provincetown Abstraction

92

Earth Cooling

Oscar Bluemner (1867-1938)

Blue Day, 1930

Casein on paper mounted on board,
15 x 20 1/8 inches
(38.1 x 51.1 cm)
Inscribed l.r.: "BLÜEMNER"

1 See Jeffrey R. Hayes, "Oscar Bluemner's Late Landscapes: 'The Musical Color of Fateful Experience,' " *Art Journal,* 44, No. 4 (Winter 1984), 352-360.
2 Oscar Bluemner Papers, Archives of American Art, Smithsonian Institution, Roll 340, frames 1935-1936.

Oscar Bluemner's fascination with modern art, color theory, and philosophy led him to imbue ordinarily placid landscapes with highly personal emotional and symbolic associations.[1] A native of Germany, Bluemner first pursued an architectural career in both Chicago and New York, following his arrival in the United States in 1892. Soon after he became a full-time artist in 1911, Bluemner's work was featured in exhibitions in Germany and at Alfred Stieglitz's 291 gallery in New York.

The casein drawing *Blue Day* was based on a sketch from nature executed in New Jersey in 1918. Bluemner had a deep attachment to the state where he had settled in 1916, and although he had left New Jersey for Braintree, Massachusetts, in 1926, he continued to paint this favored subject. *Blue Day* depicts a site in Boonton, along the old Morris canal, where a lock has been opened, the rushing water filling the foreground of the painting. Bluemner has heightened the experience of reality by exaggerating the organic rhythms of the original scene and re-creating it in terms of mass and intense color. Red buildings are a recurring motif in Bluemner's work, and in *Blue Day* they serve to balance the composition with their simple planar facades and repetition of color. The color red seemed to have special significance for the artist and was predominant in many of his works. These buildings, transformed by Bluemner into mysterious icons, display the emotional intensity of his belief that paintings reflected universal truths. Here, the mood is somewhat somber, perhaps suggesting a growing concern late in Bluemner's life that he was never able to match the recognition he enjoyed at the outset of his artistic career.

Fascinated with the craft of painting as well as the theory, Bluemner included extensive technical calculations relative to the painting of *Blue Day* in his diary for 1930. Bluemner notes that the work marked his first experimentation with casein, a substance which he added to watercolor in order to impart an opaque quality to a generally translucent medium. Bluemner was intrigued by the challenge of producing the effect of an oil painting and even varnished the casein painting in the manner of an oil. Enumerating the qualities he sought to convey in *Blue Day* through a limited palette of vivid red, blue, green, and white, Bluemner wrote in his diary of his efforts "to organize one single spaceform, as one object, of a mineral running lapis lazuli, in veins from palest blue white to black blue, of malachite, and of vermilion"—the unique vision of an important early modern artist committed to an ongoing exploration of theory and method.[2]

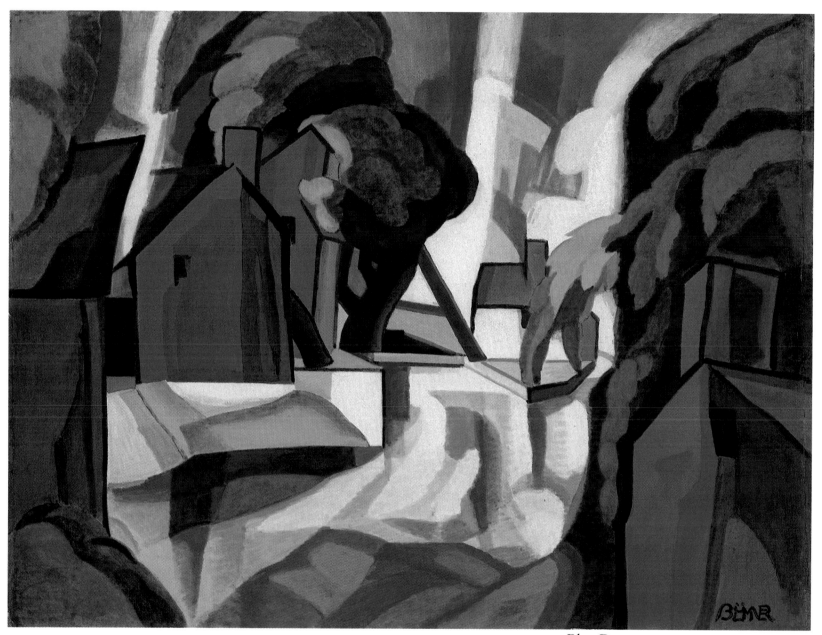

Blue Day

Near Taos, No. 6, New Mexico

John Marin (1870-1953)

Near Taos, No. 6, New Mexico, 1930

Like many other early American modernist painters, including Stuart Davis, Marsden Hartley, and Georgia O'Keeffe, John Marin journeyed to New Mexico. However, unlike most of the others, Marin had achieved critical and financial success by the time he arrived there in the summer of 1929. Consequently, the more than one hundred watercolors he produced that summer and the following attracted a great deal of attention. Marin's interest in the Southwest was undoubtedly fueled by conversations with his friend Hartley. In addition, New Mexico offered the fulfillment of sentiments Marin expressed in a 1928 essay, where he wrote that "the true artist must perforce go from time to time to the elemental big forms—Sky, Sea, Mountain, Plain—and those things pertaining thereto—to sort of re-true himself up to recharge the battery."[1] So when Mabel Dodge Luhan, the cultural impresario of the Southwest, invited him out at the suggestion of Georgia O'Keeffe, Marin was ready to go.

Marin was impressed by the space ("the country is so damn big,"[2] he marveled) and the light of New Mexico ("many times more intense than anything you get in New York, or Maine, or the White Moutains"[3]). Still, he maintained his already firmly established style.[4] The artist had arrived at his characteristic style following a somewhat circuitous route.

Trained as an architect, Marin left his practice in 1899 to enroll in the Pennsylvania Academy of the Fine Arts, studying under Thomas Anschutz and William Merritt Chase until 1901. He sailed to Europe in 1905, remained there until 1909, then went abroad again in 1910 for another year. While in Europe, he witnessed the impact of Post-Impressionism, Fauvism, and Cubism. This exposure to modernism and Marin's affiliation with Alfred Stieglitz's avant-garde 291 gallery (where Marin's first solo exhibition took place in 1910) were influential in the development of the artist's signature style which emerged around 1912.

The Museum's *Near Taos, No. 6, New Mexico* exemplifies the vigor of Marin's art and his mastery of the watercolor technique. In this painting, the artist renders a view looking east from the road to Arroyo Seco toward Mt. Wheeler.[5] The work's flowing washes of color and slashing strokes convey Marin's rapidity of execution and his dynamic worldview. Here, as in most of his work since 1912, Marin renders the energy he sensed underlying everything: "I see great forces at work—great movements. . . . "[6] Aware that rendering the "great forces" might lead to chaos, Marin noted that "I can have things that clash. I can have a jolly good fight going on . . . But I might be able to control this fight at will with a blessed equilibrium."[7] One way he achieved this balance was to paint—loosely in *Near Taos, No. 6, New Mexico*—a frame within the work which kept the image from bursting its boundaries. From 1919, Marin consistently employed this framing device. Not only did it function compositionally to order a work, but the interior frame may have served a metaphoric purpose as well, for Marin once remarked, "There is a veil in front of the Artist, he's got to pierce that veil."[8]

The Museum's collection complements *Near Taos, No. 6, New Mexico* with another impressive Marin watercolor from the same year—*Taos Canyon, New Mexico.*

*Watercolor and black crayon on paper,
15 1/4 x 22 in.
(38.7 x 55.9 cm)
Inscribed l.r.: "Marin 30"*

1 Cleve Gray, *John Marin by John Marin* (New York, Chicago, San Francisco: Holt, Rinehart and Winston, 1977), p. 161.
2 Gray, p. 58. Marin's comment was made in 1929.
3 Sharyn Rohlfsen Udall, *Modernist Painting in New Mexico 1913-1935* (Albuquerque: University of New Mexico Press, 1984), p. 127.
4 To convey a sense of the region's aridity, Marin frequently incorporated a dry brush technique in his New Mexico watercolors, as seen in passages of *Near Taos, No. 6, New Mexico.* For a detailed consideration of his technique and style at this time, see Walter Ellsworth Stevens, "John Marin: The New Mexico Period," Master's thesis, University of New Mexico 1967, Chapter 2.
5 Van Deren Coke, *Marin in New Mexico/ 1929 & 1930* (Albuquerque: University of New Mexico, University Art Museum, 1968), p. 32.
6 Gray, p. 105. Marin had this remark in the catalogue for his 1913 exhibition at 291.
7 Gray, p. 156. This is a 1928 comment.
8 Gray, p. 51. This remark is undated.

Georgia O'Keeffe (1887-1986)

Light Coming on the Plains I, II, III, 1917

*Watercolor on paper, each 11 7/8 x 8 7/8 in.
(30.2 x 22.5 cm)*

1 Lloyd Goodrich and Doris Bry, *Georgia O'Keeffe* (New York: Whitney Museum of American Art, 1970), p. 7.
2 Calvin Tomkins, "Profiles: The Rose in the Eye Looked Pretty Fine," *New Yorker,* 4 March 1974, p. 42.
3 Charles C. Eldredge, *American Imagination and Symbolist Painting* (New York: New York University, Grey Art Gallery and Study Center, 1979), p. 16.
4 Susan Fillin Yeh, "Innovative Moderns: Arthur G. Dove and Georgia O'Keeffe," *Arts Magazine,* June 1982, p. 72.

Georgia O'Keeffe painted this remarkable series of watercolors while teaching at West Texas State Normal College in Canyon, Texas. Already familiar with the Panhandle area of Texas before arriving in Canyon in 1916 (she served as art supervisor for the nearby Amarillo school system from 1912 to 1914), she felt entirely at home there, commenting later, "That was my country—terrible winds and a wonderful emptiness."[1] This appreciation, even reverence, for the beauty and sublimity of the place suffuses her images of *Light Coming on the Plains.*

In creating these three watercolors, O'Keeffe drew upon her keen, direct observation of nature as well as on her art training and aesthetic interests. Taking long walks and drives through the countryside, the artist immersed herself in the landscape. On one occasion she witnessed a particularly memorable sunrise, which may have inspired the *Light Coming on the Plains* paintings: "The light would begin to appear, and then it would disappear and then there would be a kind of halo effect, and then it would appear again. The light would come and go for a while before it finally came."[2] The watercolors' washes of blue-greens, spanning the range of values from high to low, convincingly impart this radiating and pulsating effect of daybreak. *Light Coming on the Plains I,* with its concentric rings of color, dramatically captures this dynamic vision, while the other two images more subtly transform the haloing effect into a dome of heaven. The pictures couple this naturalistic aura with a high degree of abstraction, attained through extreme simplification of form and elimination of detail. The resulting images induce a spirit of contemplation directed toward both natural phenomena and abstract forms.

O'Keeffe had been exploring the possibilities of abstraction since 1915. In so doing, she sloughed off the early training she had received at the School of the Art Institute of Chicago and the Art Students League in New York, where she studied under William Merritt Chase. In moving toward abstraction, she had been greatly influenced by Alon Bement at the University of Virginia, which she attended in 1912, and by Bement's teacher, Arthur Wesley Dow, with whom she studied at Columbia University's Teachers College in 1914-1915. Dow emphasized compositional design, believing that the successful work of art possessed a formal "beauty entirely independent of meaning."[3] O'Keeffe acknowledged his impact on her art by remarking that while she "had a technique for handling oil and watercolor easily; Dow gave me something to do with it."[4] In 1916, O'Keeffe received encouragement for her abstract work from Alfred Stieglitz, photographer and champion of modern art, who had been shown her work by a friend of hers. He wrote to O'Keeffe in Texas, praising her achievements, and in May 1916, without her knowledge, included her work in a group exhibition at his famous gallery, 291. Though at first angered by the public display of her private work, the artist later allowed Stieglitz to show her work in a solo exhibition, the last exhibition ever held at 291, the following year. In 1924, she and Stieglitz were married.

The *Light Coming on the Plains* series occurred at a particularly exciting and crucial period in the artist's life. O'Keeffe embraced abstract art and, in so doing, began her rise to preeminence among modern American artists.

Red Cannas, 1927

Red Cannas exemplifies a well-known Georgia O'Keeffe motif: the enlarged image of flowers. While the artist had painted floral subjects since childhood, her early flower paintings generally presented the subject isolated and contained, unlike the expansive robustness pictured in the Carter Museum's *Red Cannas*. O'Keeffe painted the first of what she called her "blown-up flowers"—a magnified floral image brought close to the picture plane on a large canvas—around 1923.[1] While the enlarged scale clearly relates to the contemporary photography of Paul Strand and Alfred Stieglitz, whose work she knew well, O'Keeffe explained her new approach by noting that:

> Nobody sees a flower—really—it is so small—we haven't time—and to see takes time, like to have a friend takes time. If I could paint the flower exactly as I see it no one would see what I see because I would paint it small like the flower is small.
>
> So I said to myself—I'll paint what I see—what the flower is to me, but I'll paint it big and they will be surprised into taking time to look at it—I will make even busy New Yorkers take time to see what I see of flowers.[2]

By focusing so closely on flowers, O'Keeffe commands the viewer's attention and renders an image balanced subtly between magnified representation and dynamic abstraction. This fusing of the objective and nonobjective impressed the public and critics alike. Writing of her "flower interiors" in 1927, Lewis Mumford deemed O'Keeffe "perhaps the most original painter in America today."[3]

In *Red Cannas,* the enlarged tropical flower radiates out from its petal-like stamen with half-anther (on which pollen shows). The flowing curvilinearity of the massive, bright red petals more than fills the composition and vividly suggests a luxurious organic growth continuing beyond the bounds of the canvas. *Red Cannas'* abstract forms and passionate color evoke a sensuality often seen in O'Keeffe's flower paintings of this time. The red canna seems to have been a particularly appealing subject to O'Keeffe, for beginning in 1919, she painted it on several occasions. Interestingly, the first O'Keeffe oil painting ever sold by Stieglitz, as her art dealer, depicted a red canna.[4]

Oil on canvas, 36 1/8 x 30 1/8 inches (91.8 x 76.5 cm)
Inscribed on verso:
"Georgia O'Keeffe/1927"
verso, on stretcher:
"Georgia O'Keeffe—1927—Red Cannas"

1 Her term "blown-up flowers" appears in Katherine Hoffman, *An Enduring Spirit, The Art of Georgia O'Keeffe* (Metuchen, N.J. and London: The Scarecrow Press, Inc., 1984), p. 102. O'Keeffe had rendered magnified flowers as early as 1919 (*Red Flower,* The Warner Collection of Gulf States Paper Corporation, Tuscaloosa, Alabama), however, such images appeared on smaller canvases than those after 1923 (*Red Flower,* for instance, measures 20 1/4 x 17 1/4 inches).
2 Georgia O'Keeffe, *Georgia O'Keeffe* (New York: The Viking Press, 1976), n.p. This statement originally appeared in the catalogue of an exhibition of O'Keeffe's work held at Stieglitz's An American Place gallery in 1939.
3 Lewis Mumford, "O'Keefe [sic] and Matisse," *The New Republic,* 50 (2 March 1927), p. 41.
4 Jan Garden Castro, *The Art & Life of Georgia O'Keeffe* (New York: Crown Publishers, Inc., 1985), p. 56. Typical of the smaller size of her earlier flower paintings, this 1919 composition measures 11 1/4 x 8 1/8 inches. Other depictions of red cannas can be found in the collections of the Yale University Art Gallery (c. 1920) and the University of Arizona, Tucson (c. 1923).

Georgia O'Keeffe (1887-1986)

Black Patio Door, 1955

Oil on canvas, 40 1/8 x 30 in.
(101.9 x 76.2 cm)

1 Georgia O'Keeffe, *Georgia O'Keeffe,* (New York: The Viking Press, 1976), n.p. [opp. ill. 82].
2 Other examples include two works in the Lane Collection: *In the Patio IV,* 1948, and *Patio with Black Door,* 1955. The Milwaukee Art Museum collection also includes two 1956 paintings treating the motif: *Black Door with Snow II* and *Patio with Cloud.*
3 Georgia O'Keeffe, n.p. [opp. ill. 88].
4 Emily Genauer writing in the *New York Herald Tribune,* 3 April 1955, quoted in Mitchell A. Wilder, *Georgia O'Keeffe* (Fort Worth: Amon Carter Museum, 1966), p. 22.

In 1930 on her second trip to New Mexico, Georgia O'Keeffe discovered an appealing, empty house in Abiquiu, a small village on a high plateau lying about fifty miles northwest of Santa Fe and overlooking the Rio Chama Valley. Although in disrepair, the Abiquiu adobe impressed her, especially its patio wall with door, which, she commented later, made the house "something I had to have."[1] After trying to purchase the structure for fifteen years and then waiting three more years for renovations, O'Keeffe finally moved into the house in 1948. From the mid-1940s to 1960, the patio wall with door, which so fascinated her, served as a frequent subject for her paintings.[2]

In *Black Patio Door,* the artist presents a sharply cropped, decontextualized view of the wall, which nearly fills the entire space of the painting. This wall looms large, even magnified, recalling O'Keeffe's close-up depictions of flowers from the 1920s. Like those earlier images, the tight point of view in *Black Patio Door* both enhances and obscures the subject. Here, as in so much of her work, the artist effectively melds the representational (or the objective) with the abstract. Reflecting the lifelong influence of her teacher, Arthur Wesley Dow, O'Keeffe noted that "objective painting is not good painting unless it is good in the abstract sense."[3]

In *Black Patio Door,* the artist reduces the composition to what appears to be its absolute essence. Yet, as one critic observed, "the meaning of that essence remains elusive."[4] The enigmatic character of the painting results largely from the rendering of the black door. Seen at an acute angle, the door nearly seems to float, tethered only at one corner at the bottom of the composition. Whatever sense exists of the door being an opening is countered by an equally strong suggestion of its impenetrability. Elusive and allusive in content, abstract and representational in form, *Black Patio Door* exemplifies the inherent richness in the art of Georgia O'Keeffe.

Ranchos Church—Taos (Ranch Church—Grey Sky), 1930

Georgia O'Keeffe's art and life are closely associated with the Southwest, particularly New Mexico, her home for nearly four decades. Although she had passed through the state on a trip to Colorado in 1917, her first extended stay occurred in the summer of 1929. She returned each year until 1949, when after settling the estate of her husband, Alfred Stieglitz, she moved there permanently. Over the years, the region continually fascinated and inspired her. Among the best-known of her many and varied images are her several paintings of the eighteenth-century mission church of St. Francis of Assisi, located in Ranchos de Taos.

O'Keeffe depicted this impressive church about eight times during her first two summers in New Mexico.[1] All, except one, focus on the massive, bulging exterior of the structure's apse end. This adobe church, which O'Keeffe considered "one of the most beautiful buildings left in the United States by the early Spaniards,"[2] undoubtedly appealed to her because of its tremendously close identification with the land out of which it seems to grow. Its undulating lines, its color and material, imbue the structure with a distinctly geological, as opposed to architectural, sensibility. For O'Keeffe, painting *Ranchos Church* must have been very much akin to rendering a "pure" landscape, such as *Dark Mesa and Pink Sky* (1930).[3] In both instances, immense sculptural forms and rhythmic contours fill the space, and as in the best of her work, the artist finely balances representation and abstraction.

Oil on canvas, 24 1/4 x 36 in.
(61.6 x 91.4 cm)
Inscribed verso: "Georgia O'Keeffe - 1930"

1 Lisa Mintz Messinger, "Georgia O'Keeffe," *The Metropolitan Museum of Art Bulletin,* 42 (Fall 1984), 38. Other versions of the subject are found in the collections of the Metropolitan Museum of Art, New York; the Norton Gallery and School of Art, West Palm Beach, Florida; and the Phillips Collection, Washington, D. C.

Virtually hundreds of artists have rendered images of the church in a variety of media. Among photographers, one of the best known is Paul Strand. A friend of O'Keeffe, Strand photographed the building in 1931. His platinum print of that year—now in the Amon Carter Museum—assumes a viewpoint virtually identical to that seen in the Museum's O'Keeffe painting. For a listing of over 125 artists who have taken the church as their subject, see *Images of Ranchos Church* (Santa Fe: Museum of Fine Arts, Museum of New Mexico, 1982). This exhibition catalogue lists photographers from the supplementary exhibition, "Ranchos de Taos: An Exploration in Photographic Style" organized by the Sheldon Memorial Art Gallery, Lincoln, Nebraska, in 1982.

2 Georgia O'Keeffe, *Georgia O'Keeffe* (New York: The Viking Press, 1976), n.p.

3 The painting very likely depicts the sand hills of the Rio Grande Valley, west of Taos. O'Keeffe commented on the region: "It was the shapes of the hills there that fascinated me. The reddish sand hills with the dark mesas behind them. It seemed as though no matter how far you walked you could never get into those dark hills, although I walked great distances." (Messinger, p. 43.)

Light Coming on the Plains I, II, III

102

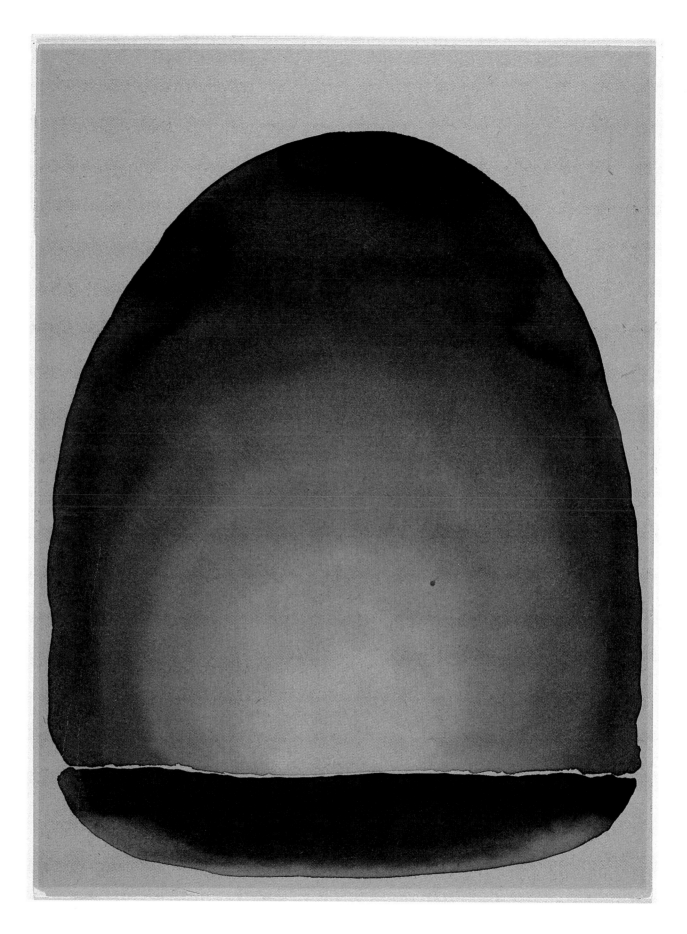

103

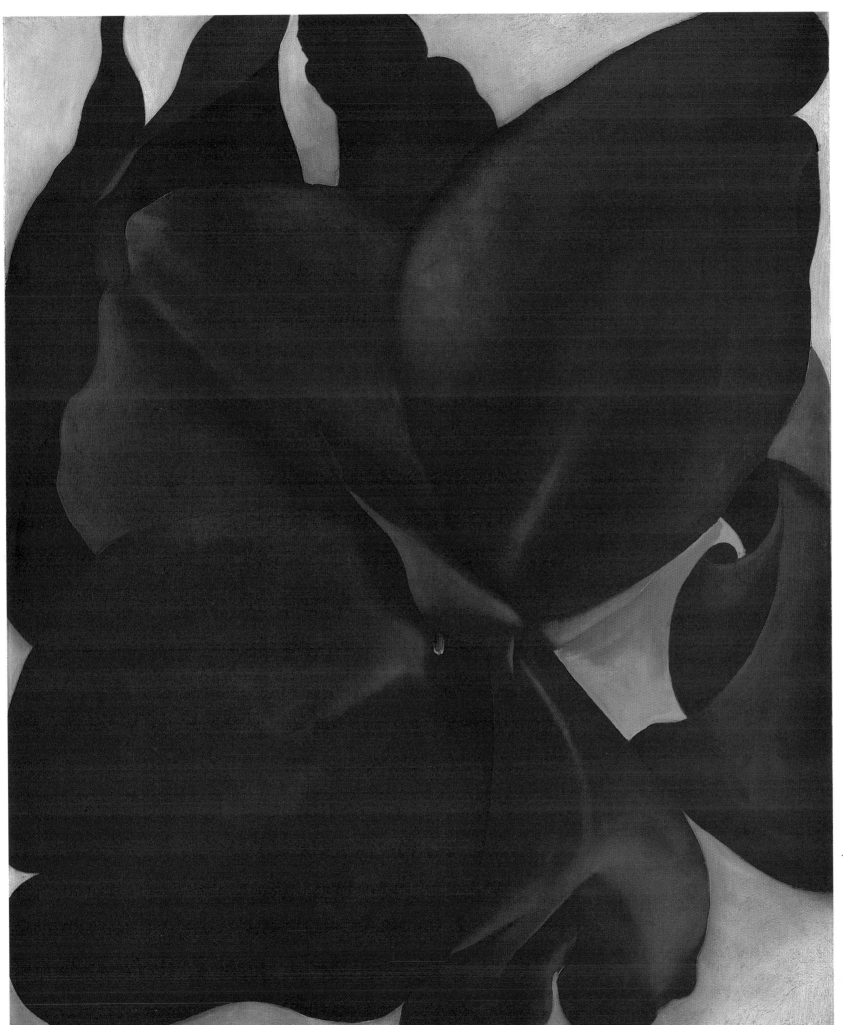

Red Cannas

Black Patio Door

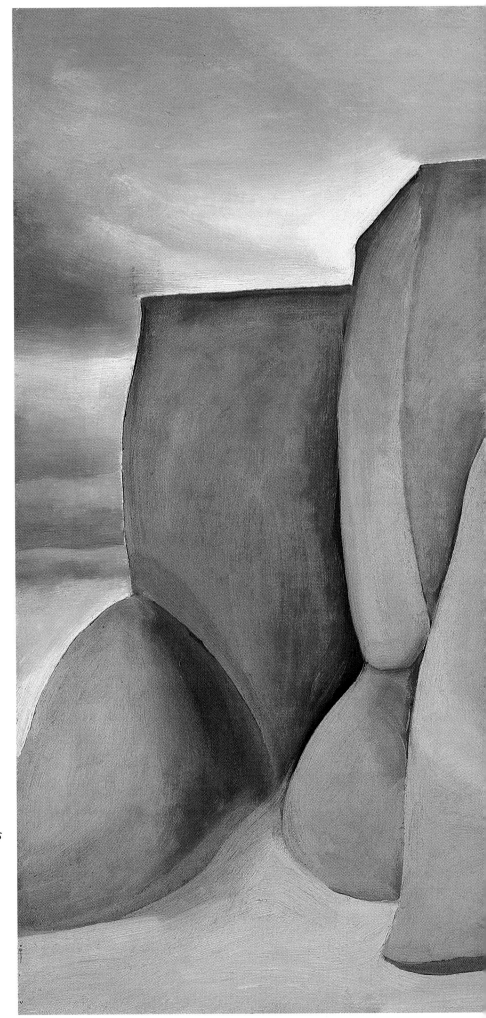

Ranchos Church—Taos

106

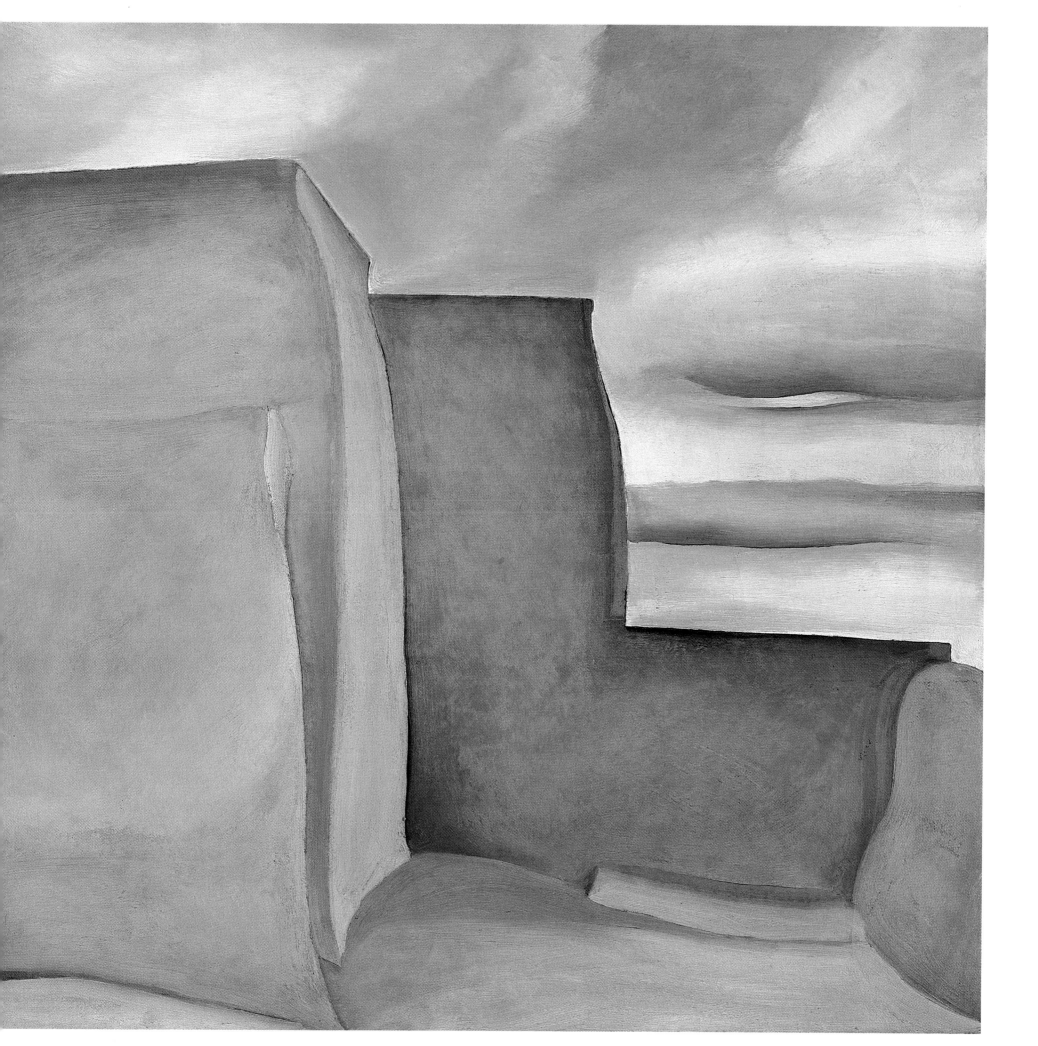

Grant Wood (1891-1942)

Parson Weems' Fable, 1939

Oil on canvas, 38 3/8 x 50 1/8 in.
(97.5 x 127.3 cm)
Inscribed l.r.: "GRANT WOOD/1939"

1 "Statement from Grant Wood concerning his Painting 'Parson Weems' Fable'," transcript dated 2 January 1940, in curatorial files, Amon Carter Museum.
2 Mason L. Weems, *Life of George Washington*, ed. Marcus Cunliffe (Cambridge: The Belknap Press of Harvard University Press, 1962), p. 12.
3 For an account of the widespread interest in George Washington in America in the 1930s and a consideration of the Amon Carter Museum's painting in the context of its times, see Karal Ann Marling, "Of Cherry Trees and Ladies' Teas: Grant Wood Looks at Colonial America," in *The Colonial Revival in America,* ed. Alan Axelrod (New York and London: W. W. Norton and Company, 1985), pp. 294-319.
4 Wanda M. Corn, *Grant Wood: The Regionalist Vision* (New Haven and London: Yale University Press, 1983), p. 3. The Very Reverend James Parks Morton, Dean of the Cathedral Church of St. John the Divine, New York, and his father, Dr. Vance M. Morton (then professor at the University of Iowa), served as models for Washington and his father. The Rev. James P. Morton recalled posing for the artist: "It took place in Grant Wood's backyard on a hot summer day. My father and I were wearing swim suits because Grant Wood wanted to observe the muscles of our legs. My father wore a powdered wig and a tri-corn hat—rented for the occasion. . . . A crowbar was used for the felled cherry tree and for the hatchet I brandished a hammer. I recall the neighbors looking from upstairs windows at these unusual proceedings." Letter, 19 February 1986, curatorial files.

One of the most popular and remarkable works in the Amon Carter Museum collection is *Parson Weems' Fable* by Grant Wood. A leading regionalist painter and printmaker, Wood undertook this work to counter the prevalent trend among historians of debunking American myths and legends. Wood argued that by ridiculing and not passing on the tale of Washington and the cherry tree to children, "something of color and imagination [has] departed from American life. It is this something that I am interested in helping to preserve."[1]

In perpetuating Parson Weems's contribution to American folklore, Wood offers a striking composition featuring a scene-within-a-scene. Weems, who invented the cherry tree incident for the fifth edition (1806) of his extraordinarily popular *Life of Washington* (1800), appears as a master showman who theatrically pulls back the curtain to reveal his creation. Behind Weems, on a perfectly cut lawn, stand the spotlighted figures of Washington and his father. In the son's hand appears the hatchet. The father holds the cut tree with its neatly hanging cherries, which echo the tassels on the curtain Weems holds back. Behind the two Washingtons stands an immaculate house, further back two slaves pick the fruit of another cherry tree, and in the distance appear wooded hills. Throughout the composition, recurrent elements serve to move the viewer's eye. These elements include circular forms (buttons, cherries, trees), a star, which appears on the house as well as on the picture's Wood-designed frame, and, most importantly, the gestures of the principal actors clearly pointing out the narrative.

Weems's account of the episode reads:

> *George*, said his father, *do you know who killed that beautiful little cherry-tree yonder in the garden?* This was a tough question; and George staggered under it for a moment; but quickly recovered himself; and looking at his father, with the sweet face of youth brightened with the inexpressible charm of all-conquering truth, he bravely cried out, *I can't tell a lie, Pa; you know I can't tell a lie. I did cut it with my hatchet.—Run to my arms, you dearest boy,* cried his father in transports, *run to my arms; glad am I, George, that you killed my tree; for you have paid me for it a thousand fold. Such an act of heroism in my son, is more worth than a thousand trees, though blossomed with silver, and their fruits of purest gold.*[2]

Wood's rendering of the cherry tree story differs from Weems's fable in two significant ways. The first and most obvious is the artist's depiction of George Washington as a six-year-old. Wood solves the pictorial dilemma of making the young hero immediately recognizable in a most pragmatic and ingenious fashion: to the body of the child he transplants the most familiar, and iconic, image of Washington—Gilbert Stuart's Athenaeum portrait.[3] In creating this man-child, Wood ironically conveys an essential lesson of Weems's story: in the child is seen the man. The second way in which Wood's depiction differs involves the rendering of the father. The original tale presents the elder Washington as the forgiving father; Wood, however, casts the father as a more authoritarian figure, akin to the artist's memories of his own father.[4] This personal coloring of the story is reinforced by Wood's inclusion of his Iowa City house in the picture and his notion of being, like

Parson Weems' Fable

Weems, a mythmaker.[5] Indeed, Wood anticipated *Parson Weems' Fable* to be the first in a series (never realized) of paintings portraying American myths.

Just as Parson Weems intended his *Life of Washington* to edify and inspire the youth of the new republic, Grant Wood hoped that *Parson Weems' Fable* would "help reawaken interest in the cherry tree and other bits of American folklore that are too good to lose. In our present unsettled times, when democracy is threatened on all sides, the preservation of our folklore is more important than is generally realized."[6]

[John E.] Briggs (then professor at the University of Iowa) served as the model for Weems. Letter from Nan Wood Graham, 16 January 1976, curatorial files.

5 Corn, pp. 120-123.
6 Statement from Grant Wood.

109

World's Greatest Comics

Ben Shahn (1898-1969)

World's Greatest Comics, 1946

Ben Shahn rose to prominence in the 1930s as an artist associated with social realism, a movement which used urban images to convey social criticism. Shahn's first works to attract attention, seen in a 1932 exhibition, related to the controversial trial and execution of the anarchists Nicola Sacco and Bartolomeo Vanzetti. Throughout his career, Shahn expressed his concern for humankind in a variety of art forms, including paintings, murals, photographs, and popularly acclaimed posters, illustrations, and prints. While many of his works confront polemically topical situations, others essay a more general and sanguine interpretation of the human condition. Among the latter is *World's Greatest Comics*.

Like much of Shahn's work, this painting's seemingly flat, simplistic, almost naive composition belies a complexly structured image. The artist sets two boys far apart, yet engages them in the same absorptive activity of reading, while containing them both in the weblike forms of the ring sets. The wiry vitality of this play equipment recalls the expressive linearity of Paul Klee, an artist Shahn greatly admired. The setting in which the boys appear is bleak, yet it is visually active due to the lines of the ring sets, the artist's vigorous brushwork, and the openness and wobbliness of the red screenlike structure. Shahn contrasts the coolness of the concrete playground and the sky with the warmth of the red abstract pattern, which reads as an apartment building despite its paper-thin form.[1] This red grid (not too far removed, perhaps, from Piet Mondrian's earlier abstract New York compositions) represents home, although its relentless uniformity and lack of entrances and substance connote an uneasy domesticity. The emptiness of the flimsy building and the denatured playground reinforce the isolation and rapt absorption of the boys. Yet, engrossed in the "world's greatest comics," the figures shut out the monotonous desolation of their environment and enter a colorful fantasy world. Shahn affirms the power of the human imagination to take flight and rise above the most mundane circumstances.

Tempera on panel, 35 x 48 in. (88.9 x 121.9 cm) Inscribed l.r.: "Ben Shahn"

[1] The red building here anticipates structures seen in the artist's *Paterson* series of the early 1950s, inspired by William Carlos Williams's poem of the same title. A passage from this 1927 poem relates to the form and mood of *World's Greatest Comics*: "Without invention, nothing is well spaced / . . . the old will go on / repeating itself with recurring / deadliness. . . ." Quoted in Kenneth W. Prescott, *The Complete Graphic Works of Ben Shahn* (New York: Quandrangle/New York Times Book Co., 1973), p. 19.

Stuart Davis (1892–1964)

Self-Portrait, 1919

Oil on canvas, 22 1/4 x 18 1/4 in.
(56.5 x 46.4 cm)
Inscribed verso: "STUART/DAVIS/SELF
PORTRAIT/TIOGA PA. 1919"

1 "How to Construct a Modern Easel Painting," a lecture delivered by Stuart Davis at the New School for Social Research, 17 December 1941, quoted in Diane Kelder, "Stuart Davis: Pragmatist of American Modernism," *Art Journal*, 39 (Fall 1979), 29.
2 Diane Kelder, *Stuart Davis* (New York, Washington, London: Praeger Publishers, 1971), p. 4.
3 Kelder, p. 23.

Just twenty-five years old when he painted this powerful self-portrait, Stuart Davis had already enjoyed seeing his earlier work appear in the highly important Armory Show (1913), in the periodicals *The Masses* and *Harper's Weekly* (1913–1916), and in two solo exhibitions (1917 and 1918). Yet the self-image reveals self-doubt, making the painting, with its aggressive color and agitated forms, very much the portrait of the "modern" artist as a young man. Indeed, in the years around 1919, Davis's style vacillated between the influences of the European modernism and the American urban realism championed by his teacher Robert Henri. As Davis commented, these influences "were foremost in forming my ideas and taste about what a modern picture should be. Both were revolutionary in character, and stood in direct opposition to traditional and academic concepts of art."[1]

The son of artists (his mother a sculptor and his father the art director of the *Philadelphia Press*), Davis quit high school in 1910, at the age of sixteen, to study painting with Henri in New York. Henri, famous for his inspired teaching and infamous as leader of the "Ashcan School," profoundly affected the young Davis with his admonition to "place the origins of art in life."[2] In 1913, a year after leaving Henri and establishing his own studio, Davis experienced that great spectacle of modernism, the International Exhibition of Modern Art, better known as the Armory Show. Although the exhibition included a large American section, it was the European work, consciously selected to chronicle the development of modern art, which intrigued, baffled, and outraged viewers. For Davis, the exhibition was enormously exciting, and he found himself especially favoring the works of Gauguin, Van Gogh, and Matisse, because, as he remarked, "broad generalization of form and the non-imitative use of color were already practices within my own experience. I also sensed an objective order in these works which I felt was lacking in my own."[3] These comments and the influence of these particular artists are reflected in *Self-Portrait*.

The influence of Paul Gauguin is seen in *Self-Portrait* in the heavily outlined, rather flat body, while the vigorous handling of paint in the face resembles the technique of Vincent van Gogh (and to a degree Robert Henri). The use of green in the face is particularly reminiscent of Henri Matisse, although Van Gogh and Gauguin boldly juxtaposed arbitrary colors, as well. Davis's intense self-examination of his exterior and interior states especially recalls Van Gogh's self-portraits. Striving to be modern, Davis incorporates elements from the artists he most admires, making *Self-Portrait* a young artist's homage to these modern masters.

Davis's search for his own style is also clearly manifested in the sense of doubt his stare expresses and in the restlessness of the composition. The artist shows himself off center, leaning in from the right, head slightly turned and framed, but not contained by the blank picture hanging askew behind him. In his quest to be modern, the young Stuart Davis actively confronts art as well as himself.

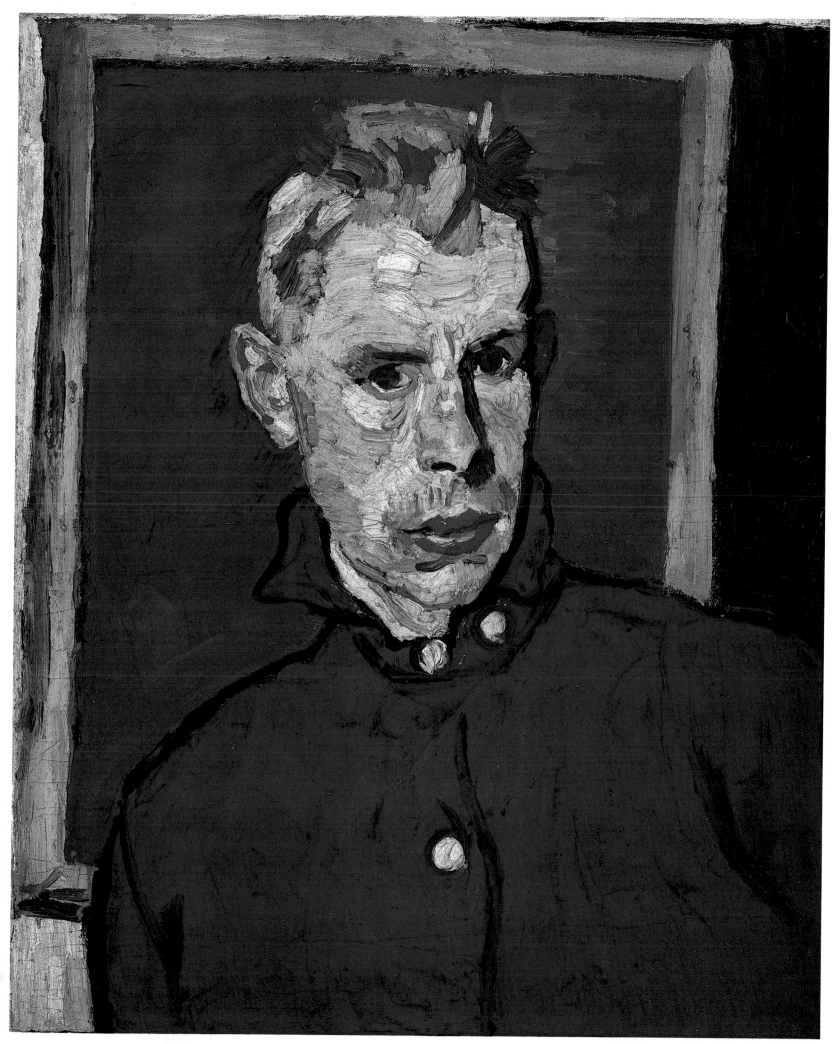

Self-Portrait

113

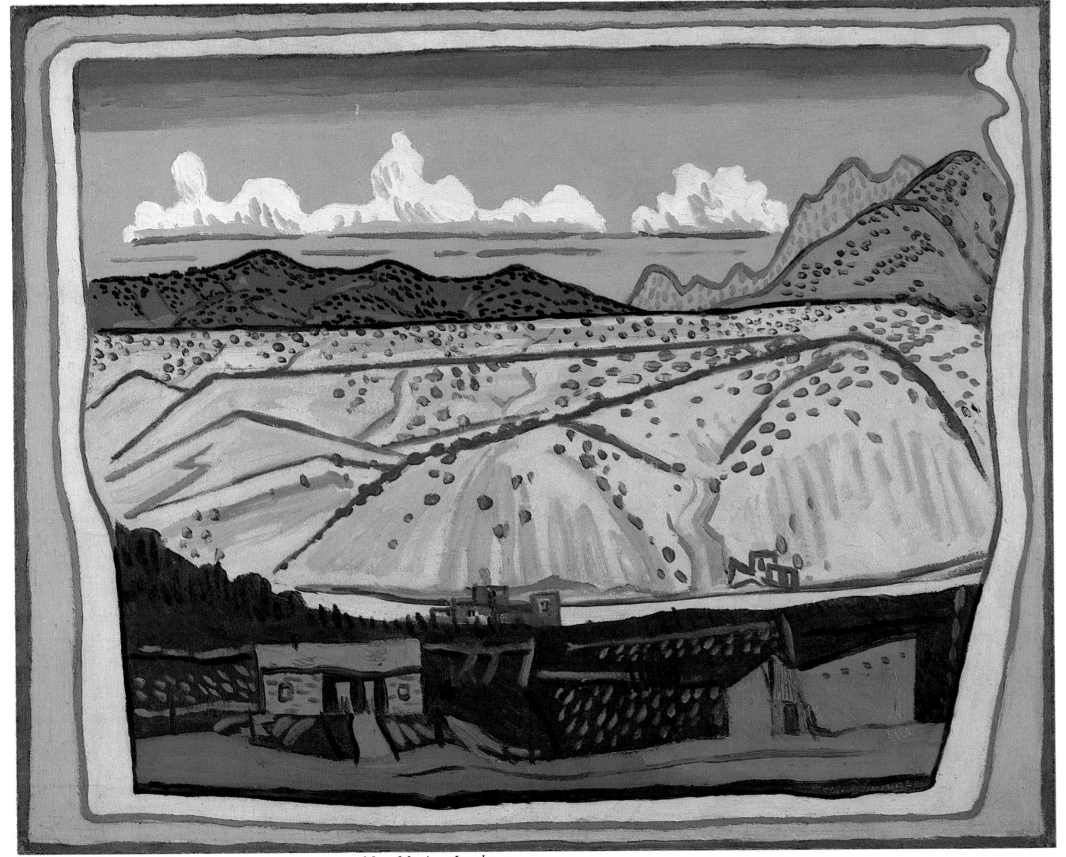

New Mexican Landscape

114

Stuart Davis (1892-1964)

New Mexican Landscape, 1923

At the invitation of the artist John Sloan, Stuart Davis traveled to Santa Fe in the summer of 1923. During the years surrounding his visit, the Santa Fe-Taos area developed into an important art community, attracting artists and writers from all over the country. Davis's teacher, Robert Henri, had journeyed to Santa Fe in 1916 and encouraged his pupils and colleagues, including John Sloan, to make the trip. The appeal of northern New Mexico, especially for New York artists, lay not only in its ruggedly beautiful and spacious landscape, but also in its romantic primitiveness. In Santa Fe, which had neither streetlights nor paved roads when Davis visited there, a painter was physically and psychologically far removed from the fast-paced, chaotic urban experience.[1] Yet, for someone like Stuart Davis who truly thrived on the jazzy, city environment, the rawness of the Southwest with its commanding landscape could be artistically restrictive.

Davis commented on his three months in New Mexico:

[I] did not do much work because the place itself was so interesting. I don't think you could do more work there except in a literal way, because the place is always there in such a dominating way. You always have to look at it.

Then there's the great dead population. You don't see them but you stumble over them. A piece of pottery here and there and everywhere. It's a place for an ethnologist, not an artist. Not sufficient intellectual stimulation. Forms made to order, to imitate.[2]

Ironically, because his professed lack of affinity for the place affected the intensity of his work, Davis's few New Mexico landscapes stand as the most relaxed and pleasant pictures of his career.[3]

In *New Mexican Landscape*, line and color appear applied and form created with a kind of ease and naïveté which makes the work eminently appealing. By dividing the painting into contrasting horizontal zones, Davis succinctly captures northern New Mexico's variegated landscape and crystalline atmosphere in which far-distant shapes retain their clarity. However, to counter the literalness he found inherent in rendering this landscape, Davis enclosed the composition with a soft, double frame. By this device, the artist emphasized the artificiality of picture making as well as how far removed he felt from this type of environment. Nevertheless, the frame, in its undulation, enhances and reinforces the composition's highly animated nature. Seemingly in spite of himself, Stuart Davis created in *New Mexican Landscape* a most attractive and enjoyable view of the Southwest.

Oil on canvas, 32 x 40 1/4 in. (81.3 x 102.2 cm) Inscribed l.r.: "Stuart Davis 1923."

1 Sanford Schwartz, "When New York Went to New Mexico," *Art in America*, July/August 1976, p. 92.
2 James Johnson Sweeney, *Stuart Davis* (New York: Museum of Modern Art, 1945), p. 15.
3 Schwartz, p. 97.

Blips and Ifs

Stuart Davis (1892-1964)

Blips and Ifs, 1963-1964

Oil on canvas, 71 1/8 x 53 1/8 in.
(180.7 x 134.9 cm)
Inscribed u.c.: "Stuart Davis"
verso, on stretcher: "BLIPS & IFS STUART
DAVIS 1963-64"
Acquisition in memory of John de Menil,
Trustee, Amon Carter Museum, 1961-1969

The last completed painting by Stuart Davis, *Blips and Ifs,* displays the visual ebullience characteristic of Davis's mature style. Although its highly charged abstract nature greatly differentiates it from the two other Davis compositions in the Museum's collection—*Self-Portrait* (1919) and *New Mexican Landscape* (1923)—*Blips and Ifs* exhibits the same strong contrasts and plays of color which distinguish the artist's work throughout his long career. Similarly, while the inclusion of words and word fragments typifies the artist's work from the 1950s on, Davis had at various times since the very beginning of his career incorporated letters and signs into his paintings.[1] Despite its seeming to have sprung forth spontaneously, *Blips and Ifs* is a work which evolved out of Davis's more than fifty years of art-making.

Blips and Ifs evinces the artist's commitment to expressing modernity through "color-space," a manipulation of abstract form and color derived from Cubism. Much impressed with the modern European art he saw at the Armory Show of 1913, Davis began to explore the Cubist idiom in the latter part of the decade. He found particularly appealing the "synthetic" or collage side of Cubism, with its colorful, sometimes humorous, and often abrupt juxtapositions of paper scraps. *Blips and Ifs* clearly illustrates this interest. That Davis should be drawn to collage, rather than to the more hermetic, analytic aspect of Cubism, reflects his grounding in the world around him. Having studied as a teenager with Robert Henri, who continually extolled the importance of "life" to the creation of art, Davis always regarded his own works as related to, indeed, originating in the contemporary American scene. In a 1943 article entitled "The Cube Root," Davis listed:

> Some of the things which have made me want to paint, outside of other paintings . . . the brilliant colors on gasoline stations; chain-store fronts, and taxi-cabs; the music of Bach; synthetic chemistry; the poetry of Rimbeau; fast travel by train, auto, and aeroplane which brought new and multiple perspectives; electric signs . . . 5 & 10 cent store kitchen utensils; movies and radio; Earl Hines hot piano and Negro jazz music in general. . . .[2]

To this list might be appropriately added the "blips" of the television screen.[3] Commenting on his agenda, Davis wrote that he aimed not to depict these things graphically but rather to create "analogous dynamics in the design" of his work.[4]

Certainly, *Blips and Ifs* transforms the visual potpourri of modern times into a monumental and colorfully jazzy image. With its various emblematic forms and "torn" words, the painting suggests, yet defies, strict interpretation. However, *Blips and Ifs* clearly conveys the sensation of speed, the excitement, and even the confusion of contemporary life. Davis asserts his affinity for this age by prominently including here, as he often did, his squiggly signature in the upper portion of the composition. By this gesture, Stuart Davis makes clear the artist's presence and significance in this dynamic world of *Blips and Ifs*.

1 H. H. Arnason points out that the blocked-out words "compleat" and "pad" and the cursive "any" in *Blips and Ifs* were among Davis's favorite word signs and occurred in other works. H. H. Arnason, *Stuart Davis Memorial Exhibition* (Washington, D. C.: National Collection of Fine Arts, Smithsonian Institution, 1965), p. 49.
2 Diane Kelder, *Stuart Davis* (New York, Washington, London: Praeger Publishers, 1971), p. 130.
3 Brian O'Doherty considers the relation of television to Davis's art in his *American Masters: The Voice and the Myth* (New York: Random House, Inc., 1973), p. 78.
4 Kelder, p. 131.

Georgia O'Keeffe (1887-1986)
Dark Mesa and Pink Sky, 1930
Oil on canvas, 16 1/8 x 30 1/8 in.
(41.0 x 76.5 cm)

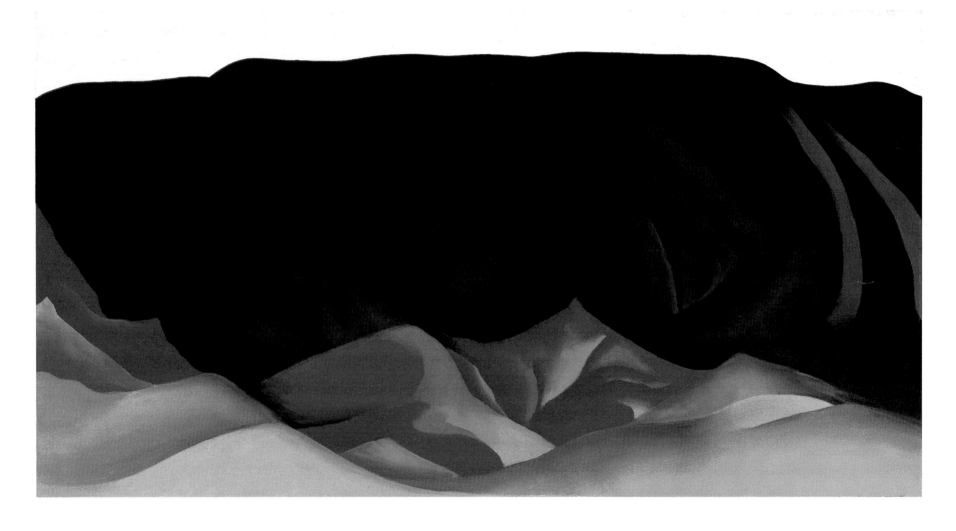

Selected Bibliography

CECILIA BEAUX

Beaux, Cecilia. *Background with Figures: Autobiography of Cecilia Beaux*. Boston and New York: Houghton Mifflin Company, 1930.

Drinker, Henry S. *The Paintings and Drawings of Cecilia Beaux*. Philadelphia: Pennsylvania Academy of the Fine Arts, 1955.

Goodyear, Frank H., Jr. *Cecilia Beaux: Portrait of An Artist*. Philadelphia: Pennsylvania Academy of the Fine Arts, 1974.

ALBERT BIERSTADT

Hendricks, Gordon. *A. Bierstadt*. Fort Worth: Amon Carter Museum, 1972.

————. *Albert Bierstadt: Painter of the American West*. New York: Harry N. Abrams, Inc., Publishers, 1972.

OSCAR BLUEMNER

Coggins, Clemency, Martha Holsclaw, and Martha Hoppin. *Oscar Bluemner: American Colorist*. Cambridge: Fogg Art Museum, 1967.

Hayes, Jeffrey R. "Oscar Bluemner: Life, Art, and Theory." Diss. University of Maryland 1982.

————. *Oscar Bluemner: A Retrospective Exhibition*. New York: Barbara Mathes Gallery, 1985.

Zilczer, Judith. *Oscar Bluemner: The Hirshhorn Museum and Sculpture Garden Collection*. Washington, D.C.: Smithsonian Institution Press, 1979.

MARY CASSATT

Breskin, Adelyn D. *The Graphic Work of Mary Cassatt, A Catalogue Raisonné*. New York: H. Bittner, 1948.

————. *Mary Cassatt: A Catalogue Raisonné of the Oils, Pastels, Watercolors, and Drawings*. Washington, D.C.: Smithsonian Institution Press, 1970.

Bullard, E. John. *Mary Cassatt, Oils and Pastels*. New York: Watson-Guptill Publications, 1972.

Gerdts, William H. *American Impressionism*. Seattle: University of Washington, Henry Art Gallery, 1980.

Hale, Nancy. *Mary Cassatt, A Biography of the Great American Painter*. Garden City, New York: Doubleday & Co., 1975.

Lindsay, Suzanne G. *Mary Cassatt and Philadelphia*. Philadelphia: Philadelphia Museum of Art, 1985.

Mathews, Nancy Mowll. *Cassatt and Her Circle: Selected Letters*. New York: Abbeville Press, 1984.

Sweet, Frederick. *Miss Mary Cassatt, Impressionist from Philadelphia*. Norman: University of Oklahoma Press, 1966.

WILLIAM MERRITT CHASE

Gerdts, William H. *American Impressionism*. New York: Abbeville Press, 1984.

Pisano, Ronald G. *William Merritt Chase*. New York: Watson-Guptill Publications, 1979.

————. *A Leading Spirit in American Art: William Merritt Chase 1849-1916*. Seattle: University of Washington, Henry Art Gallery, 1983.

Roof, Katherine Metcalf. *The Life and Art of William Merritt Chase*. New York: Charles Scribner's Sons, 1917.

FREDERIC CHURCH

Huntington, David C. *The Landscapes of Frederic Edwin Church: Vision of an American Era*. New York: George Braziller, Inc., 1966.

Kelly, Franklin, and Gerald Carr. *The Early American Landscapes of Frederic Edwin Church, 1845-1854*. Fort Worth: Amon Carter Museum, 1986.

Stebbins, Theodore E., Jr. *Close Observation: Selected Oil Sketches by Frederic E. Church*. Washington, D.C.: Corcoran Gallery of Art, 1978.

THOMAS COLE

Merritt, Howard S. *Thomas Cole*. Rochester, New York: University of Rochester, Memorial Art Gallery, 1969.

Noble, Louis Legrand. *The Life and Works of Thomas Cole*. Ed. Elliot S. Vesell. rpt. Cambridge: Harvard University Press, Belknap Press, 1964.

Parry, Ellwood C., III. *Ambition and Imagination in the Art of Thomas Cole.* Newark: University of Delaware Press; London and Toronto: Associated University Presses, forthcoming.

JASPER FRANCIS CROPSEY

Bermingham, Peter. *Jasper F. Cropsey, 1823-1900, Retrospective View of America's Painter of Autumn.* College Park, Maryland: University of Maryland Art Gallery, 1968.

Talbot, William. *Jasper F. Cropsey, 1823-1900.* Washington, D. C.: National Collection of Fine Arts, 1970.

_____. *Jasper F. Cropsey, 1823-1900.* New York and London: Garland Publishing Inc., 1977.

STUART DAVIS

Arnason, H. H. *Stuart Davis Memorial Exhibition.* Washington, D.C.: National Collection of Fine Arts, Smithsonian Institution Press, 1965.

Kelder, Diane. *Stuart Davis.* New York, Washington, London: Praeger Publishers, 1971.

Lane, John R. *Stuart Davis: Art and Art Theory.* New York: The Brooklyn Museum, 1978.

O'Doherty, Brian. *American Masters: The Voice and the Myth.* New York: Random House, Inc., 1973.

Sweeney, James Johnson. *Stuart Davis.* New York: Museum of Modern Art, 1945.

Udall, Sharyn Rohlfsen. *Modernist Painting in New Mexico 1913-1935.* Albuquerque: University of New Mexico Press, 1984.

CHARLES DEAS

Tuckerman, Henry. *Book of the Artists.* New York: James F. Carr, 1967.

CHARLES DEMUTH

Eiseman, Alvord L. *Charles Demuth.* New York: Watson-Guptill Publications, 1982.

Fahlman, Betsy. *Pennsylvania Modern: Charles Demuth of Lancaster.* Philadelphia: Philadelphia Museum of Art, 1983.

Farnham, Emily. *Charles Demuth: Behind a Laughing Mask.* Norman: University of Oklahoma, 1971.

Gebhard, David, and Phyllis Plous. *Charles Demuth: The Mechanical Encrusted on the Living.* Santa Barbara: University of California, Santa Barbara, The Art Galleries, 1971.

Grenauer, Emily. *Charles Demuth of Lancaster.* Harrisburg, Pennsylvania: William Penn Memorial Museum, 1966.

Ritchie, Andrew Carnduff. *Charles Demuth.* New York: Museum of Modern Art, 1950.

ARTHUR DOVE

Haskell, Barbara. *Arthur Dove.* San Francisco: San Francisco Museum of Art, 1974.

Morgan, Ann Lee. *Arthur Dove: Life and Work, with a Catalogue Raisonné.* Newark: University of Delaware Press; London and Toronto: Associated University Presses, 1984.

Newman, Sasha M. *Arthur Dove and Duncan Phillips: Artist and Patron.* Washington, D.C.: The Phillips Collection, 1981.

Wight, Frederick S. *Arthur G. Dove.* Los Angeles: University of California, The Art Galleries, 1958.

SETH EASTMAN

McDermott, John Francis. *Seth Eastman: Pictorial Historian of the Indian.* Norman: University of Oklahoma Press, 1961.

FRANCIS WILLIAM EDMONDS

Clark, H. Nichols B. "A Fresh Look at the Art of Francis W. Edmonds: Dutch Sources and American Meanings." *The American Art Journal,* 14, No. 3 (Summer 1982), 73-94.

Mann, Maybelle. *Francis William Edmonds.* Washington, D.C.: International Exhibitions Foundation, 1975.

DE SCOTT EVANS

Maciejunes, Nannette V. *A New Variety, Try One: De Scott Evans or S. S. David.* Columbus, Ohio: Columbus Museum of Art, 1985.

JOHN HABERLE

Frankenstein, Alfred. *After the Hunt: William Harnett and Other American Still Life Painters, 1870-1900.* 2nd ed. Berkeley and Los Angeles: University of California Press, 1969.

Gerdts, William H. *Painters of the Humble Truth: Masterpieces of American Still Life, 1801-1939.* Tulsa and Columbia: Philbrook Art Center with University of Missouri Press, 1981.

Sill, Gertrude Grace. *John Haberle: Master of Illusion.* Springfield, Massachusetts: Museum of Fine Arts, 1985.

WILLIAM MICHAEL HARNETT

Frankenstein, Alfred. *After the Hunt: William Harnett and Other American Still Life Painters, 1870-1900.* 2nd ed. Berkeley and Los Angeles: University of California Press, 1969.

Gerdts, William H. *Painters of the Humble Truth: Masterpieces of American Still Life, 1801-1939.* Tulsa and Columbia: Philbrook Art Center with University of Missouri Press, 1981.

MARSDEN HARTLEY

Hartley, Marsden. *Adventures in the Arts*. New York: Boni and Liveright, 1921.

Haskell, Barbara. *Marsden Hartley*. New York: Whitney Museum of American Art, 1980.

Marsden Hartley 1908-1942, The Ione and Hudson D. Walker Collection. Minneapolis: University of Minnesota, University Art Museum, 1984.

McCausland, Elizabeth. *Marsden Hartley*. Minneapolis: University of Minnesota Press, 1952.

Scott, Gail, ed. *On Art by Marsden Hartley*. New York: Horizon Press, 1982.

Udall, Sharyn Rohlfsen. *Modernist Painting in New Mexico 1913-1935*. Albuquerque: University of New Mexico Press, 1984.

CHILDE HASSAM

Adams, Adeline. *Childe Hassam*. New York: American Academy of Arts and Letters, 1938.

Buckley, Charles E. *Childe Hassam: A Retrospective Exhibition*. Washington, D.C.: Corcoran Gallery of Art, 1965.

Childe Hassam, 1859-1935. Tucson: University of Arizona Museum of Art, 1972.

Hoopes, Donelson F. *Childe Hassam*. New York: Watson-Guptill Publications, 1979.

MARTIN JOHNSON HEADE

McIntyre, Robert G. *Martin Johnson Heade*. New York: Pantheon Press, 1948.

Stebbins, Theodore E., Jr. *The Life and Works of Martin Johnson Heade*. New Haven and London: Yale University Press, 1975.

WINSLOW HOMER

Beam, Philip. *Winslow Homer at Prout's Neck*. Boston: Little, Brown and Company, 1968.

Downes, William Howe. *The Life and Works of Winslow Homer*. Boston and New York: Houghton Mifflin Company, 1911.

Gardner, Albert Ten Eyck. *Winslow Homer, American Artist: His World and His Work*. New York: C. N. Potter, 1961.

Goodrich, Lloyd. *Winslow Homer*. New York: The MacMillan Company, 1945.

———. *Winslow Homer*. New York: Whitney Museum of American Art, 1973.

Hendricks, Gordon. *The Life and Work of Winslow Homer*. New York: Harry N. Abrams, Inc., 1979.

Wilmerding, John. *Winslow Homer*. New York: Praeger Publishers, 1972.

DAVID JOHNSON

Baur, John I. H. "'.... the exact brushwork of Mr. David Johnson,' An American Landscape Painter, 1827-1908." *The American Art Journal*, 12, No. 4 (Autumn 1980), 32-65.

EASTMAN JOHNSON

Baur, John I. H. *Eastman Johnson, 1824-1906: An American Genre Painter*. Brooklyn: The Brooklyn Museum, 1940.

Hills, Patricia. *Eastman Johnson*. New York: Whitney Museum of American Art, 1972.

JOHN FREDERICK KENSETT

Driscoll, John Paul, and John K. Howat, et al. *John Frederick Kensett: An American Master*. Worcester, Massachusetts: W. W. Norton & Co. in association with the Worcester Art Museum, 1985.

Howat, John K. *John Frederick Kensett, 1816-1872*. New York: The American Federation of Arts, 1968.

Siegfried, Joan C. *John Frederick Kensett, A Retrospective Exhibition*. Saratoga Springs, New York: Hathorn Gallery, Skidmore College, 1967.

FITZ HUGH LANE

Paintings and Drawings by Fitz Hugh Lane at the Cape Anne Historical Association. Gloucester, Massachusetts: Cape Anne Historical Association, 1974.

Wilmerding, John. *Fitz Hugh Lane*. New York: Praeger Publishers, 1971.

JOHN MARIN

Coke, Van Deren. *Marin in New Mexico/1929 & 1930*. Albuquerque: University of New Mexico, University Art Museum, 1968.

Grey, Cleve, ed. *John Marin by John Marin*. New York, Chicago, and San Francisco: Holt, Rinehart and Winston, 1977.

Reich, Sheldon. *John Marin: A Stylistic Analysis and Catalogue Raisonné*. Tucson: University of Arizona Press, 1970.

Udall, Sharyn Rohlfsen. *Modernist Painting in New Mexico 1913-1935*. Albuquerque: University of New Mexico Press, 1984.

WILLIAM J. McCLOSKEY

Gerdts, William H. *Painters of the Humble Truth: Masterpieces of American Still Life, 1801-1939*. Tulsa and Columbia: Philbrook Art Center with University of Missouri Press, 1981.

Gerdts, William H., and Russell Burke. *American Still-Life Painting*. New York, Washington, London: Praeger Publishers, 1971.

Moure, Nancy Dustin Wall. *Dictionary of Art and Artists in Southern California before 1930*. Los Angeles: Privately printed, 1975.

THOMAS MORAN

Clark, Carol. *Thomas Moran: Watercolors of the American West*. Austin: University of Texas Press, 1980.

Fern, Thomas S. *The Drawings and Watercolors of Thomas Moran (1837-1926)*. South Bend, Indiana: Notre Dame University, Art Gallery, 1976.

Wilkins, Thurman. *Thomas Moran: Artist of the Mountains*. Norman: University of Oklahoma Press, 1966.

GEORGIA O'KEEFFE

Castro, Jan Garden. *The Art & Life of Georgia O'Keeffe*. New York: Crown Publishers, Inc., 1985.

Eldredge, Charles C. *American Imagination and Symbolist Painting*. New York: New York University, Grey Art Gallery and Study Center, 1979.

Georgia O'Keeffe and Her Contemporaries. Amarillo: Amarillo Art Center, 1985.

Goodrich, Lloyd, and Doris Bry. *Georgia O'Keeffe*. New York: Whitney Museum of American Art, 1970.

Haskell, Barbara. *Georgia O'Keeffe, Works on Paper*. Santa Fe: Museum of New Mexico Press, 1985.

Hoffman, Katherine. *An Enduring Spirit, The Art of Georgia O'Keeffe*. Metuchen, N. J. and London: The Scarecrow Press, Inc., 1984.

Lisle, Laurie. *Portrait of An Artist: A Biography of Georgia O'Keeffe*. New York: Seaview Books, 1980.

O'Keeffe, Georgia. *Georgia O'Keeffe*. New York: Viking Press, 1976.

Wilder, Mitchell A. *Georgia O'Keeffe*. Fort Worth: Amon Carter Museum, 1966.

JOHN FREDERICK PETO

Frankenstein, Alfred. *John F. Peto*. Brooklyn, New York: The Brooklyn Museum, The Brooklyn Institute of Arts and Sciences, 1950.

Wilmerding, John. *Important Information Inside: The Art of John F. Peto and the Idea of Still-Life Painting in Nineteenth-Century America*. Washington, D.C.: National Gallery of Art, 1983.

WILLIAM RANNEY

Grubar, Francis S. *William Ranney: Painter of the Early West*. Washington, D.C.: Corcoran Gallery of Art, 1962.

FREDERIC REMINGTON

Hassrick, Peter H. *Frederic Remington: Paintings, Drawings, and Sculpture in the Amon Carter Museum and the Sid W. Richardson Foundation Collection*. New York: Harry N. Abrams, Inc., 1973.

————. *Frederic Remington: The Late Years*. Denver: Denver Art Museum, 1981.

Jussim, Estelle. *Frederic Remington, the Camera & the Old West*. Fort Worth: Amon Carter Museum, 1983.

Samuels, Peggy, and Harold Samuels. *Frederic Remington: A Biography*. Garden City, New York: Doubleday & Co., Inc., 1982. Reprinted by the University of Texas Press.

Vorpahl, Ben Merchant. *Frederic Remington and the West: With the Eye of the Mind*. Austin: University of Texas Press, 1978.

SEVERIN ROESEN

Gerdts, William H. *Painters of the Humble Truth: Masterpieces of American Still Life, 1801-1939*. Tulsa and Columbia: Philbrook Art Center with University of Missouri Press, 1981.

Marcus, Lois Goldreich. *Severin Roesen: A Chronology*. Williamsport, Pennsylvania: Lycoming County Historical Society, 1976.

CHARLES MARION RUSSELL

Adams, Ramon F., and Homer E. Britzman. *Charles M. Russell, the Cowboy Artist: A Biography*. Pasadena, California: Trail's End Publishing Co., 1948.

Clark, Carol. *Charles M. Russell*. Fort Worth: Amon Carter Museum, 1983.

Dippie, Brian M. *"Paper Talk": Charlie Russell's American West*. New York: Alfred A. Knopf, 1979.

————. *Remington & Russell: The Sid Richardson Collection*. Austin: University of Texas Press, 1982.

McCracken, Harold. *The Charles M. Russell Book: The Life and Work of the Cowboy Artist*. Garden City, New York: Doubleday & Co., 1957.

Renner, Frederic G. *Charles M. Russell: Paintings, Drawings, and Sculpture in the Amon G. Carter Collection: A Descriptive Catalogue*. Austin: University of Texas Press, 1966. Reprinted by Harry N. Abrams, Inc., Publishers.

MORTON LIVINGSTON SCHAMBERG

Agee, William C. *Morton Livingston Schamberg, 1881-1918*. New York: Salander-O'Reilly Galleries, 1982

————. *Morton Livingston Schamberg (1881-1918): The Machine Pastels*. New York: Salander-O'Reilly Galleries, Inc., 1986.

Levin, Gail. *Synchromism and American Color Abstraction*. New York: Whitney Museum of American Art and George Braziller, Inc., 1978.

Wolf, Ben. *Morton Livingston Schamberg*. Philadelphia: University of Pennsylvania Press, 1963.

BEN SHAHN

Morse, John D. *Ben Shahn.* New York and Washington: Praeger Publishers, 1972.

Prescott, Kenneth W. *Ben Shahn: A Retrospective, 1898-1969.* New York: The Jewish Museum, 1976.

————. *The Complete Graphic Works of Ben Shahn.* New York: Quadrangle/ New York Times Book Co., 1973.

Rodman, Selden. *Portrait of the Artist as an American. Ben Shahn: A Biography with Pictures.* New York: Harper & Brothers Publishers, 1951.

Shahn, Ben. *The Shape of Content.* New York: Vintage Books, 1957.

Shahn, Bernarda Bryson. *Ben Shahn.* New York: Harry N. Abrams, Inc., Publishers, 1972.

JOHN MIX STANLEY

Schimmel, Julie. "John Mix Stanley and Imagery of the West in Nineteenth-Century American Art." Diss. New York University 1983.

Taft, Robert. *Artists and Illustrators of the Old West, 1850-1900.* New York: Charles Scribner's Sons, 1953.

WORTHINGTON WHITTREDGE

Dwight, Edward H. *Worthington Whittredge (1820-1910): A Retrospective Exhibition of an American Artist.* Utica, New York: Munson-Williams-Proctor Institute, 1969.

Trenton, Patricia, and Peter H. Hassrick. *The Rocky Mountains: A Vision for Artists in the Nineteenth Century.* Norman: University of Oklahoma Press, 1983.

Whittredge, T. Worthington. *The Autobiography of Worthington Whittredge, 1820-1910.* rpt. Ed. John I. H. Bauer. New York: Arno Press, 1969.

GRANT WOOD

Corn, Wanda M. *Grant Wood: The Regionalist Vision.* New Haven and London: Yale University Press, 1983.

Czestochowski, Joseph S. *John Steuart Curry and Grant Wood, A Portrait of Rural America.* Columbia, Missouri: University of Missouri Press, 1981.

Dennis, James M. *Grant Wood: A Study in American Art and Culture.* New York: Viking Press, 1975.

Garwood, Darrell. *Artist in Iowa: A Life of Grant Wood.* 1944; rpt. Westport, Connecticut: Greenwood, 1971.

Arthur G. Dove (1880-1946)
Exchange Street Geneva, 1938
India ink and watercolor on paper,
5 1/2 x 9 in.
(14.0 x 22.9 cm)
Inscribed l.c.: "Dove"

Contributors

LINDA AYRES

The Hunter's Return; New England Landscape (Evening After a Storm); Boston Harbor; Newport Coast; Thunderstorm Over Narragansett Bay; Marshfield Meadows, Massachusetts; Two Hummingbirds Above a White Orchid; The Narrows from Staten Island; Eagle Cliff, Franconia Notch, New Hampshire; Marion Crossing the Pedee (Linda Ayres and Jane Myers); Virginia Wedding; Crossing the Pasture; Bo-Peep; Flags on the Waldorf; Mother and Son (Mrs. Beauveau Borie and Her Son Adolphe)

JAN KEENE MUHLERT

The Lobster; Team of Horses

JANE MYERS

Marion Crossing the Pedee (Jane Myers and Linda Ayres); The Flute; Attention, Company!; Ease; Abundance; Can You Break a Five?; Free Sample/Try One; Wrapped Oranges; Lamps of Other Days; A Closet Door; Figure B (Geometrical Patterns); Blue Day

MARK THISTLETHWAITE

Idle Hours; Mother and Daughter, Both Wearing Large Hats (Fillette au grand chapeau); In the Province #7; Provincetown Abstraction; Earth Cooling; Near Taos, No. 6, New Mexico; Light Coming on the Plains I, II, III; Red Cannas; Black Patio Door; Ranchos Church—Taos (Ranch Church—Grey Sky); Parson Weems' Fable; World's Greatest Comics; Self-Portrait; New Mexican Landscape; Blips and Ifs

RON TYLER

Sunrise, Yosemite Valley; On the Cache la Poudre River, Colorado; Cliffs of Green River; A Group of Sioux; Ballplay of the Sioux on the St. Peters River in Winter; Oregon City on the Willamette River; Wood-Boatmen on a River; A Dash for the Timber; The Fall of the Cowboy; His First Lesson; Lost in a Snowstorm—We Are Friends; In Without Knocking; A Tight Dally and a Loose Latigo

John Marin (1870-1953)
Taos Canyon, New Mexico, 1930
Watercolor, gouache, and black crayon on
paper, 15 1/2 x 21 in.
(39.4 x 53.3 cm)
Inscribed l.r.: "Marin 30"

Acknowledgments

We are grateful to David Brewster for identifying the boats in the painting *Boston Harbor;* to Robert Workman, Museum of Art, Rhode Island School of Design, for information concerning the site depicted in *Thunderstorm Over Narragansett Bay;* to David Brewster and Gerard Boardman, South Street Seaport Museum, for their assistance in identifying the pilot schooner in *The Narrows from Staten Island;* to H. Nichols B. Clark for information on Francis William Edmonds contained in the essay *The Flute;* to Stuart Feld and Kathleen Burnside, co-authors of the forthcoming catalogue raisonne of Childe Hassam, for providing much of the information in the essay *Flags on the Waldorf;* and to Jana Johnson, Educational Horticulturist at the Fort Worth Botanic Garden, for providing helpful information regarding the painting *Red Cannas*.

Also, we would like to express thanks to Sandra Scheibe, Amon Carter Museum, for typing the manuscript; Milan Hughston, Amon Carter Museum, for research assistance; Carol Clark, Williams College Museum, for reading the text and offering advice; Linda Lorenz, Amon Carter Museum, for photography; Kathleen Bennewitz, Amon Carter Museum, for her research assistance; and Walt Davis, Dallas Museum of Natural History, for assistance in identifying the hummingbirds in Heade's painting.

Index of Paintings

FRONTISPIECE *Cineraria*, Charles Demuth
ix *View of Pikes Peak*, George Caleb Bingham
x *Cliffs Along the Green River*, Peter Moran
xi *Assiniboin Hunting on Horseback*, Peter Rindisbacher
xi *Indian Village*, Alfred Jacob Miller
xiv *Sombrero and Gloves*, Marsden Hartley
3 *The Hunter's Return*, Thomas Cole
5 *New England Landscape*, Frederic Edwin Church
6 *Boston Harbor*, Fitz Hugh Lane
9 *Newport Coast*, John Frederick Kensett
11 *Thunderstorm Over Narragansett Bay*, Martin Johnson Heade
14 *Marshfield Meadows, Massachusetts*, Martin Johnson Heade
15 *Two Hummingbirds Above a White Orchid*, Martin Johnson Heade
17 *The Narrows from Staten Island*, Jasper Francis Cropsey
19 *Eagle Cliff, Franconia Notch, New Hampshire*, David Johnson
21 *Sunrise, Yosemite Valley*, Albert Bierstadt
22 *On the Cache la Poudre River, Colorado*, Worthington Whittredge
25 *Cliffs of Green River*, Thomas Moran
27 *A Group of Sioux*, Charles Deas
29 *Ballplay of the Sioux on the St. Peters River in Winter*, Seth Eastman
31 *Oregon City on the Willamette River*, John Mix Stanley
33 *Wood-Boatmen on a River*, George Caleb Bingham
36 *Marion Crossing the Pedee*, William Ranney
37 *Virginia Wedding*, William Ranney
39 *The Flute*, Francis William Edmonds
41 *Crossing the Pasture*, Winslow Homer
43 *Blyth Sands*, Winslow Homer
45 *Bo-Peep*, Eastman Johnson
48 *Attention, Company!*, William Michael Harnett
49 *Ease*, William Michael Harnett
51 *Abundance*, Severin Roesen
53 *Can You Break a Five?*, John Haberle
55 *Free Sample/Try One*, De Scott Evans
57 *Wrapped Oranges*, William J. McCloskey
59 *Lamps of Other Days*, John Frederick Peto
61 *A Closet Door*, John Frederick Peto
63 *Idle Hours*, William Merritt Chase
65 *A Dash for the Timber*, Frederic Remington
67 *The Fall of the Cowboy*, Frederic Remington
69 *His First Lesson*, Frederic Remington
72 *Lost in a Snowstorm—We Are Friends*, Charles Marion Russell
73 *In Without Knocking*, Charles Marion Russell
74 *A Tight Dally and a Loose Latigo*, Charles Marion Russell
77 *Flags on the Waldorf*, Childe Hassam
79 *Mother and Son*, Cecilia Beaux
81 *Mother and Daughter, Both Wearing Large Hats*, Mary Cassatt
83 *The Lobster*, Arthur G. Dove
85 *Team of Horses*, Arthur G. Dove
87 *Figure B*, Morton Livingston Schamberg
87 *Composition*, Morton Livingston Schamberg
87 *Composition*, Morton Livingston Schamberg
88 *Three Acrobats*, Charles Demuth
88 *In the Province #7*, Charles Demuth
92 *Provincetown Abstraction*, Marsden Hartley
93 *Earth Cooling*, Marsden Hartley
95 *Blue Day*, Oscar Bluemner
96 *Near Taos, No. 6, New Mexico*, John Marin
102 *Light Coming on the Plains I, II, III*, Georgia O'Keeffe
104 *Red Cannas*, Georgia O'Keeffe
105 *Black Patio Door*, Georgia O'Keeffe
107 *Ranchos Church—Taos*, Georgia O'Keeffe
109 *Parson Weems' Fable*, Grant Wood
110 *World's Greatest Comics*, Ben Shahn
113 *Self-Portrait*, Stuart Davis
114 *New Mexican Landscape*, Stuart Davis
116 *Blips and Ifs*, Stuart Davis
118 *Dark Mesa and Pink Sky*, Georgia O'Keeffe
124 *Exchange Street Geneva*, Arthur G. Dove
126 *Taos Canyon, New Mexico*, John Marin

Designed by Bob Nance

Text type is Linotron 202 Bembo by Akra Data, Inc.
Birmingham, Alabama

Color separations by Graphic Process, Inc.
Nashville, Tennessee

Printed and bound by Kingsport Press, Inc.
Kingsport, Tennessee

Text sheets are Lustro Offset Enamel Dull by S. D. Warren Company
Boston, Massachusetts

Endleaves are Multicolor by Process Materials Corporation
Carlstadt, New Jersey

Cover cloth is Sail Cloth by Holliston Mills
Kingsport, Tennessee